Interactive Design 3 Graphis Mission Statement: *Graphis* is committed to presenting exceptional work in international design, advertising, illustration and photography. Since 1944, we have presented individuals and companies in the visual communications industry who have consistently demonstrated excellence and determination in overcoming economic, cultural and creative hurdles to produce true brilliance.

InteractiveDesign3

CEO & Creative Director: B. Martin Pedersen

Editor: Vanessa Fogel
Production/Design: Luis Diaz
Co-Publisher: Brittany Brouse

Design Interns: Danielle Macagney and Krista Samoles

Published by Graphis Inc.

(opposite) STUDIO INTERNATIONAL/HRS—Hrvatski rukometni savez (CROTIAN HANDBALL FEDERATION)
(next page) Goodby, Silverstein & Partners/Hewlett-Packard Inc.

Zembla Magazine International Literary Magazine

ABCDEF
GHIJKL
MNOPQR
STUVWX
YZ

CONTACT
SUBSCRIPTIONS
STOCKISTS
SUBMISSIONS

"NEVER THINK A WEBSITE IS AS GOOD AS THE REAL THING"

Contents **Inhalt Sommaire**

Remarks: We extend our heartfelt thanks to contributors throughout the world who have made it possible to publish a wide and international spectrum of the best work in this field. Entry instructions for all Graphis Books may be requested from: **Graphis Inc.**, 307 Fifth Avenue, Tenth Floor, New York, New York 10016, or visit our Web site at www.graphis.com.

Anmerkungen: Unser Dank gilt den Einsendern aus aller Welt, die es uns ermöglicht haben, ein breites, internationales. Spektrum der besten Arbeiten zu veröffentlichen. Teilnahmebedingungen für die Graphis-Bücher sind erhältlich bei: **Graphis Inc.**, 307 Fifth Avenue, Tenth Floor, New York, New York 10016. Besuchen Sie uns im World Wide Web, www.graphis.com.

Remerciements: Nous remercions les participants du monde entier qui ont rendu possible la publication de cet ouvrage offrant un panorama complet des meilleurs travaux. Les modalités d'inscription peuvent être obtenues auprès de: **Graphis Inc.**, 307 Fifth Avenue, Tenth Floor, New York, New York 10016. Rendez-nous visite sur notre site web: www.graphis.com.

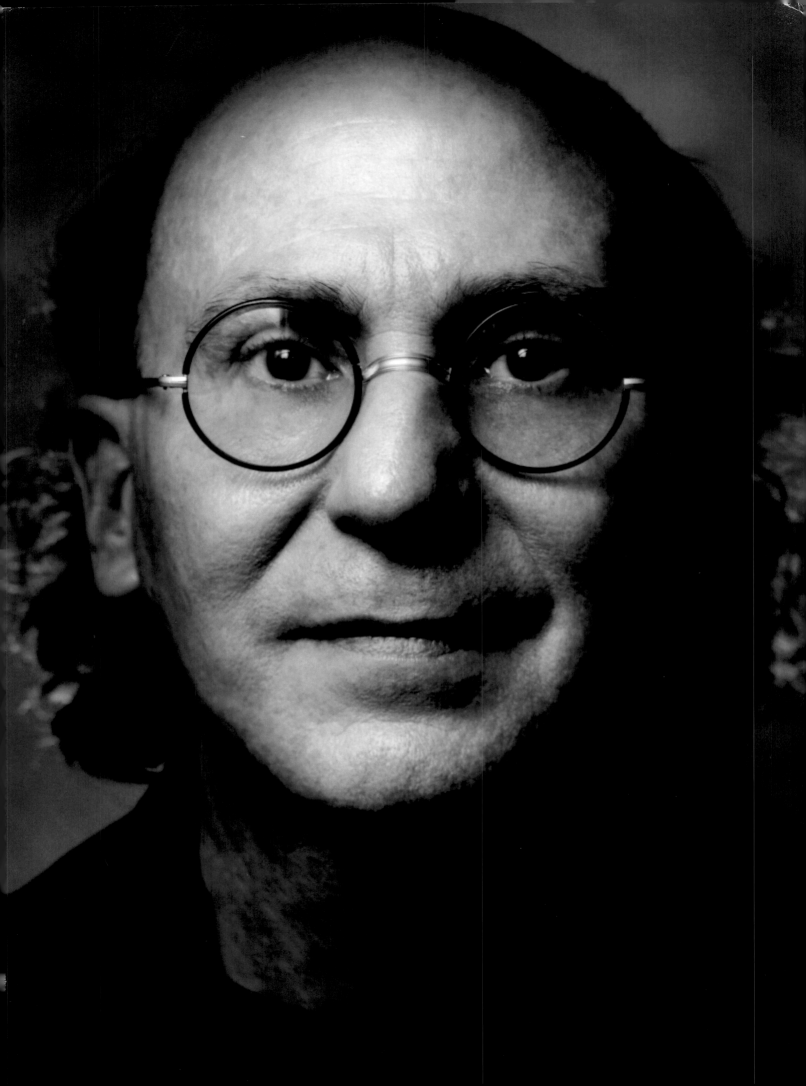

R/GA: BOB GREENBERG'S NINE LIVES

R/GA:"Bob Greenberg's Nine Lives"
By Rogier van Bakel
Portrait by Albert Watson

The web is the latest language to be developed. It's taking people like us here at R/GA to make that language sing.

Bob Greenberg

Bob not only knows how to distill the essence of an idea, but his combination of design talent and database wizardry is creating a new form of communication.

Red Burns, *Chair of the Interactive Telecommunications Program at NYU's Tisch School of the Arts*

Year after year Bobby breaks the mental barriers of design and communication, demonstrating that the unimaginable can happen.

Robert Greenberg's mind is running a mile a minute, and the trouble is, his mouth can't keep up. It's my own fault for asking him a too open-ended question about the future of the interactive medium, a question that all but invites rambling. "There are two things that I can see happening," begins the chairman and CEO of the seminal New York design firm R/GA, and a man who probably understands more about how non-linear, interactive information works than anyone else on the planet. He pauses for a moment's reflection. "No, three things. First of all, I think that." Another pause. "Four things," says Greenberg. "Four."

He spends the next ten minutes weaving strands of his vision together, leaving every other sentence unfinished, frequently getting ahead of himself, one urgent statement begetting another in a wild mishmash that veers from exhilarating to exasperating and back again. In the end, he has lost track of whether he's hit all four points, which seems somehow apt for a guy who a) never uses the subway because his dyslexia gets him hopelessly lost in the underground maze, and b) is obsessed with corralling the power of non-linearity.

Greenberg, 55 and a lifelong movie buff, cut his teeth on that most linear of media: film. In 1977, he and his brother Richard started R/GA ("we put the slash there so we wouldn't look like an insurance company") with a grand total of $12,000, hell-bent on breaking into the movie business. Ever the design aesthete, Greenberg spent a good chunk of that seed money on an Interlübke furniture system that allowed the brothers to make the most of the small space where they lived and worked. "We took an apartment that was about 20 feet wide and 20 feet deep," Greenberg recalls. "My bedroom was too small for a bed. I essentially slept in a closet, right next to the animation camera. My brother slept in a bookcase that you could pivot to hide the bedding. The best comment we heard came from our first client, IBM. They were visiting and one of their guys said, 'This space is great and all, but it's so cramped, I bet you can't wait to get home at night.'"

With close to 275 employees, and headquartered in an airy two-story office building on New York's 39th Street (there's even a quasi-bucolic courtyard for alfresco brainstorms and lunch breaks), R/GA operates under very different circumstances today—and not just in terms of physical space. As Greenberg sees it, the company has just transitioned into its third major phase. "Or maybe the fourth," he says, grinning amiably. "Depends on how you do the counting."

First came the work on films, trailers, and opening titles, including the then-revolutionary flying type of 1978's Superman. Like no other firm of the time, R/GA recognized the dawning of the digital age, then married film and computers thanks to new technology, often invented in-house, that led to a 1986 Academy Award for the Greenberg team. It also got R/GA a permanent place in the annals of design. "We did it before there were Silicon Graphics workstations or G5 Macs," Greenberg says. "That work still means something—or at least it means something to the young people who study design, who are entering the field. They look at us the way we looked at Saul Bass and Lou Dorfsman. They come up to me all the time to talk about how we did Alien and Superman."

R/GA next pioneered the visual-effects realm with tour-de-force feature films like *Zelig*, *Predator*, and *Braveheart*, while also taking on commercials. Gradually, the company became a full-service digital studio, combining the disparate areas of print, spots, and feature film. By Greenberg's estimate, he has been involved in some 400 motion pictures, 4,000 commercials, and print ads too numerous to count.

For a mostly left-brained kind of guy, Greenberg loves numbers. "I'm a little bit superstitious," he confesses. "I'm especially fond of the numbers 9, 19, and 29. And for whatever reason, this company seems to have progressed through stages that are roughly nine years long. In numerology, the number nine refers to endings — which of course are then followed by beginnings if you're not dead."

Now, at 27 (3x9) and far from dead, R/GA has remade itself as the foremost interactive advertising agency in the U.S. The category as a whole is hardly new; many interactive ad shops first thrived, then withered, in roughly the 1998-2002 time span. But to Greenberg it seems like there's very little competition, and not just because of the brutal shakeout that the field endured.

For starters, he says he doesn't feel the surviving interactive boutiques breathing down his neck, because he claims to have better people—not to mention the invaluable clout and support of communications giant IPG, R/GA's corporate owner. He's also blissfully unthreatened by the big traditional advertising agencies, which, for the most part, "just don't get it," he says. "Too many creatives outside of this company think of interactive as coding a print brochure into HTML. They add a link here, a banner there, and they think they're done."

The right approach, Greenberg thinks, is to combine non-linear executions of entertainment, communications, and marketing. That goes a lot further than the pursuit of arresting visuals. For a certified design guru, Greenberg is remarkably conversant in database management systems and e-business applications. Over the last six years or so, he has also built a particularly strong team of "interaction designers," led by Chris Colborn, whose task it is to anticipate and shape the user experience. Colborn decides what piece of information goes where, what should happen when someone clicks here, how broadband aficionados and dialup users can both reap benefits from an R/GA-designed site or game.

He insists that interaction design goes deeper than information architecture, which is what his discipline is typically known as. "Information architects usually play a lesser role—there's no vision expected of them at the level that I'm involved here," Colborn says. His department works on equal footing with the company's visual design group and the copywriters. "It's all complementary: copywriters and visual designers are advocates for the brand, whereas interaction designers are advocates for the user. It's collaborative, too. No one imposes a creative voice. The opposite all too often happens at other agencies."

Not surprisingly, R/GA's clients are pleased as punch. "What R/GA does better than most is deliver great design with the user in mind," says Michael D. Moore, director of Nestlé Purina's Interactive Group. "Many say they do this, but R/GA actually lives up to it. They don't think of themselves as being in the website business or even the technology business. Both of those are means to an end—that end being effective communications with an audience, in whatever form or format is best for that audience."

Peers, too, are quick to heap on the praise. Red Burns, chair of the Interactive Telecommunications Program at NYU's Tisch School of the Arts, believes that "Bob knows how to distill the essence of an idea. His design talent, combined with the use of powerful databases, is creating a new form of communication."

And noted information designer Richard Saul Wurman likens the spindly-looking Greenberg to a world-class athlete. "In 1954, Roger Bannister ran a sub-four-minute mile," Wurman says. "After hundreds of people had tried for a hundred years, his breakthrough was immediately followed by many other runners achieving the same feat. Bannister will be remembered for not breaking the physical barrier, but rather the mental barrier. Bobby, his companies, and his legion of brilliant employees year after year break the mental barriers of design and communication for the rest of the industry—because they demonstrate that the unimaginable can happen."

As appreciative as Greenberg is of those laurels, he's not tempted to rest on them. His goal is for R/GA to become in the interactive channel what Goodby, Fallon, and Wieden & Kennedy are in traditional advertising—an agency small enough to innovate and have fun, yet large enough to service a slew of A-list companies.

On that easily quantifiable last score, R/GA is doing rather spectacularly. Of the 18 new-business pitches the company undertook last year, it won 14, including Levi Strauss, Circuit City, Hilton, and Verizon Communications. No doubt, some of those companies were salivating over R/GA's signature work for Nike, which comprises such richly textured, bleeding-edge websites as nikegoddess.com and nikegridiron.com. The i-shop's 2003 revenues of an estimated $68 million are reportedly up 20 percent over the year before.

R/GA also scored big on another front: awards. For Nike alone, the shop won the trifecta, taking home four Clios, four Cannes Cyber Lions, and five One Show Interactive Pencils.

While Greenberg in his round glasses, bald pate, and unruly side hair may have the look of a geeky artist, he also possesses a businessman's acumen. His latest creative rebirth nurtures both personae. That is to say, the interactive medium is not just where the excitement is right now, it's also where the cash is, or so Greenberg believes. "I think that 2004 will be a bit of an awakening for traditional agencies," he says. "Because for them, clients' budgets are going down, or at best stay they'll stay the same. Clients are going to a multichannel approach, and that's why on

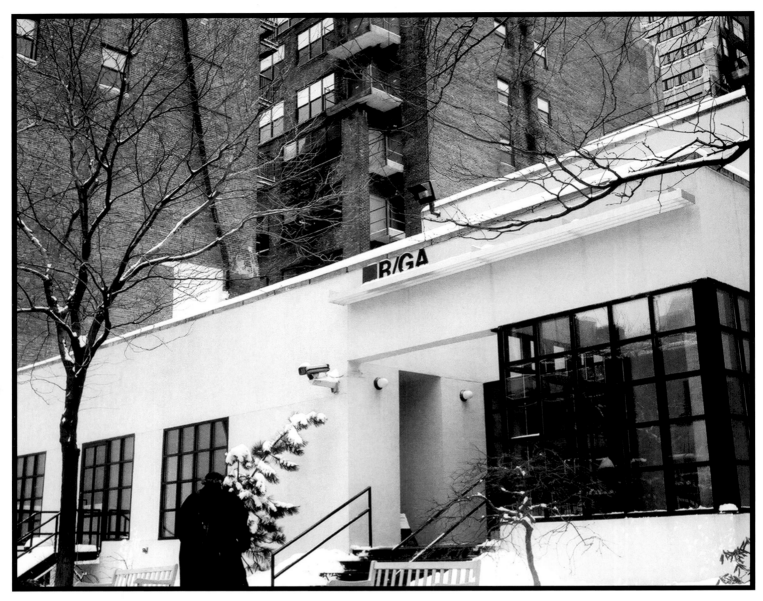

TV you will see fewer commercials being run more often. The real growth is in interactive communications. And that's in part because the millennials, the 18-to-24-year-olds who are the most important demographic for advertisers right now, are more gung-ho on computers than on TV sets. They're not such heavy viewers as earlier generations; they're looking for more of a two-way experience."

R/GA's shift to interactive shop also makes strategic sense in another way: with the interactive channel's new-found prominence, Greenberg and his staff no longer suffer several degrees of separation from their clients. "We've worked on roughly 4,000 commercials without access to the clients," Greenberg says, still a little incredulous. "If we wanted to discuss something with the client's brand people, there was always the ad agency that served as a conduit. These days, we can bring an idea to Nike, right to the marketing heads, to Phil Knight if we want to, instead of going through an agency. That's pretty great."

R/GA Creative Director Rei Inamoto adds that, on big projects, the New York shop now gets briefed at the same time as Nike's long-time agency of record, Portland's Wieden & Kennedy. "It's a sign that things have changed," Inamoto observes. "Five years ago, that would never have happened. Interactive was then almost an afterthought."

When R/GA team members discuss interactive media, they don't just mean web-based content, but also information disseminated through cell phone screens, wireless PDAs, and other info-age gadgets. Colborn, R/GA's VP of interaction design, happily points to the new Suunto watch on his wrist. It's a Microsoft-powered contraption that wirelessly fetches sports scores, weather forecasts, stock quotes, et cetera.

"Recommended for early adopters," he says, implying that the technology may not be quite ready for prime time yet. "It has very low screen resolution, obviously. But you know what? Stuff like this keeps you on your toes. It's pretty cool really. Just when you think you've mastered designing for one platform, another one pops up."

Greenberg, too, is unconcerned about the shrinking of his canvas, from big-screen TV to 15-inch computer monitor to PDA to wristtop. "I really don't think it's a problem," he says. "I remember flying to L.A. and I noticed a guy who was watching the in-flight movie on this little Sony screen that pops out of your armrest, and he was crying. You'd think that his emotional response to whatever he was watching would have been impaired by the bad sound or the small picture, but apparently it didn't matter. He was making a connection and getting all choked up. My point is that you can get that experience on a cell phone too. I'm perfectly convinced of that."

All he and his team need to do, Greenberg says, is develop the right language to tackle the medium, much like movie pioneers did a hundred years ago. "The director who influenced me the most was Sergei Eisenstein," he muses, "especially his Aleksandr Nevsky, which I have on DVD now. I just sit back and wonder how in the world, so long ago, without visual effects, was Eisenstein able to do stuff that we wouldn't be able to do with all the visual-effects equipment we have today? He invented the language: the cuts, the dissolves, the repositions, the focal lengths.

"And so, I figure: Well, what about the web? The web is the newest language, and it's barely been developed. That's a huge opportunity, and it's going to take people like us here at R/GA—the designers, producers, the communicators, the writers—to push that out. To make it sing."

This essay was originally published in Graphis issue #353

Pg.6 *Robert M. Greenberg, Portrait by Albert Watson.*

Pg.10 *The front of the R/GA building, formerly an airfreight terminal and the bay windows were the loading docks for the trucks. Photo by Sarah Shatz.*

Pg.12 (top) *Nike Goddess (www.nikegoddess.com).* This Home Page features the Speed Campaign. It also serves as a launching point to explore events and promotional opportunities. "Shop" is a section of the site that is divided into the fitness categories of run, gym, yoga, outdoor and active, making it easy to search for products geared toward specific needs.

Challenge: To create a premier online destination for active women interested in researching and purchasing fitness apparel, equipment and accessories.

Solution: An e-commerce experience that is built entirely in Flash, allowing customers to interact with products in new ways. Products can be rotated, revealing the front and back. One of the unique features on NikeGoddess.com is the Wish Box, a much more interactive version of a wish list. It features drag and drop functionality, encouraging women to create a virtual closet filled with thumbnail images of their favorite items. The Box can then be emailed, printed or saved for easy reference.

Pg.12 (center and bottom) *Nike Goddess (www.nikegoddess.com), Launched in 2001, updated on a regular basis.* Producer: Afua Brown; Art Director: Yzabelle Munson; Designer: Johanna Langford; Junior designer: Jeannie Kang; Flash developers: David Morrow, Christine Reindl; Programmer: Ray Vazquez; Copy Writer: Kristina Grish; Interaction designer: Erin Lynch; Quality Assurance: Tracey Carangelo; Executive Producer: Matt Howell; Client: Nike.

Each fitness category is organized into Jackets, Tops, Bottoms, Footwear and Accessories/Equipment and are scrollable to allow mixing and matching of outfits.

Pg.13 (top) *Nike Lab Site (www.nikelab.com) takes on another theme, "Dreams in Motion," 2003.* Creative Director: Rei Inamoto; Art Director: Jerome Austria; Designers: Mikhail Gervits, Hiroko Ishimura, Gui Borchert; Producer: Jennifer Allen; Technical Lead: Martin Legowiecki; Flash Developers: Lucas Shuman, Chuck Genco, Raymond Vazquez; Interaction Designer: Carlos Gomez de Llarena; Copy Writer: Jason Marks; QA: August Yang. Client: Nike.

Detailed product information is delivered through the Lab Reports, the part of the site that provides visitors with the story behind the breakthrough technology. Using 3-D images, photography, animated vignettes and audio descriptions, visitors are able to interact with products in entirely new ways.

Pg.13 (center), *Nike Lab (www.nikelab.com), Launched November 2002.* Executive Producer: Kip Voytek; Creative Director: Nick Law; Producer: Sheila DosSantos; Art Director: Rei Inamoto; Interaction Director: Pat Stern; Designer: Mikhail Gervitz, Jeannie Kang; Interaction Designers: Carlos Gomez de Llarena; Copy Writer: Jason Marks; Tech Lead: Scott Prindle; Flash Programmers: Martin Legowiecki, Lucas Shuman, Ted Warner; Client: Nike.

Challenge: To create a showcase for innovation, highlighting Nike's most technologically advanced products in a style that pushes the boundaries of what's possible on the Web.

Solution: Nike Lab moves beyond the conventional linear representation of product information by creating immersive, narrative experiences designed to tell unique stories inspired by Nike's most innovative products. Nike Lab has evolved into a digital installation gallery, where leading artists from around the world create experiences that bring Nike products to life.

Pg.13 (bottom) *Nike Lab (www.nikelab.com) 2003.* Nike Lab used filmstrips as an innovative interface and navigational tool. The thumbnail images are windows to deeper content, revealing interactive experiences by some of the world's most talented digital artists along with unique product displays.

Pg.14 (top) *Nike Gridiron (www.nikegridrion.com), 2003.* Executive Producer: Matt Howell; Creative Director: Rei Inamoto; Producer: Beverly May; Art Directors: Nathan Iverson, Rei Inamoto; Designers/Animators: Misha Gervitz, Sacha Sedriks; Technical Lead: Scott Prindle; Flash Developer: Lucas Shuman; Software Engineer: Stan Weichers, Hamid Younessi; Video Editor: Stephen Barnwell, Matt Walsh; Interaction Designer: Pat Stern, Kip Voytek, Matt Walsh; Copy Writer: Jason Marks, Ken Hamm, Andrew F. Kessler; Quality Assurance: Tracey Carangelo, August Yang, Paul Maingot.

Challenge: Create an online experience on the Web for Nike's return to football prominence. The site's launch was coordinated with a 60-second television spot directed by David Fincher.

Solution: A breakthrough interactive game experience that features six marquee football athletes, capturing the action and intensity of each of their positions. Nike Gridiron's central content piece is a set of six Web-delivered 3-D football games. Each game is paired with a Nike athlete, whose unique attributes are incorporated into the gameplay.

Pg.14 (center) *Nike Gridiron. Player page:* Each player (Michael Vick is shown) is paired with information related to the player including, the 3-D game, a gear area highlighting equipment associated with the athlete, a player interview and a training video.

Pg.14 (bottom) *Nike Gridiron. Game page:* Michael Vick's game focuses on his speed and challenges consumers to use their skills to scramble, pass and run.

Pg.15 *Nike Basketball—Sole System (www.nikebasketball.com), 2002.* Creative Director: Nick Law; Executive Producer: Kip Voytek; Producer: Shawn Natko; Art Director: Winston Thomas; Senior Designer: Nathan Iverson; Designer/Developer: Andrew Hsu; Flash Designer: David Morrow; Senior Engineer: John Jones, Chuck Genco, Martin Legowiecki; Senior Interaction Designer: Patrick Stern; Interaction Designer: Richard Ting; Quality Assurance Engineer: Justin Wasik, Jennifer Allen; Copy Writer: Jason Marks.

Located on Nike Basketball, Sole System is the 3-D digital universe of Nike Basketball shoes. It is an immersive resource tool for consumers, containing an ever-evolving visual database of the last three decades of Nike Hoop technology and Nike shoes.

Pg.16 (top) *Rhode Island School of Design (www.risd.edu), June 2001.* Senior Producer: Elizabeth Rankich; Associate Producer: Lee Passavia Art Director: Sasha Kurtz; Senior Visual Designer: Lesli Karavil; Flash Designer & Production Artist: Kohsuke Yamada; Interaction Designers: Dan Harvey, Max Kazemzadeh; Technical Team Leader: Tom Freudenheim; Lead Programmer: George Matthes; Senior Programmer: Michael Roufa, Charoonkit Thahong; Quality Assurance: Sunny Nan; Client: Rhode Island School of Design.

Challenge: How do you design a site for a prestigious design school? RISD required an online presence that would reflect the richness of the educational experience as well as the graphic aesthetic on which it bases its reputation. Additionally the site needed to serve multiple audiences, by providing information to students about the application process and contain news for the alumni.

Solution: R/GA thoroughly revised the site's navigation, giving it a more simplified and intuitive structure. A system of hierarchical templates was created to accommodate the breadth of content and assist users in navigating deeper into the site. The site invites potential students into the life and process that exists behind the studio walls, while maintaining the elegance suitable for patrons of the RISD museum.

Pg.16 (center) *Nasdaq market master.* Design: R/GA; Client: Nasdaq.

Pg.16 (bottom) *Tisch School of the Arts, N.Y.U. (www.tisch.nyu.edu), 2003.* Creative Director: Nick Law; Art Director: Nick Law; Designers: Nina Schlechtriem, Brandon Malloy; Interaction Designers: Dixon Rohr, Dan Harvey, Ryan Leffel; Producer: Lee Passavia, Adam Blumenthal; Production Coordinator: Patrick Soria; Programming: Ed Bocchino, George Mathes; Copy Writer: Cheryl Brown; Client: Tisch School of the Arts.

Challenge: The site needed to convey Tisch's impeccable credentials in the fields of art and education and provide an array of accessible resources to the broad group of Tisch users. Just as important was maintaining a coherent tone across the site.

Solution: The result is an experience where the information is organized in a fresh, intuitive way and a global navigation system that maintains consistency across the site while highlighting services that are relevant to many audiences. The site design maintains enough flexibility to allow each department to have the ability to create its own distinctive imagery, color, and content.

Pg.17 *Frank Lloyd Wright, Broadband Design and Production, 1999. Client: PBS/Intel.*
An early foray into broadband interactive television, R/GA created an interactive companion piece to Ken Burns' documentary on Frank Lloyd Wright. The piece, which was broadcast to a trial audience via Intercast technology, offered a deeper look into the architect's projects. Viewers were encouraged to listen to descriptions about the structures, view additional video and take virtual tours of the Guggenheim Museum, Falling Water and Unity Temple. Eric Lloyd Wright, the architect's grandson, provided narration, guiding the viewer through the many areas of exploration.

R/GA 350 West 39th Street New York, NY 10018 www.rga.com

Rogier van Bakel: *The former editor-in-chief of Advertising Age's Creativity and Jungle, Dutch-born van Bakel has left his mark on journalism as a writer, too. van Bakel has written for Wired, Rolling Stone, Business 2.0, The New York Times Magazine, among others. He was a judge for the 2003 Webby Awards, the online world's Oscars.*
"To me, the most satisfying online experiences are those where four things have come together," says Rogier van Bakel, a New York-based journalist. "They are, an esthete's sense of style and order; a geek's deep knowledge of the power of digital tools; an architect's understanding of how to make complicated spaces inviting and effortlessly maneuverable; and a marketer's knack for defining the unique voice of his brand. Greenberg combines all those talents—and even makes it seem easy."

Albert Watson: *Albert Watson was born in Scotland in 1942. Educated at the Royal College of Art in London, he is one of the most sought-after photographers, who has covered the gamut of portraiture, advertising campaigns, music CD packaging and editorial projects with his classical and bold signature. He was the official photographer for the wedding of Prince Andrew and Sarah Ferguson, as well as for His Majesty Mohammed VI of Morocco. Watson received a Grammy Award in 1975 for best album cover. He has art directed music videos for pop stars such as Sade, Al Green, and Morrissey. He regularly contributes to Time, Newsweek, Rolling Stone, Vibe. His client list includes Estée Lauder, Max Factor, Gilette, Armani—to name a few. Watson is the author of Cyclops (1996) and Maroc (1998), and Las Vegas (2003).*

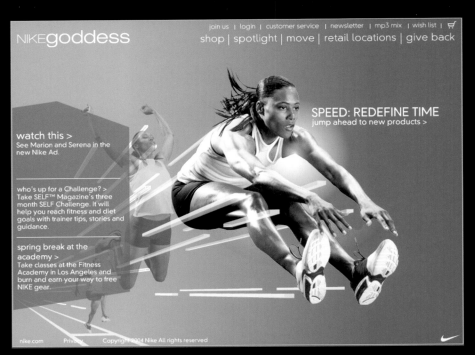

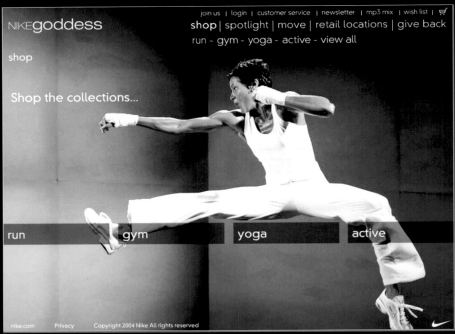

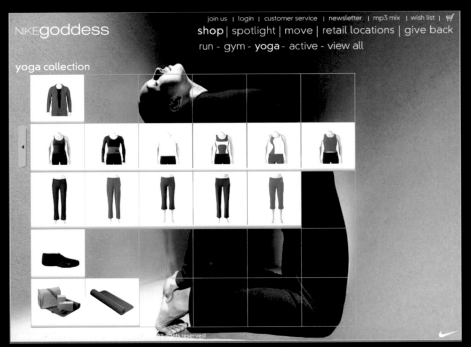

FROM PAPER TO BRAIN →IDEAS SPILL, FORMING → MAGIC INTO REALITY . TOTAL MAGIA

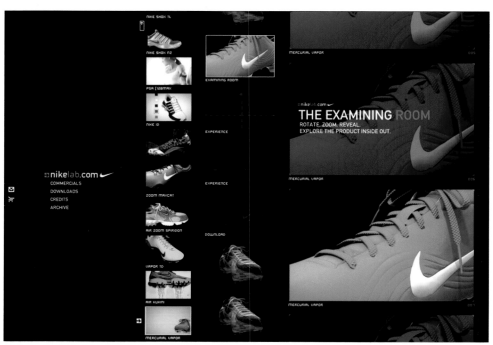

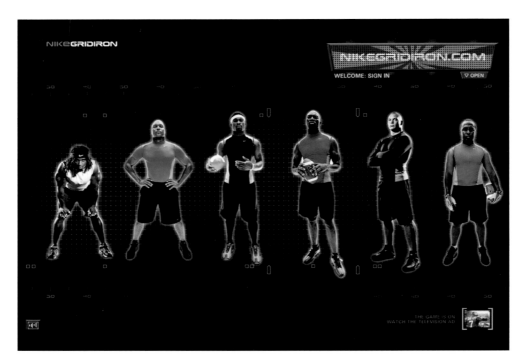

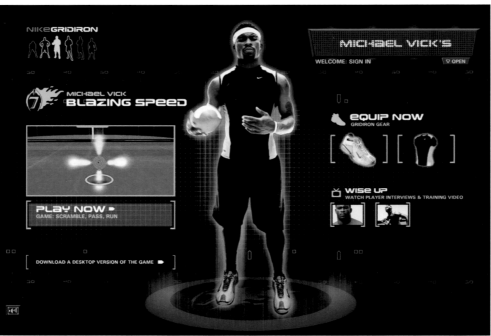

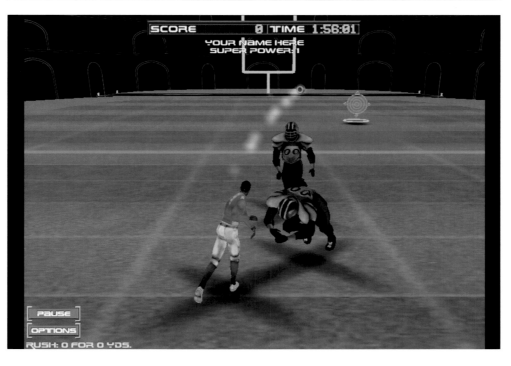

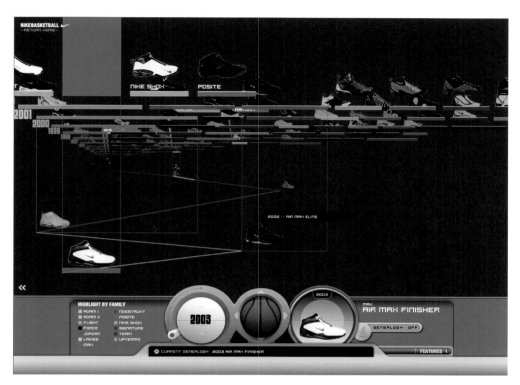

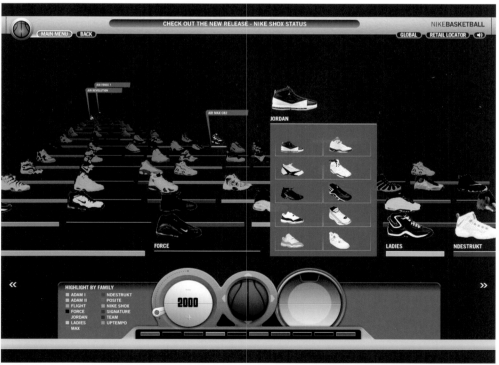

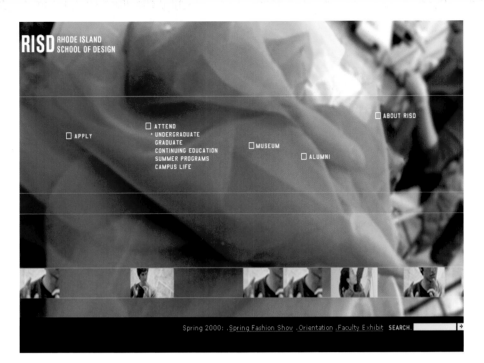

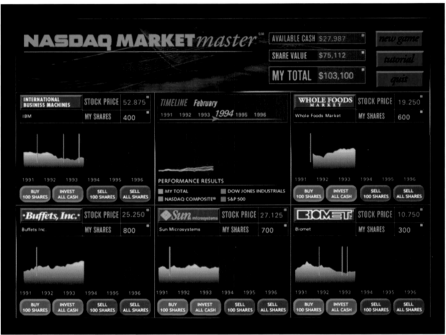

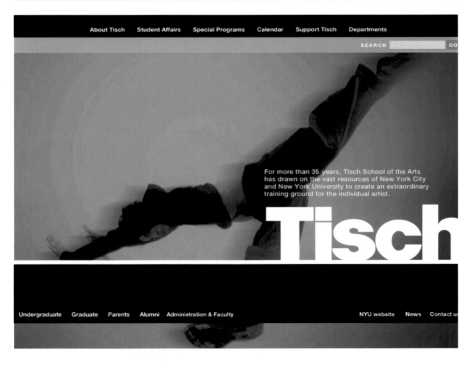

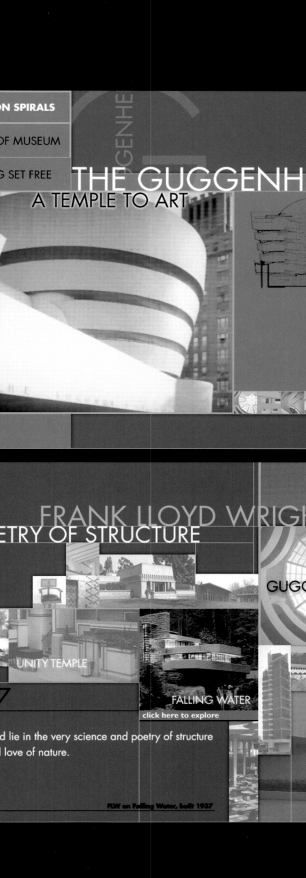

Page Tools

⊕ Guide
What is the "Letter to Stakeholders"?

⊕ Downloads
Letter to Stakeholders
(476K PDF)
More downloads

⊕ E-Mail This Page
Share this page with a friend
or colleague.

Letter to Stakeholders

THE GE TEAM

I am very proud of your team. They are passionate and committed. I spend about one-third of my time on people with my partner Bill Conaty, GE's Human Resources leader. We recruit, we train, we develop, we improve, we think about people constantly. I am happy to report that retention remains high, with voluntary turnover among our leaders of less than 3%.

TITLE
Senior Vice President,
Law and Public Affairs

← BACK NEXT →

BEN HEINEMAN

BACK TO GROUP VIEW

Historically, we have been known as a company that developed *professional managers*. These are broad problem-solvers with experience in multiple businesses or functions. However, I want to raise a generation of *growth leaders*—people with market depth, customer touch and technical understanding. This change emphasizes depth.

We are expecting people to spend more time in a business or a job. We think this will help our team develop "market instincts," so important for growth, and the confidence to grow global businesses. Ultimately, careers should be broad *and* deep, giving our leaders the confidence to solve problems and the experience to drive growth. But today, to get the right balance, we are emphasizing depth.

About a year ago, one of our executive development classes

ARE YOU
LEADING CHANGE
OR CHASING IT?
FIVE
GROWTH

Letter to Stakeholders

GE has made tremendous progress on the strategy for long-term growth outlined in this year's annual report. Learn more in the Letter to Stakeholders.

Financials

View our entire Financial Report in HTML format.

Governance

Read about GE's position on Corporate Governance and meet our Board of Directors.

Site Tools

→ Downloads
→ Guides
→ Feedback
→ E-mail this page

Proxy Statement → View the Proxy Statement for voting information before the Annual Meeting on April 28th.

Dear Fellow Stakeholders
The Environment We See
The GE Business Model
Building a Stronger Portfolio
GE's Growth Strategy
The GE Team
Restoring Investor Trust
The Future
Financial Highlights

Page Tools

⊕ Guide
What is the "Letter to
Stakeholders"?

⊕ Downloads
Letter to Stakeholders
(476K PDF)
More downloads

⊕ E-Mail This Page
Share this page with a friend
or colleague.

Letter to Stakeholders

THE GE TEAM

I am very proud of your team. They are passionate and committed. I spend about one-third of my time on people with my partner Bill Conaty, GE's Human Resources leader. We recruit, we train, we develop, we improve, we think about people constantly. I am happy to report that retention remains high, with voluntary turnover among our leaders of less than 3%.

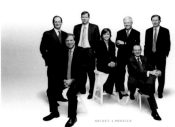

SELECT A PROFILE

Historically, we have been known as a company that developed *professional managers*. These are broad problem-solvers with experience in multiple businesses or functions. However, I want to raise a generation of *growth leaders*—people with market depth, customer touch and technical understanding. This change emphasizes depth.

We are expecting people to spend more time in a business or a job. We think this will help our team develop "market instincts," so important for growth, and the confidence to grow global businesses. Ultimately, careers should be broad *and* deep, giving our leaders the confidence to solve problems and the experience to drive growth. But today, to get the right balance, we are emphasizing depth.

About a year ago, one of our executive development classes

(and next spread) VSA Partners

GE

GENERAL ELECTRIC 2003 ANNUAL REPORT

LETTER TO STAKEHOLDERS | FIVE QUESTIONS | LEADERSHIP TEAM | GOVERNANCE | CITIZENSHIP | FINANCIALS
Downloads · Guides · Feedback

HOW DO YOU MAKE MONEY FOR YOUR CUSTOMERS?

TWO
SERVICES

Letter to Stakeholders
GE has made tremendous progress on the strategy for long-term growth outlined in the last annual report. Learn more in the Letter to Stakeholders.

Financials
View our entire Financial Report in HTML format.

Governance
Read about GE's position on Corporate Governance and meet our Board of Directors.

Site Tools
+ Downloads
+ Guides
+ Feedback
+ E-mail this page

Proxy Statement → View the Proxy Statement for voting information before the Annual Meeting on April 28th.

GE

GENERAL ELECTRIC 2003 ANNUAL REPORT

LETTER TO STAKEHOLDERS | FIVE QUESTIONS | LEADERSHIP TEAM | GOVERNANCE | CITIZENSHIP | FINANCIALS
Downloads · Guides · Feedback

ROSS JARDIN
GE TRANSPORTATION, AIRCRAFT ENGINES

Services that reach new frontiers.

PRESTWICK, SCOTLAND

EVENDALE, OHIO | SHANGHAI, CHINA | PRESTWICK, SCOTLAND

01	02	03	04	05
LETTER TO STAKEHOLDERS	SERVICES	LEADERSHIP FOCUS	GLOBALIZATION	GROWTH PLATFORMS

GE

GENERAL ELECTRIC 2003 ANNUAL REPORT

LETTER TO STAKEHOLDERS | FIVE QUESTIONS | LEADERSHIP TEAM | GOVERNANCE | CITIZENSHIP | FINANCIALS
Downloads · Guides · Feedback

WHAT DISTINGUISHES A PARTNER FROM A VENDOR?

THREE
RELATIONSHIPS

Letter to Stakeholders
GE has made tremendous progress on the strategy for long-term growth outlined in the last annual report. Learn more in the Letter to Stakeholders.

Financials
View our entire Financial Report in HTML format.

Governance
Read about GE's position on Corporate Governance and meet our Board of Directors.

Site Tools
+ Downloads
+ Guides
+ Feedback
+ E-mail this page

Proxy Statement → View the Proxy Statement for voting information before the Annual Meeting on April 28th.

GENERAL ELECTRIC 2003 ANNUAL REPORT

HOW DO YOU *DEFEAT* THE *COMMODITY THREAT?*

—— ONE ——

TECHNOLOGY

Letter to Stakeholders

GE has made tremendous progress on the strategy for long-term growth outlined in the last annual report. Learn more in the Letter to Stakeholders.

Financials

View our entire Financial Report in HTML format.

Governance

Read about GE's position on Corporate Governance and meet our Board of Directors.

Site Tools

→ Downloads
→ Guides
→ Feedback
→ E-mail this page

Proxy Statement → View the Proxy Statement for voting information before the Annual Meeting on April 28th

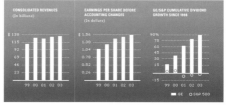

Sales that speak the local language.

SHANGHAI, CHINA

— MORE —

EVENDALE, OHIO | SHANGHAI, CHINA | PRESTWICK, SCOTLAND

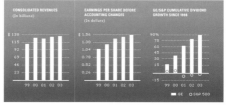

EDDIE O'LOUGHLIN
GE TRANSPORTATION, AIRCRAFT ENGINES

Just as GE's aircraft engine customers conduct operations globally, so its aircraft engine services team operates in locations on every continent but Antarctica.

— MORE —

EVENDALE, OHIO | SHANGHAI, CHINA | PRESTWICK, SCOTLAND

Dear Fellow Stakeholders
The Environment We See
The GE Business Model
Building a Stronger Portfolio
GE's Growth Strategy
The GE Team
Protecting Investor Trust
The Future
Financial Highlights

Page Tools

Guide
What is the "Letter to Stakeholders"?

Downloads
Letter to Stakeholders (476K PDF)
More downloads

E-Mail This Page
Share this page with a friend or colleague

FINANCIAL HIGHLIGHTS

CONSOLIDATED REVENUES
(In billions)

$ 138
115
92
69
46
23

'99 00 01 02 03

EARNINGS PER SHARE BEFORE ACCOUNTING CHANGES
(In dollars)

$ 1.56
1.30
1.04
0.78
0.52
0.26

'99 00 01 02 03

GE/S&P CUMULATIVE DIVIDEND GROWTH SINCE 1998

90%
75
60
45
30
15
0
-15

'99 00 01 02 03

■ GE ○ S&P 500

Through the cycles, GE's long-term financial goals are: revenue growth of twice the U.S. Gross Domestic Product (GDP); 10%-plus annual earnings growth; operating cash flow growth greater than earnings; and a return on total capital exceeding 20%.

Here is how GE performed in 2003:

- Revenues grew 1% to $134.2 billion. Excluding Power Systems and the expected impact of the decline in U.S. gas turbine shipments, revenue grew 6%, about twice GDP growth.

- Earnings before required accounting changes grew 3% to $15.6 billion, or $1.55 per share. Excluding Power Systems, earnings grew 17%.

- Cash flow from operating activities was $12.9 billion, up 28%, reflecting a $2.2 billion improvement from inventory, receivables and payables. Return on average total capital remained strong at 19.9%.

- The Board of Directors increased the dividend 5% for GE's 28th consecutive annual increase. At year-end, GE's yield was 2.5%, a 40% premium to the S&P 500. GE returned $8 billion to investors in 2003, primarily through dividends.

- GE remained one of only seven triple-A rated industrial companies. The Company continued to reduce "parent-supported debt" at GE Capital, with total reductions of more than $9 billion over 2002–03. Commercial paper as a percentage of total debt remained below 30%.

- Total return for GE shareholders (stock price appreciation assuming reinvested dividends) was 31% versus the S&P 500's total return of 29%. At year-end, GE traded at a price/earnings ratio (P/E) of

IOTA ●●○

iota max

micro architectural exchange

IOTA ●●○

personalities

IOTA
inland office for tomorrow's architecture

TIHANY DESIGN

ABOUT PROJECTS PRODUCTS

NEWS • "Tihany Style: Hospitality Design" new book published by Mondadori at bookstores this fall

TIHANY DESIGN

ABOUT PROJECTS PRODUCTS

NEWS • "Tihany Style: Hospitality Design" new book published by Mondadori at bookstores this fall

TIHANY DESIGN

ABOUT PROJECTS PRODUCTS

NEWS • "Tihany Style: Hospitality Design" new book published by Mondadori at bookstores this fall

Mirko Ilic Corp/Tihany Design

HISTORY RESTORATION TOUR RESOURCES CONTACT

MALCOLM WILLEY HOUSE FRANK LLOYD WRIGHT ARCHITECT

replay intro about the logo site bibliography site credits

HISTORY RESTORATION TOUR RESOURCES CONTACT

PHOTO ALBUM

To view larger images and captions, roll cursor over thumbnail photos above.

timeline archive recollections

HISTORY RESTORATION TOUR RESOURCES CONTACT

Upon reaching the top of the steps, one experiences the feeling of a "pinch" from the low sheltering roof above. The horizontal "pinstriping" brick pattern that results from alternating courses of sand mold and paving bricks is evident here. One may also note at this point clues to the grammer of the house – rectangles and right angles characterisitic of the bricks in contrast with the 30/60 degree triangle of the terrace.

massing model virtual tour details and furnishings tour info

(this spread) Design Guys/Wright at Home

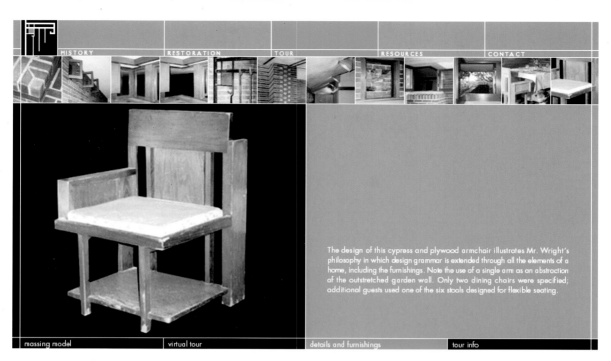

HISTORY RESTORATION TOUR RESOURCES CONTACT

The design of this cypress and plywood armchair illustrates Mr. Wright's philosophy in which design grammar is extended through all the elements of a home, including the furnishings. Note the use of a single arm as an abstraction of the outstretched garden wall. Only two dining chairs were specified; additional guests used one of the six stools designed for flexible seating.

massing model virtual tour details and furnishings tour info

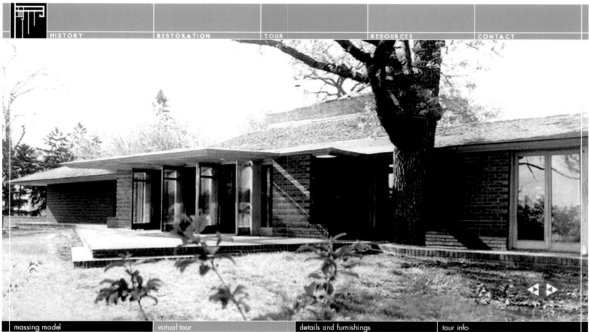

HISTORY RESTORATION TOUR RESOURCES CONTACT

massing model virtual tour details and furnishings tour info

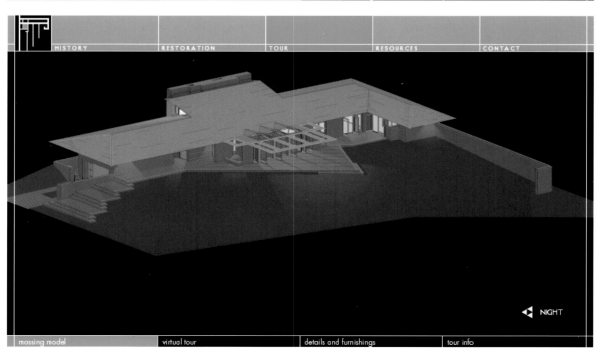

HISTORY RESTORATION TOUR RESOURCES CONTACT

NIGHT

massing model virtual tour details and furnishings tour info

QUIT

0 10 20 30

ART OF DESIGN ENGINEERING & TECHNOLOGY HISTORY ENTERTAINMENT

OWNER EXPERIENCE MORE INFO CROSSFIRE NEWS & EVENTS PRICE & EQUIP

CHRYSLER

© 2003 DAIMLERCHRYSLER | LEGAL

(this spread) Firstborn/BBDO and The Arnell Group

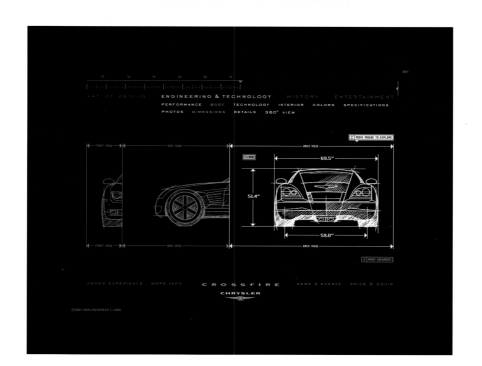

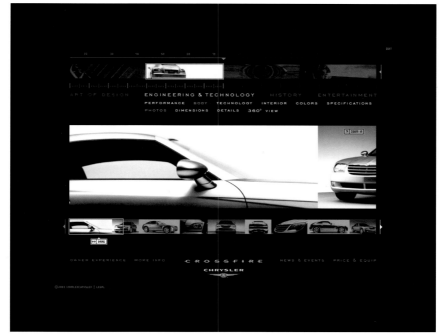

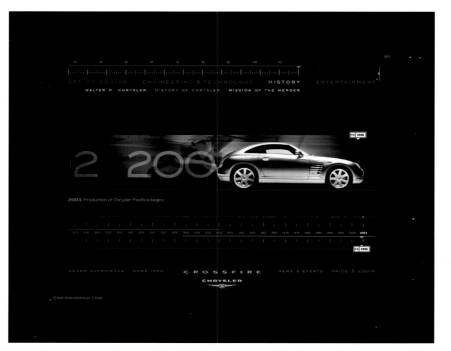

SEARCH [] ↑ OK
∨ SHOWROOM
 ▷ ION SEDAN
 ▷ ION QUAD COUPE
 ▷ L300 SEDAN
 ▷ L300 WAGON
 ▷ VUE
 ▷ USED CARS
▷ ABOUT US
▷ FINANCIAL TOOLS
▷ MY SATURN
▷ CONTACT US

☐ MY SATURN REGISTRATION
LOGIN [] / ☐
PASSWORD [] ↑ OK
FIND RETAILER [ENTER ZIP] ↑ OK

Section. showroom

It's Different in a Saturn®

compare models: ☐ PRICE / ☐ CAPACITY / ☐ PERFORMANCE read: ☐ TODAY'S HEADLINES

Every Saturn is designed with one thing in mind: the person that may one day drive it. Take a closer look at the models above. You never know, that person just might be you.

© 2003 Saturn Corporation / OnStar / GM Sites / Legal / Privacy Policy

SEARCH [] ↑ OK
▷ SHOWROOM
∨ ABOUT US
 ▷ OUR STORY
 ▷ WHAT PEOPLE SAY
 ▷ EVENTS
 DESIGN CENTER
 ▷ SATURN TEAM
▷ FINANCIAL TOOLS
▷ MY SATURN
▷ CONTACT US

Section. about us / **Design Center**

Sky Concept

003

sky concept / The SKY concept began with one simple question: What are people looking for in a sports car? The answer was clear, if not a little bit surprising: open air, room for a few friends and their stuff and — here comes the surprising part — a sense of responsibility. Introducing the SKY — an open-air roadster designed for a whole new generation of free spirits.

[MAIN PAGE]

FIND RETAILER [ENTER ZIP] ↑ OK

© 2003 Saturn Corporation / GM Sites / Legal / Privacy Policy

SEARCH [] ↑ OK
▷ SHOWROOM
▷ ABOUT US
▷ FINANCIAL TOOLS
▷ MY SATURN
∨ CONTACT US
 ▷ RETAILERS
 ▷ CUSTOMER ASSISTANCE

Section. contact us

How Can We Help?

find a saturn retailer

Enter your ZIP code below to get information on your local retailer.

[ENTER ZIP] OK

request a brochure

For product information on current Saturn vehicles, simply download a brochure. Or, request a brochure to be sent by email.

contact saturn

Saturn Corporation
100 Saturn Parkway
371999 MD S-24
Spring Hill, Tennessee 37174
(800) 553-6000

or

email us

*You can save yourself some time by checking the frequently asked questions before contacting customer assistance directly.

FIND RETAILER [ENTER ZIP] ↑ OK

©2003 Saturn Corporation GM Sites / OnStar / Legal / Privacy Policy

All new. Land Rover LR3.

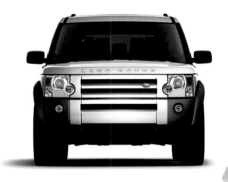

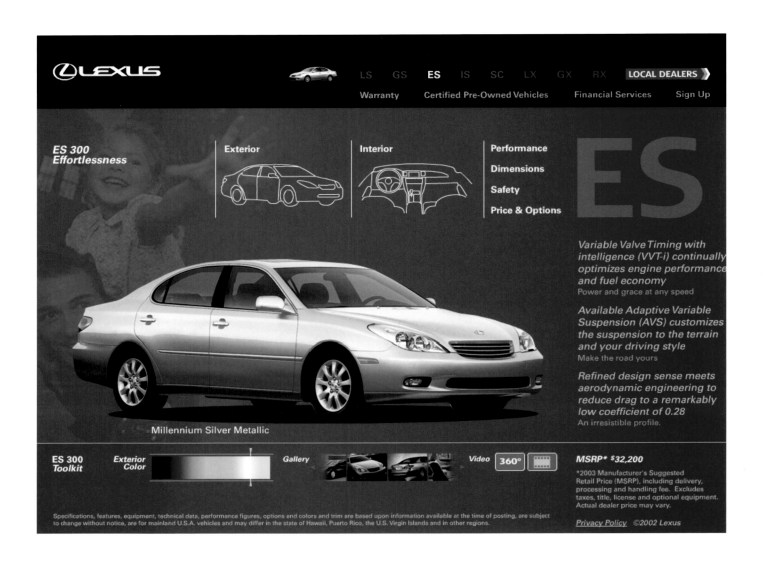

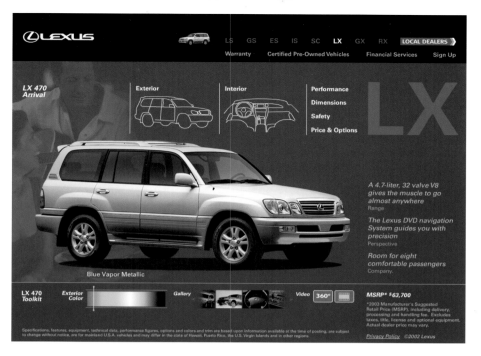

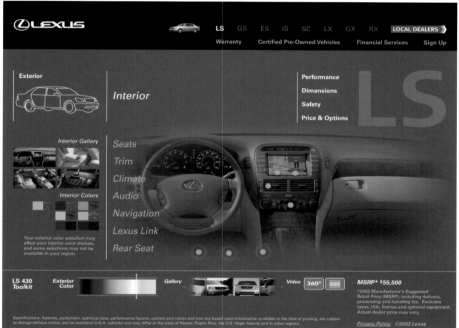

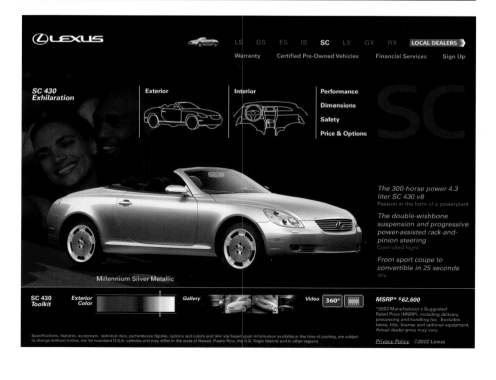

REVEALED IN ITS PUREST FORM

TASTE THE EVOLUTION ▼

HOME

CORZO

CORZO

CONTACT US | TERMS AND CONDITIONS

DESIGNED AND PRODUCED BY Firstborn

TASTE THE EVOLUTION ▼

HOME
THE HISTORY
THE PROCESS
THE EVOLUTION
COCKTAILS
DOWNLOADS
EVENTS
PRESS
TASTE THE EVOLUTION

CORZO

CORZO

CONTACT US | TERMS AND CONDITIONS

DESIGNED AND PRODUCED BY Firstborn

CORZO GRAND MARGARITA

2 parts CORZO Silver Tequila
1 part GRAND MARNIER Liqueur
Dash fresh lime juice
2 oz pineapple juice

Shake well and strain into a Martini glass

Garnish: A salted rim and Pineapple slice

GO BACK

COCKTAILS

CORZO
THE FINEST FRENCH TEQUILA

CORZO

CORZO
THE FINEST FRENCH TEQUILA

HOME
THE HISTORY
THE PROCESS
THE EVOLUTION
COCKTAILS
DOWNLOADS
EVENTS
PRESS
TASTE THE EVOLUTION

THE AGAVE PLANT

The agave cactus, also known as "maguey", has wide, fibrous, lanceolate leaves that are blue or grayish-green in color. The leaves of the plant are rigid and store nutrients in the fruit bearing stalk. The plant has a tender, sweet sap-filled core covered by layers of wax that protect the plant from the harsh Mexican sun.

CORZO

COCKTAILS

CORZO
THE FINEST FRENCH TEQUILA

VOLUME

AGAVE SUNSET
PLAY THIS TRACK
EVOLUTION GROOVE

CORZO

AFRICAN AMERICAN
ODYSSEY

SEARCH: [] [Go]
Find what you need
on PBS and NPR

| TIMELINE | REFERENCE ROOM | KIDS | CLASSROOM | COMMUNITY | RESOURCES |

CHANNELS

- HISTORY
- ARTS & CULTURE
- RACE & SOCIETY
- PROFILES

Your guide to African American history and culture.

From Sojourner Truth to Jacob Lawrence, discover the courage and talent that shaped the African American experience.

Quick Quote:

"Power concedes nothing without a demand. It never did and it never will."

--**Frederick Douglass**, abolitionist

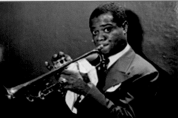
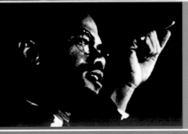

On This Day:

Baseball legend Willie Maes was born in Westfield, AL in 1931.

Hot Feature:

The first were bought in 1619. The last freed in 1865. In the intervening 250 years, slaves labored to make America what it is today. Visit Slavery and the Making of America online.

Free Stuff:

Make an e-card or download a screensaver and wallpaper!
Check it out!

✉ E-Bulletin

Get a sneak preview of related PBS and NPR programs.
Subscribe here

feedback | privacy policy | credits | site map | pledge

Produced By:

thirteen
WNET NEW YORK

In Association With:
n p r

Sponsored By:
cpb

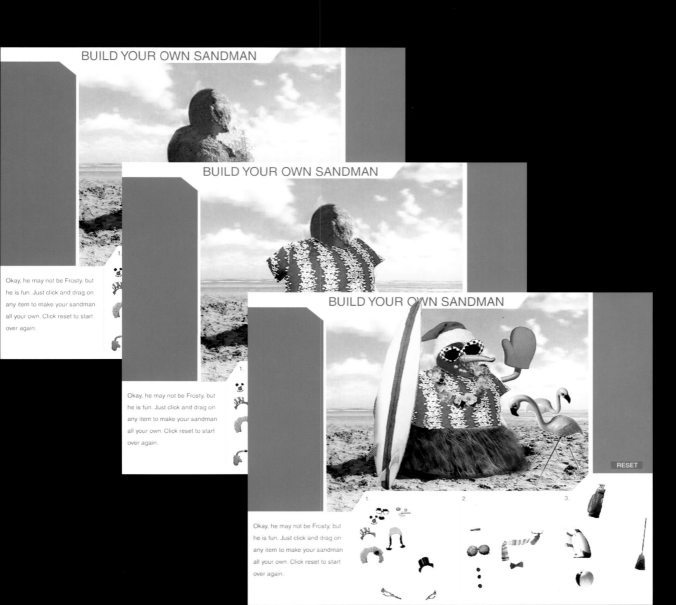

BUILD YOUR OWN SANDMAN

Okay, he may not be Frosty, but he is fun. Just click and drag on any item to make your sandman all your own. Click reset to start over again.

RESET

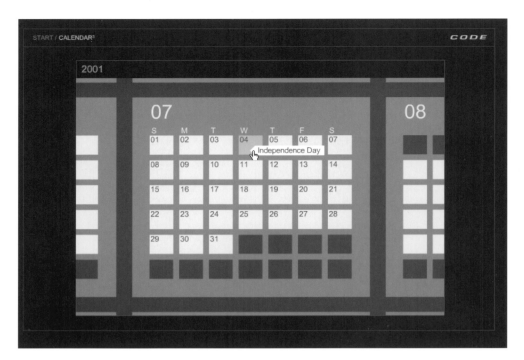

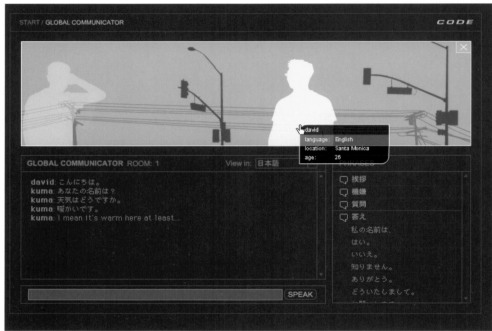

(this spread) Hello Design/Hello Design

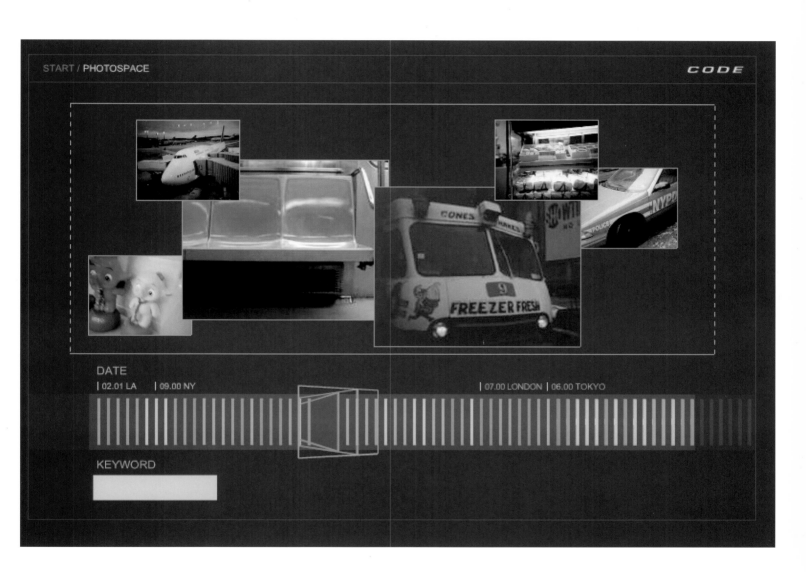

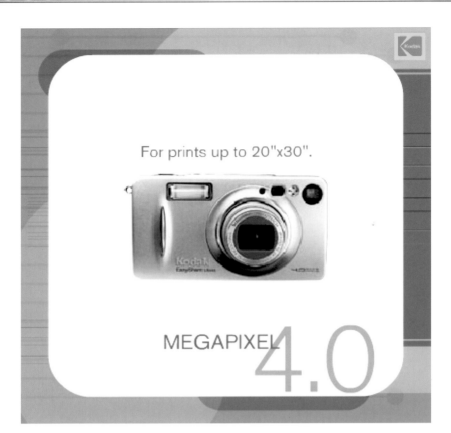

For prints up to 20"x30".

MEGAPIXEL 4.0

Fits your lifestyle.

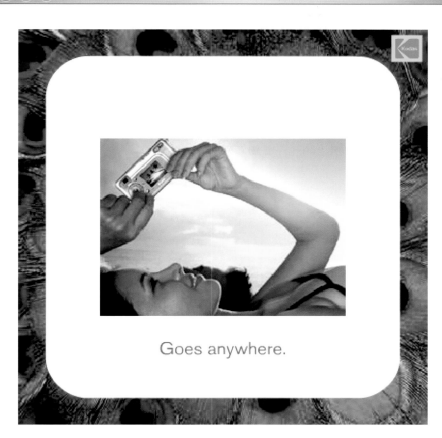

Goes anywhere.

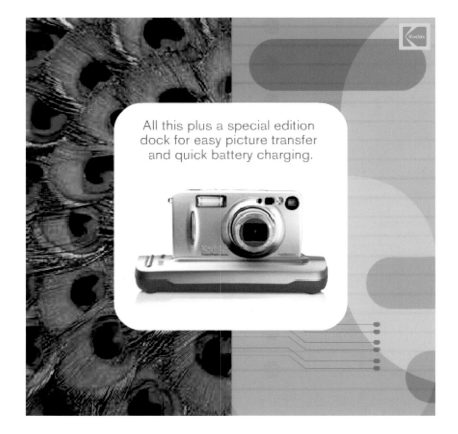

All this plus a special edition dock for easy picture transfer and quick battery charging.

Kodak EasyShare LS420 special edition digital camera
Explore the features
See what's included
Find out where to get it

Click any image to see features

Click here for more complete specs on Kodak.com

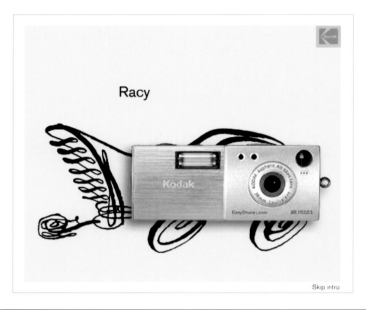

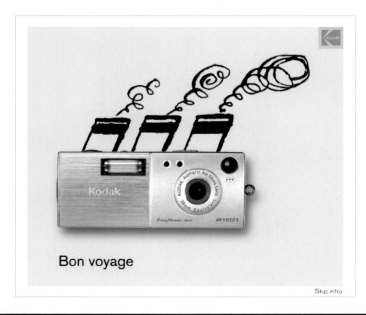

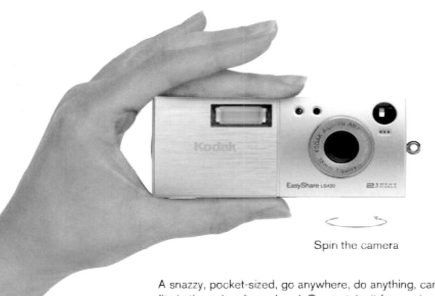

Spin the camera

A snazzy, pocket-sized, go anywhere, do anything, camera that fits in the palm of your hand. Go on, take it for a spin.

(this spread) Young & Laramore/OpenGlobe

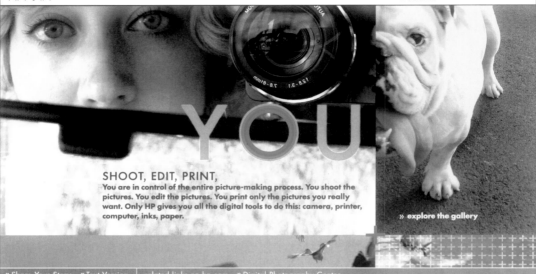

» Gallery » Featured Stories » Tools » Science you + hp

YOU

SHOOT, EDIT, PRINT,

You are in control of the entire picture-making process. You shoot the pictures. You edit the pictures. You print only the pictures you really want. Only HP gives you all the digital tools to do this: camera, printer, computer, inks, paper.

» explore the gallery

» Share Your Story » Text Version | related links on hp.com » Digital Photography Center

» Gallery » Featured Stories » Tools » Science you + hp

YOU

ARE THE PICTURE-MAKING PROCESS

Your camera is your vision. Your PC is your memory. Your printer is your proof. Your paper and ink are your guarantee. Create and print using the entire suite of HP digital tools – engineered together to work better together.

SELECT IMAGES FOR FEATURED TOOLS

» Share Your Story » Text Version | related links on hp.com » Digital Photography Center

» Gallery » Featured Stories » Tools » Science you + hp

ADAPTIVE LIGHTING

WHAT YOU SEE IS WHAT YOU GET

As the world's first digital camera to successfully incorporate the theory of Adaptive Lighting, the Photosmart 945 can see exactly what your eye sees. The result is corrective lighting and a better color balance for indoor shots that require a flash and extreme lighting situations outdoors. So your photos come out looking more like what you saw. Which means you end up with more photos worth keeping.

RELATED SCIENCES AND PRODUCTS

» Share Your Story » Text Version | related links on hp.com » Digital Photography Center

(this spread) Goodby, Silverstein & Partners/Hewlett-Packard Inc.

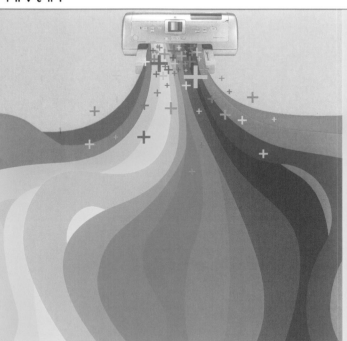

YOU LIVE A COLORFUL LIFE

Photosmart 7960 8-Ink Printer
With more than 300 shades of every color resulting in millions of printable colors, the Photosmart 7960 8-ink printer has everything you need to accurately document your life. Not to mention unique neutral gray and deep black inks to truly represent even your moodiest moments. You can still drop off your film at the one-hour

RELATED SCIENCES AND PRODUCTS

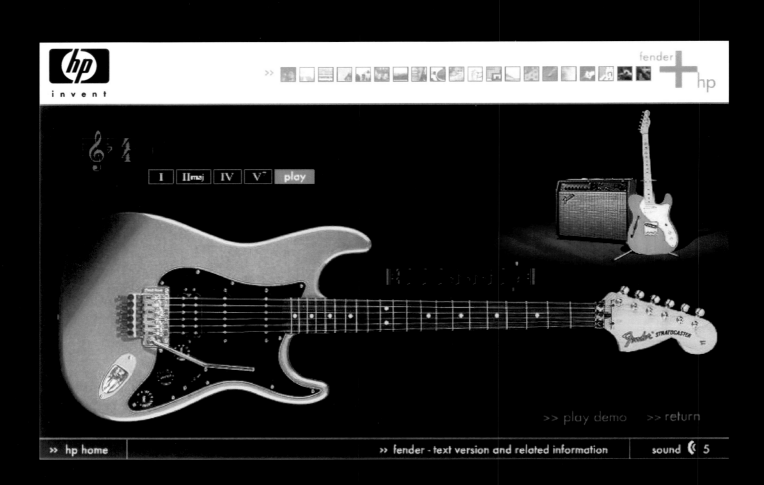

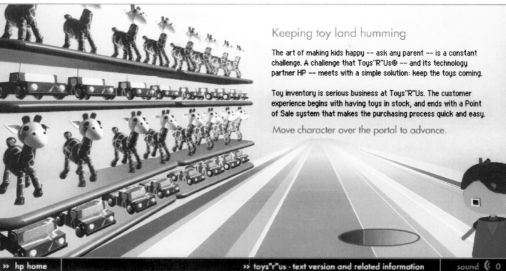

Keeping toy land humming

The art of making kids happy -- ask any parent -- is a constant challenge. A challenge that Toys"R"Us® -- and its technology partner HP -- meets with a simple solution: keep the toys coming.

Toy inventory is serious business at Toys"R"Us. The customer experience begins with having toys in stock, and ends with a Point of Sale system that makes the purchasing process quick and easy.

Move character over the portal to advance.

Tower Palace
Seoul, Korea

The proof is in the process.

The adoption of HP's tablet PC has resulted in tremendous productivity gains for SOM. By eliminating the technological barriers between designer and design, SOM architects are now able to eliminate the barriers between today's inspired vision and tomorrow's inspiring skylines.

Click here to view the next HP story, or choose from the navigation above.

>> start over

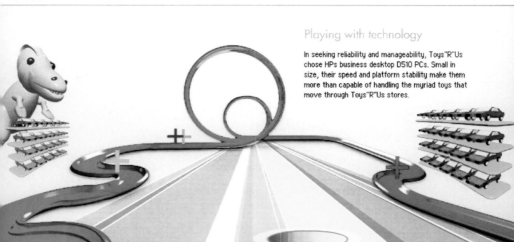

Playing with technology

In seeking reliability and manageability, Toys"R"Us chose HPs business desktop D510 PCs. Small in size, their speed and platform stability make them more than capable of handling the myriad toys that move through Toys"R"Us stores.

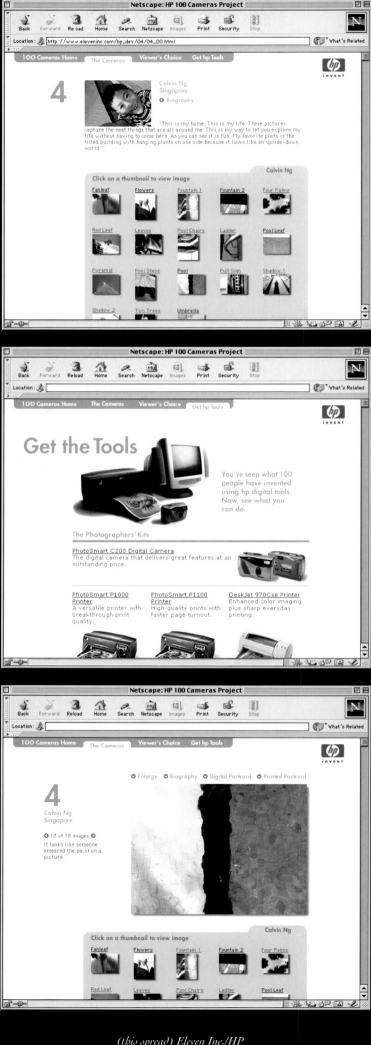

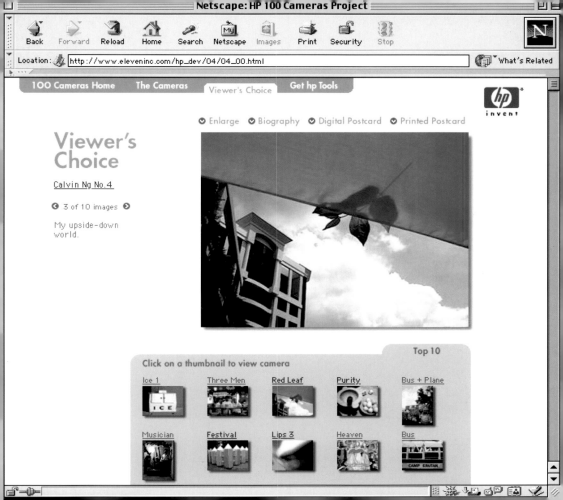

Back　Forward　Stop　Refresh　Home　|　Source　Search

Address: 🔒 http://www.viscern.com/oms/index.html　　　› go

VISCERN

Where there is a vision

home

who we are

contact us

welcome to Viscern

Wherever there is vision. Wherever there is concern. That's where you'll find us. At Viscern we help organizations with noble causes to achieve their goals.

Which Viscern company can serve you best?

T H E V I S C E R N C O M P A N I E S

RSI

Among churches and Christian organizations, RSI provides trusted counsel and advice to promote spiritual growth while meeting financial goals »

KETCHUM

America's oldest and most successful fundraising firm, Ketchum has been helping not-for-profit organizations meet their philanthropic goals since 1919 »

Internet zone

Back　Forward　Stop　Refresh　Home　|　Source　Search

Address: 🔒 http://rsichurch.viscern.com/cms/onlinecatalog.html　　　› go

RSI
Church Services Group

online catalog

home

who we are

news & events

success stories

what we do

our approach

faq's

preferred providers

career opportunities

on-line catalog

contact us

on-line catalog

How would an RSI budget program work for your church? Find out, risk free. Choose the program. Then contact RSI to receive a program manual complete with sample materials.

In The Light Of Grace

Fresh and easy to implement, In the Light of Grace is a two-Sunday budget program with mailers that stimulate congregations to examine giving in a new light. Lessons and seminars further help church members apply stewardship to their daily lives. All the components build toward a special churchwide experience called Commitment Sunday. In the Light of Grace may be purchased in two versions: The first presents the Bible's precepts on tithing; the second emphasizes general stewardship and growth in giving. In both versions, this unusual program combines an innovative look at giving with a commitment card collection process simple enough to suit any church.

THE RESOURCE CENTER
CLICK HERE TO ENTER

Recent Additions

GuideStar Nonprofit Economic Survey

Number of Unchurched Adults Has Doubled Since 1991

Biblical Principles Concerning Personal Financial Stewardship

Link: https://ww1.viscern.com/order.html

Back　Forward　Stop　Refresh　Home　|　Source　Search

Address: 🔒 http://rsicatholic.viscern.com/cms/index.html　　　› go

RSI
Catholic Services Group

your journey starts here

home

who we are

　History

　Overview

　Leadership

news and events

success stories

what we do

our approach

faq's

helpful links

contact us

meeting needs, growing in stewardship

Thousands of successful spiritual journeys. Millions of dollars raised. Since 1972 Catholic communities in America have chosen RSI to be their partner—to teach stewardship as a way of life and to meet (and exceed) their financial objectives. Welcome. What can help you achieve?

The Archdiocese of Chicago
Click here to download a video that encapsulates the story of the largest diocesan campaign in America, raising $242 million for the Archdiocese of Chicago. »

RSI Featured Consultant
Assisting people to understand and make use of their spiritual gifts is what motivates John Dean as an RSI consultant. »

Tsunami Relief
RSI shares a desire to help the victims of the Asian Tsunami disaster. We are proud to partner with two noble organizations who are providing direct aid to those in need. »

THE RESOURCE CENTER
CLICK HERE TO ENTER

Recent Additions

Why Catholics Don't Give
by Charles E. Zech

Giving and Generations

Understanding Women Donors

VISCERN
KETCHUM

A Letter to Our RSI Consultant
I want to take this opportunity to thank you, our RSI consultant, personally

Internet zone

Sibley Peteet Design—Dallas/Viscern Companies Website

DESIGNERS	PHOTOGRAPHERS	PRINTERS & PUBLISHERS	INK MANUFACTURERS

INK MANUFACTURERS

GretagMacbeth ink formulation and quality control solutions provide accurate color communication seamlessly between ink formulator and the pressroom. Ink manufacturers can easily share color data, make ink mixing fast, reproducible and consistent, and speed the process of formulating special inks. Save time, lower costs and achieve higher customer satisfaction.

COLOR FORMULATION & QC
Ink Formulation
Color Quality
SpectroEye
Eye-One Display 2
SpectraLight III
Color i5

>> CONNECT YOUR COLOR WITH CxF
>> Photo Credits

GETCONNE

DESIGNERS	PHOTOGRAPHERS	PRINTERS & PUBLISHERS	INK MANUFACTURERS

Sol-Source

With Sol-Source, you get natural daylight viewing in an office, studio, factory or showroom for not much more than the cost of a traditional desk lamp. It's ideal for graphics, fashion, art, printing, retail and other applications that need an accurate cost-effective daylight source for viewing colors.

- Flexible arm puts daylight anywhere you need it.
- Convenient clamp mounts to most surfaces.
- Optional weighted base provides even more options for lamp placement.

COLOR MANAGEMENT
Eye-One Display 2
Eye-One Publish
Eye-One Photo
Eye-One Beamer
Eye-One iO
Eye-One Share
Sol-Source
Judge II

>> www
>> pdf
English

>> CONNECT YOUR COLOR WITH CxF
>> Photo Credits

RTC HELPS MARKETERS CONNECT WITH CONSUMERS IN THE RETAIL MEDIUM. WE PROVIDE A COMPREHENSIVE RANGE OF SERVICES AND PRODUCTS – RETAIL PLANNING AND DESIGN, MANUFACTURING, PROGRAM MANAGEMENT AND GLOBAL LOGISTICS, RETAIL TECHNOLOGY AND STORE READY SOLUTIONS – THAT HELP OUR CLIENTS ACTIVATE THEIR RETAIL PRESENCE IN MORE THAN 100 COUNTRIES.

MISSION
MANAGEMENT
LOCATIONS
CAREERS
HISTORY
RECOGNITION

ABOUT RTC CAPABILITIES CLIENTS OBSERVATIONS CONTACT AROUND THE WORLD

LOCATIONS

World Headquarters
2800 Golf Road
Rolling Meadows, IL 60008
847.640.2400

Headquarters: Europe
Castle Road
Sittingbourne
Kent ME10 3RN
44.1795.412.795

Headquarters: Latin America
Avenida 26, Calles 36 y 38
San Jose, Costa Rica
506.243.8000

Headquarters: Asia
Suite 504, Lu Plaza
2 Wing Yip Street
Kwun Tong, Kowloon
Hong Kong

☐ RTC REGIONAL HEADQUARTERS
☐ OTHER RTC LOCATIONS

Joseph Khotimlyansky – Model Maker, U.S.

2004 RTC, INC. » CLIENT ACCESS

RTC PROVIDES A FULL SPECTRUM OF CAPABILITIES WITH A SINGLE FOCUS: THE SUCCESSFUL ACTIVATION OF RETAIL SPACE. FROM RESEARCH AND STRATEGY THROUGH CONCEPTUAL DESIGN AND DEVELOPMENT, ENGINEERING AND PROTOTYPING, TESTING, MANUFACTURING, IMPLEMENTATION AND OVERALL MANAGEMENT. WE OFFER A CONTINUUM OF SERVICES THAT DELIVERS PROFITABLE RESULTS FOR RETAILERS AND BRAND MARKETERS.

PLANNING/DESIGN
MANUFACTURING
MANAGEMENT/LOGISTICS
RETAIL TECHNOLOGY
STORE READY SOLUTIONS

ABOUT RTC CAPABILITIES CLIENTS OBSERVATIONS CONTACT AROUND THE WORLD

ALBERTSONS

The shopping experience is a critical factor in retail sales and profitability. Recognizing the advantage inherent in making a visit to the grocery store more enjoyable for parents with children, Albertson's turned to RTC's Store Ready Solutions for help. iZoom family friendly shopping carts are designed to encourage longer store visits and deliver greater revenues through incremental sales. And RTC's Profit Pusher shelf merchandising system allows store staff to focus more attention on their customers instead of their products, adding to overall customer satisfaction.

• Shelf Management
• Family Friendly Shopping Carts

WALMART			ALBERTSONS			MEIJER		
01	02	03	01	02	03	01	02	03

STORE READY SOLUTIONS

To learn more about RTC Store Ready Solutions, please contact:

Gary Cohen
Senior Vice President,
Customer Business Development, U.S.

ADDITIONAL CLIENTS:
AHOLD KROGER
ALBERTSONS LONGS DRUG
ANHEUSER-BUSCH MEIJER
COCA-COLA WALGREENS
HEB WALMART
KRAFT

RTC PROVIDES A FULL SPECTRUM OF CAPABILITIES WITH A SINGLE FOCUS: THE SUCCESSFUL ACTIVATION OF RETAIL SPACE. FROM RESEARCH AND STRATEGY THROUGH CONCEPTUAL DESIGN AND DEVELOPMENT, ENGINEERING AND PROTOTYPING, TESTING, MANUFACTURING, IMPLEMENTATION AND OVERALL MANAGEMENT. WE OFFER A CONTINUUM OF SERVICES THAT DELIVERS PROFITABLE RESULTS FOR RETAILERS AND BRAND MARKETERS.

PLANNING/DESIGN
MANUFACTURING
MANAGEMENT/LOGISTICS
RETAIL TECHNOLOGY
STORE READY SOLUTIONS

ABOUT RTC CAPABILITIES CLIENTS OBSERVATIONS CONTACT AROUND THE WORLD

WALMART			ALBERTSONS			MEIJER		
01	02	03	01	02	03	01	02	03

STORE READY SOLUTIONS

Retailers today face a number of universal store performance issues. Guided by a working knowledge of the in-store environment, we've taken a leadership role in the development of smart solutions that help retailers generate maximum return with minimum investment.

We offer a range of proven retail systems that reduce labor costs, reduce theft and improve the shopping experience in ways that drive increased sales and profits. Our product options are engineered to fit existing fixtures and environments, providing immediate solutions that are cost effective and productivity enhancing.

We're continuing to work with our retail and brand partners to develop more sophisticated merchandising systems for an expanded array of applications and product categories. RTC Store Ready Solutions enable our customers to do what they do best – focus on exceeding their customer's expectations.

2004 RTC, INC. » CLIENT ACCESS

SamataMason/RTC Inc.

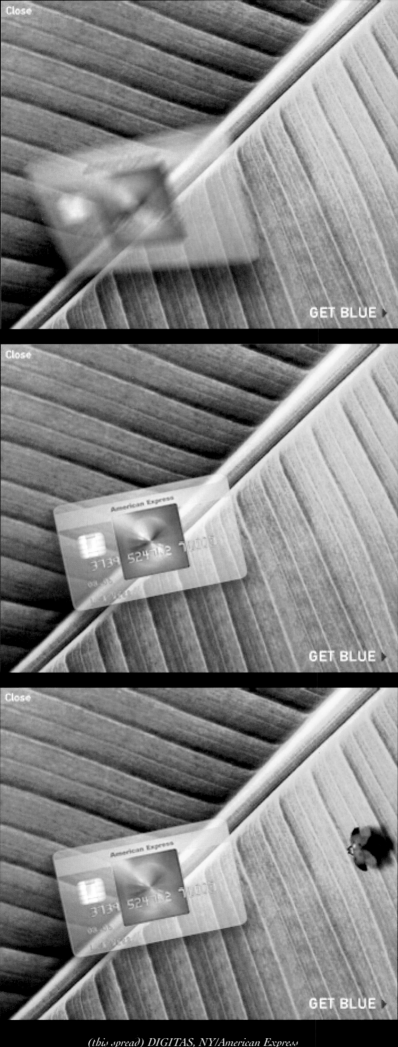

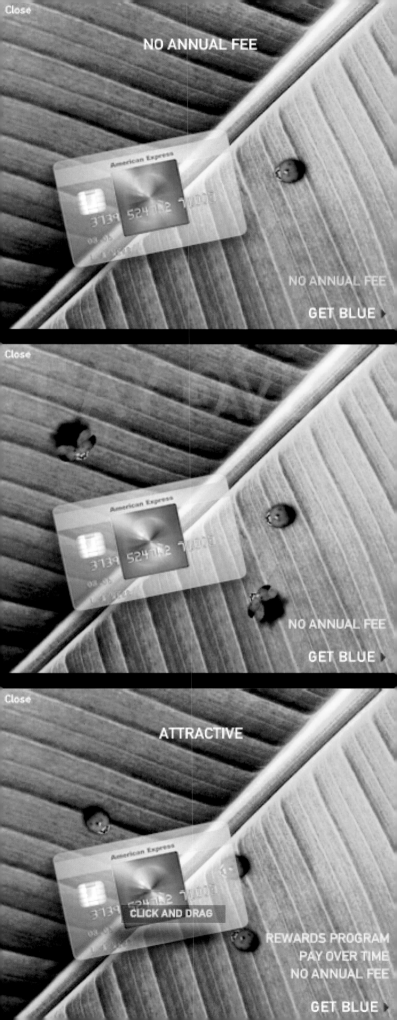

Back Forward Stop Refresh Home AutoFill Print Mail Favorites

Address: @ http://www.otis.edu/index.php?id=235 › go

OTIS COLLEGE OF ART + DESIGN

News
Calendar
Search

Favorites | History | Search | Scrapbook | Page Holder

Galleries Faculty Work

FACULTY WORK

Faculty Work
Student Work
Ben Maltz Gallery
Bolsky Gallery
Wooden Quilt Project
Ben Maltz Picture Gallery

Admissions
About
Academics
Public Programs
Galleries
Alumni
Giving

Christian Mounger Eric Ostendorff Scott Greiger Annetta Kapon

Steve Kazanjian Michelle Mason Andrew Dibben Katie Phillips

Nathan Ota Patrick Nickell Arno Kroner Meg Cranston

Ave Pildas D.J. Hall Roy Dowell Richard Lundquist

More Faculty Work

For more examples of Faculty Work please click Here.

Print this page E-mail this page Sitemap Contact Us Copyright

Internet zone

(this spread) Sibley Peteet Design — Dallas/Sibley Peteet Design — Dallas

(this spread) Bamboo/Bamboo

http://bamboo-design.com/

dictionary/thesaurus Ask.com Hotmail weather.com MapQuest Apple News ▾ USbank FedEx Amazon White/Yellow Pages

LAUNCH SITE

This Site Requires the Flash 6 Plugin
DOWNLOAD FLASH 6 HERE

bamboo

bamboo

bamboo

INTRO | WHO WE ARE | WHAT WE DO | CONTACT US

CAPABILITIES

BLUE Q
 SINGLES GUM
 SMOKERS GUM

D'AMICO
 - CAMPIELLO
 LURCAT

LUNDS HOLDING
 BYERLY'S

PUNCH
 MENU
 CUPS
 PRINT

SCHROEDER
 MILK PACKAGING
 LINE EXTENSIONS
 MILK PROMOTIONS
 BRILLIANTREE

TARGET
 CANDY
 SALON SERIES
 RESTORE & RESTYLE
 SONIA KASHUK

FULL CLIENT LIST

ciao SICILY

CAMPIELLO

CAMPIELLO POSTERS
Bamboo put a contemporary spin on European poster styles
of the 1940's to create a visually strong campaign which
appeals to the love of Italian culture and cuisine shared by
Campiello's clientele.

1 2 3 4 5 6 7 8 Rollover posters for detail

(this spread) Juicy Temples/Juicy Temples

EXPLORE OUR PORTFOLIO

showcasing the latest
designs for identity,
web, print, interior
and motion graphics.

STUDIO

PROCESS

PRESS

CONTACT

CASE STUDIES

PORTFOLIO

fs

fahrenheit studio

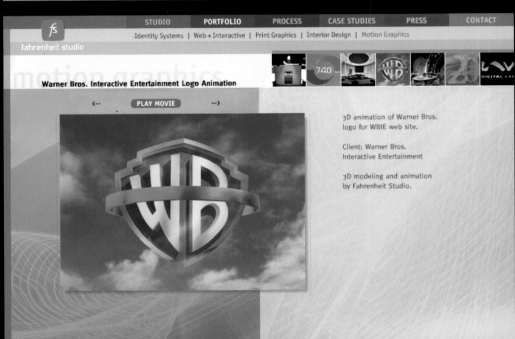

STUDIO PORTFOLIO PROCESS CASE STUDIES PRESS CONTACT

fs
fahrenheit studio

Identity Systems | Web + Interactive | Print Graphics | Interior Design | Motion Graphics

motion graphics

Warner Bros. Interactive Entertainment Logo Animation

<-- PLAY MOVIE -->

3D animation of Warner Bros.
logo for WBIE web site.

Client: Warner Bros.
Interactive Entertainment

3D modeling and animation
by Fahrenheit Studio.

STUDIO PORTFOLIO PROCESS CASE STUDIES PRESS CONTACT

fs
fahrenheit studio

studio

Studio

Overview
Capabilities
Clients
Projects (pdf)
Quotes (pdf)
Directors
Web Archive

:: Fahrenheit Studio is a Los Angeles-based
multidisciplinary design studio founded in
1995 by the creative team of Robert Weitz
and Dylan Tran. We specialize in
developing cross-media branding
campaigns that include identity systems,
web and interactive, print, motion graphics
and interior environments.

Our branding campaigns retain their
impact and production value, independent
of their delivery format.

(this spread) Fahrenheit Studio/Fahrenheit Studio

48 Windows Music & Mix

1 2 3 -->

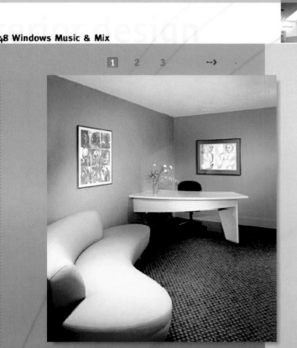

Digital audio recording facility
for post-production studio in
Santa Monica, CA.

Client: 48 Windows Music
& Mix

Interior and custom furniture
design by Fahrenheit Studio.
Photography by Benny Chan.

See also case study

DESIGN.

The factory of the mind never sleeps.

THE ART DEPARTMENT
creative services

WELCOME.

WE ARE A SMALL, NEW YORK–BASED DESIGN
STUDIO SPECIALIZING IN A FULL SPECTRUM OF
PRINT COLLATERAL, INCLUDING IDENTITY AND
BRANDING, ANNUAL REPORTS, PACKAGING
AND ADVERTISING. PLEASE TAKE A LOOK AROUND.

PROJECT NUMBER: 299-1362-04-WEB [ENTER]

THE ART DEPARTMENT
creative services

STRATEGY:

ASSEMBLE IDEAS, MANUFACTURE STRONG
MESSAGING, PRODUCE INTRIGUE AND
DESIRE, AND DISTRIBUTE VISIONARY DESIGN.

☐ logo / branding
☒ corp communication
☐ editorial
☐ packaging / promo
☐ advertising
☐ other

AMRESCO CAPITAL TRUST

● ● ●
< 1/7 >

THE ART DEPARTMENT
creative services

1998 ANNUAL REPORT

THIS ANNUAL EXPLAINS THIS NEWLY–FORMED
COMMERCIAL MORTGAGE REAL ESTATE TRUST
BY ASKING BASIC QUESTIONS ANSWERED
DIRECTLY WITH CRISP, CONTEMPORARY TYPO-
GRAPHY USED IN CONJUNCTION WITH VIBRANT,
CONCEPTUAL ILLUSTRATIONS BY MARK TELLOK.

where
we come from.

figure 3

[PLEASE CHECK ONE]
☐ *the people* ☒ *the process* ☐ *client list*

CREATE.

Design is not built overnight, but in a series of processes through a labor of love.

THE ART DEPARTMENT
creative services

THE PROCESS

DESIGN IS DEVELOPED ON AN ASSEMBLY LINE OF IDEAS—
ADDING TO AND TAKING AWAY UNTIL THE CONCEPT IS
COMPLETE. IT IS RESEARCHED, RETHOUGHT, REVISED
AND REFINED UNTIL IT IS FULLY REALIZED. OUR FULL-
SERVICE STUDIO TAKES A PROJECT FROM ITS INCEPTION,
THROUGH DESIGN AND PRODUCTION TO MANAGING THE
PRINT PROCESS AND DELIVERY. WE LISTEN TO OUR
CLIENTS, WELCOMING INSIGHTS AND FEEDBACK AS A KEY
PART OF THE DEVELOPMENT. CREATIVE STRATEGIES,
DETAILED TIME-LINES, AND PROJECT OVERVIEWS ARE
PROVIDED, SO THAT EVERYONE ACHIEVES THE DESIRED
RESULT: INNOVATIVE AND EFFECTIVE COMMUNICATION.

ABOUT US | PORTFOLIO | CONTACT

☐ *logo / branding*
☐ *annual reports*
☐ *editorial*
☒ *packaging / promo*
☐ *advertising*
☐ *other*

BEST
OF THE
SEASON

• • • •
< 1/6 >

THE ART DEPARTMENT
creative services

SNOW GLOBE SALES PROMO FOR NEW YORK TIMES

THIS GLITZY PROMO PIECE WAS SENT TO POTENTIAL
RETAIL ADVERTISERS FOR A SPECIAL GIFT SECTION
IN THE NYTIMES MAGAZINE DURING THE HOLIDAYS.
THE OBJECTIVE WAS TO DESIGN SOMETHING
THAT COULD BE KEPT AND DISPLAYED. ONCE THE
MINI-BROCHURE IS REMOVED ANY PICTURE CAN BE
INSERTED. AN INSTRUCTION SHEET IS IN THE BACK
AND AN EYE-CATCHING OUTER WRAP WAS DESIGNED
TO COMPLETE THE PACKAGE.

figure 1

ABOUT US | PORTFOLIO | CONTACT

CONNECT.

**Call for more information or an estimate
on your next project. People are standing by.**

THE ART DEPARTMENT
creative services

CALL, OR WRITE, OR E-MAIL....

THE ART DEPARTMENT
222 AVENUE B, #2R
NEW YORK, NY 10009
PHONE: 212-228-5552
MOBILE: 646-242-3698
CG@THEARTDEPARTMENT-NYC.COM

ABOUT US | PORTFOLIO | CONTACT

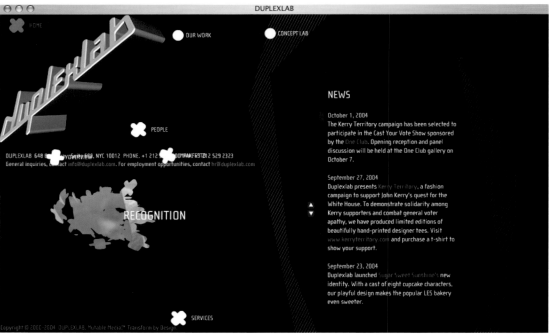

(this spread) Duplexlab/Duplexlab

LOGO DESIGN

BROADCAST DESIGN

BOOKLET DESIGN

PRINT AD DESIGN

SPORTS DESIGN

PACKAGING DESIGN

PROMO DESIGN

REFERENCES

PHOENIX DESIGN WORKS

(this spread) Phoenix Design Works/Phoenix Design Works

BROADCAST DESIGN

"WHEN YOU WON'T SACRIFICE CREATIVE IDEALS FOR FINANCIAL GAIN, THAT'S THE WAY YOU'VE GOT A CREATIVE AGENCY." MIKE ISAACSON

PHOENIX DESIGN WORKS

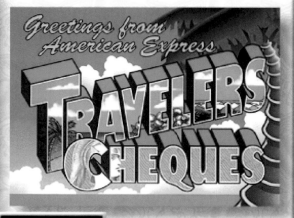

Greetings from American Express TRAVELERS CHEQUES

PLAY MOVIE

◀ MENU OUT ▶

BOOKLET DESIGN

"ONE OF THE MOST STRIKING DIFFERENCES BETWEEN A CAT & A LIE, IS THAT A CAT ONLY HAS NINE LIVES." MARK TWAIN

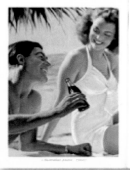

◀ MENU OUT ▶

PACKAGING DESIGN

"NO WORK OF GENIUS HAS EVER PRODUCED BY A REASONABLE MAN" ANONYMOUS

MENU OUT ▶

To view a case study, click on the title... You can skip to a specific step by c
on a red bar. To sort the case studies, use the drop down menu or click on t
number. Click here to learn more about the process of designing.

Sort by: [Client Firm ⬍]

	1	2	3	4	5	6	7	8	9	10	11
nt Mok 1998							—				
Architects ghby Design Group / 2000					—	—			—		
etown Law Center Inc. ber / 2001	—					—			—		
ark Flowers ghby Design Group / 2000					—				—		
om nt Mok 1997	—										
Networks, Inc. etworks ry / 2002										—	
jects jects ber / 1995	—									—	
ya & Moroni aeda ber / 2002			—			—			—		
otif kis Design Office y / 2001	—	—	—		—	—			—		—

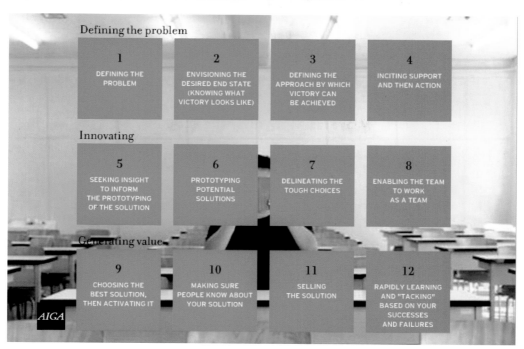

Defining the problem

1	2	3	4
DEFINING THE PROBLEM	ENVISIONING THE DESIRED END STATE (KNOWING WHAT VICTORY LOOKS LIKE)	DEFINING THE APPROACH BY WHICH VICTORY CAN BE ACHIEVED	INCITING SUPPORT AND THEN ACTION

Innovating

5	6	7	8
SEEKING INSIGHT TO INFORM THE PROTOTYPING OF THE SOLUTION	PROTOTYPING POTENTIAL SOLUTIONS	DELINEATING THE TOUGH CHOICES	ENABLING THE TEAM TO WORK AS A TEAM

Generating value

9	10	11	12
CHOOSING THE BEST SOLUTION, THEN ACTIVATING IT	MAKING SURE PEOPLE KNOW ABOUT YOUR SOLUTION	SELLING THE SOLUTION	RAPIDLY LEARNING AND "TACKING" BASED ON YOUR SUCCESSES AND FAILURES

AIGA

AIGA

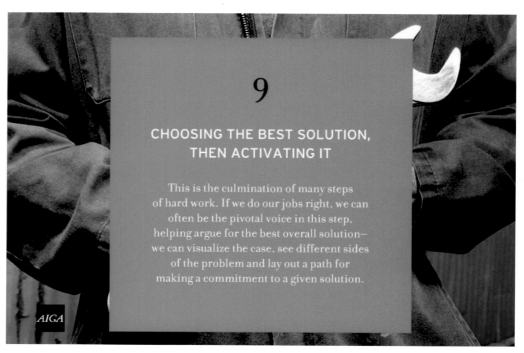

9

CHOOSING THE BEST SOLUTION, THEN ACTIVATING IT

This is the culmination of many steps of hard work. If we do our jobs right, we can often be the pivotal voice in this step, helping argue for the best overall solution— we can visualize the case, see different sides of the problem and lay out a path for making a commitment to a given solution.

AIGA

(this spread) Sibley Peteet Design—Dallas/AIGA

designinthefastlane.mov

designinthefastlane.mov

designinthefastlane.mov

Tena Koe, Greetings, Ni Hao, Talofa Lava, Namaste, Guten Tag, Bonjour

CAPITAL MONTESSORI : EDUCATION FOR LIFE : ENTER

(this spread) DNA DESIGN/CAPITAL MONTESSORI Pre-School

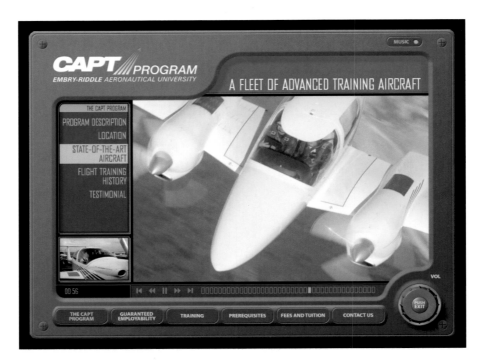

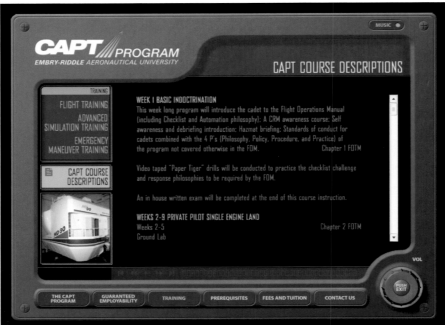

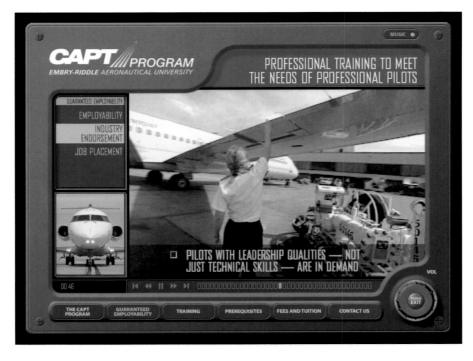

(this spread) DHI Visual Communication/CAPT Program

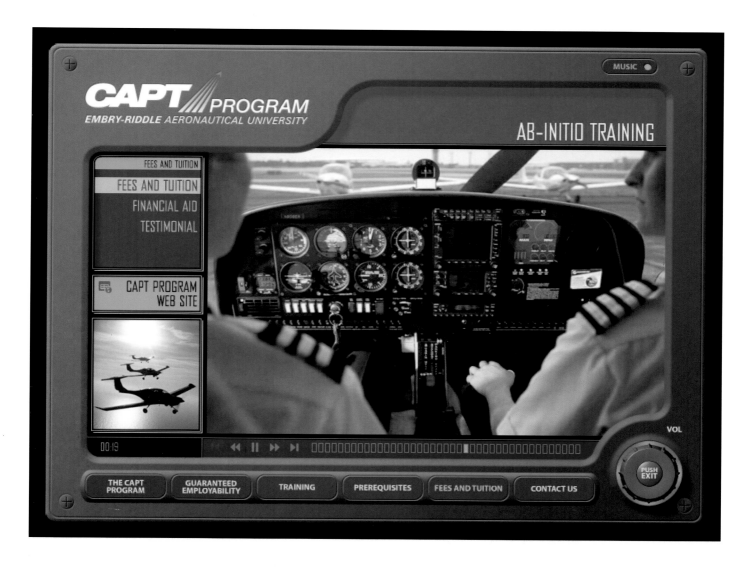

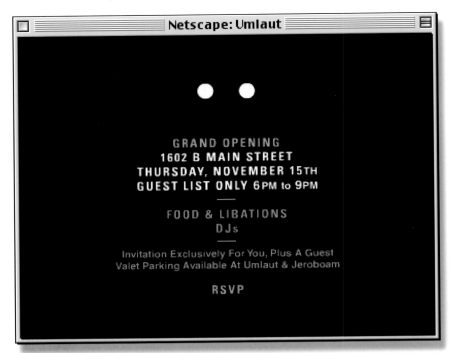

Netscape: Umlaut

GRAND OPENING
1602 B MAIN STREET
THURSDAY, NOVEMBER 15TH
GUEST LIST ONLY 6PM to 9PM

—

FOOD & LIBATIONS
DJs

—

Invitation Exclusively For You, Plus A Guest
Valet Parking Available At Umlaut & Jeroboam

RSVP

Netscape: Umlaut

• = •

Netscape: Umlaut

URBAN BEATS

(this spread) Sibley Peteet Design—Dallas/The Entertainment Collaborative

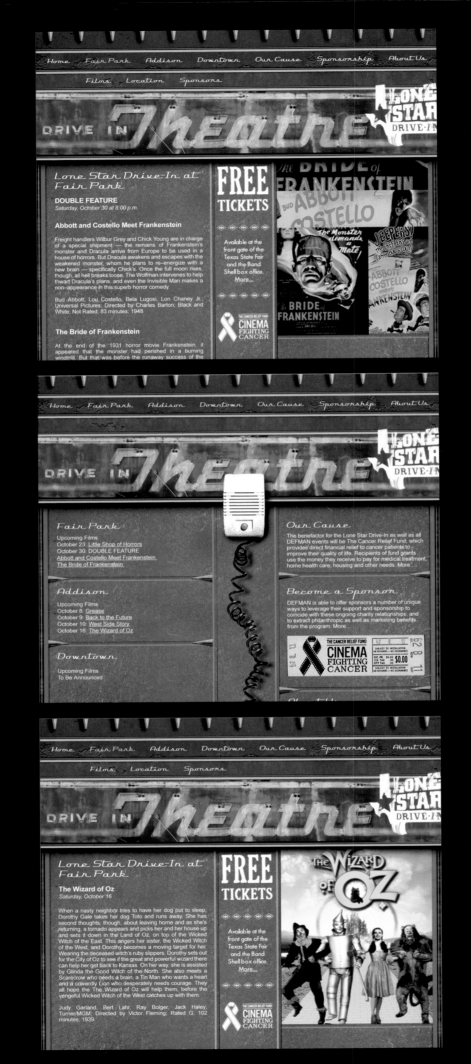

DRIVE IN Theatre A LONE STAR DRIVE-IN

Lone Star Drive-In at Fair Park

DOUBLE FEATURE
Saturday, October 30 at 8:00 p.m.

Abbott and Costello Meet Frankenstein

Freight handlers Wilbur Grey and Chick Young are in charge of a special shipment — the remains of Frankenstein's monster and Dracula arrive from Europe to be used in a house of horrors. But Dracula awakens and escapes with the weakened monster, whom he plans to re-energize with a new brain — specifically Chick's. Once the full moon rises, though, all hell breaks loose. The Wolfman intervenes to help thwart Dracula's plans, and even the Invisible Man makes a non-appearance in this superb horror comedy.

Bud Abbott, Lou Costello, Bela Lugosi, Lon Chaney Jr.; Universal Pictures; Directed by Charles Barton; Black and White; Not Rated; 83 minutes; 1948

The Bride of Frankenstein

At the end of the 1931 horror movie Frankenstein, it appeared that the monster had perished in a burning windmill. But that was before the runaway success of the

FREE TICKETS

Available at the front gate of the Texas State Fair and the Band Shell box office.
More...

THE CANCER RELIEF FUND
CINEMA FIGHTING CANCER

DRIVE IN Theatre LONE STAR DRIVE-IN

Fair Park

Upcoming Films
October 23: Little Shop of Horrors
October 30: DOUBLE FEATURE
Abbott and Costello Meet Frankenstein
The Bride of Frankenstein

Addison

Upcoming Films
October 8: Grease
October 9: Back to the Future
October 10: West Side Story
October 16: The Wizard of Oz

Downtown

Upcoming Films
To Be Announced

Our Cause

The benefactor for the Lone Star Drive-In as well as all DEFMAN events will be The Cancer Relief Fund, which provides direct financial relief to cancer patients to improve their quality of life. Recipients of fund grants use the money they receive to pay for medical treatment, home health care, housing and other needs. More...

Become a Sponsor

DEFMAN is able to offer sponsors a number of unique ways to leverage their support and sponsorship to coincide with these ongoing charity relationships, and to extract philanthropic as well as marketing benefits from the program. More...

THE CANCER RELIEF FUND
CINEMA FIGHTING CANCER

$0.00

DRIVE IN Theatre LONE STAR DRIVE-IN

Lone Star Drive-In at Fair Park

The Wizard of Oz
Saturday, October 16

When a nasty neighbor tries to have her dog put to sleep, Dorothy Gale takes her dog Toto and runs away. She has second thoughts, though, about leaving home and as she's returning, a tornado appears and picks her and her house up and sets it down in the Land of Oz, on top of the Wicked Witch of the East. This angers her sister, the Wicked Witch of the West, and Dorothy becomes a moving target for her. Wearing the deceased witch's ruby slippers, Dorothy sets out for the City of Oz to see if the great and powerful wizard there can help her get back to Kansas. On her way, she is assisted by Glinda the Good Witch of the North. She also meets a Scarecrow who needs a brain, a Tin Man who wants a heart and a cowardly Lion who desperately needs courage. They all hope the The Wizard of Oz will help them, before the vengeful Wicked Witch of the West catches up with them.

Judy Garland, Bert Lahr, Ray Bolger, Jack Haley; Turner/MGM; Directed by Victor Fleming; Rated G; 102 minutes; 1939.

FREE TICKETS

Available at the front gate of the Texas State Fair and the Band Shell box office.
More...

THE CANCER RELIEF FUND
CINEMA FIGHTING CANCER

THE WIZARD OF OZ

(this spread) Click Here/Deep Ellum Film, Music, Arts and Noise, Inc

Lone Star Drive-In at Fair Park

Creature from the Black Lagoon
Sunday, October 17

In the heart of the Amazonian rain forest, Dr. Carl Maia uncovers a most unusual fossil. It has five fingers arranged much like a human hand, but it sports webbing and claws that suggest a marine predator. Dr. Maia assembles a team of scientists (Dr. David Reed, Kay Lawrence, Dr. Mark Williams and Dr. Edwin Thompson) to visit the fabled Black Lagoon in search of more fossils. Lucas, the captain of the Rita (their chartered riverboat), tells them the story of an elusive aquatic monster that stalks the Black Lagoon. When Dr. Maia returns to his camp, he finds that some savage beast has slaughtered his assistants, convincing the team the legend of the half-man/half-fish monster is not merely legend. From that point on, we see the beast stalking the crew of the Rita even as they seek to capture him. Adding to an already tense situation, there is internal conflict between the two young scientists over the love of Kay. The Creature also finds Kay quite the "catch." In the end, he eludes his captors (but not before sustaining serious injuries) and returns to the blackness of the lagoon. For a sequel, perhaps...?

Richard Carlson, Julie Adams; Universal

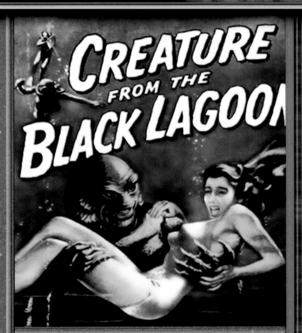

WELCOME TO VENUS
LAND OF NO RETURNS

Get the Card that gets you special access to the US Open.

OFFICIAL CARD OF **HEAVY HITTERS**

OFFICIAL CARD OF THE US OPEN

APPLY FOR THE CARD

TABLE OF CONTENTS

MAP OF USTA NATIONAL TENNIS CENTER
A complete listing of everything you'll need at the US Open.

NYC RESTAURANT GUIDE
Save on great meals at some of New York's best restaurants.

US OPEN LIVE AT ROCKEFELLER CENTER
Experience the Open without leaving Manhattan.

USOPEN.ORG PERSONAL SCHEDULER
Customize and print your daily plans to make sure you don't miss a thing.

EXCLUSIVE BENEFITS
Discover the exclusive benefits of being an American Express Cardmember—at the US Open and all over the world.

ATHLETE GALLERY
View bios and highlight reels for some of the world's top players.

USOPEN.ORG PICK 'EM GAME
Pick the winners and you could pick up some fantastic prizes.

USOPEN.ORG FAN AUCTION
Bid on autographed memorabilia and one-of-a-kind US Open experiences.

US OPEN FAN GUIDE
PRESENTED BY AMERICAN EXPRESS

The world's top players, competing in the biggest tennis event in the US. This is your guide to getting in on all the action.

OFFICIAL CARD OF THE US OPEN

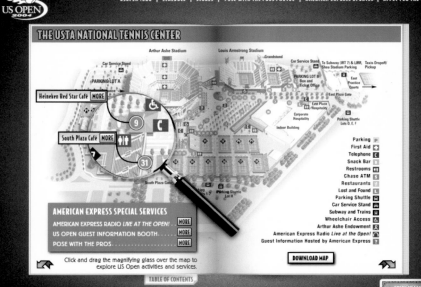

THE USTA NATIONAL TENNIS CENTER

Arthur Ashe Stadium

Louis Armstrong Stadium

Grandstand

Car Service Stand

PARKING LOT A

Car Service Stand

To Subway (IRT 7) & LIRR, Shea Stadium Parking

Taxis Dropoff/ Pickup

Heineken Red Star Café MORE

PARKING LOT B Box and Ticket Office

East Practice Courts

East Gate

East Plaza Gate

South Plaza Café MORE

Corporate Hospitality

East Plaza Hospitality

Indoor Building

Parking Shuttle Lots D, E, F

South Plaza Gate

Parking Shuttle Lot H

AMERICAN EXPRESS SPECIAL SERVICES

AMERICAN EXPRESS RADIO *LIVE AT THE OPEN!* MORE

US OPEN GUEST INFORMATION BOOTH MORE

POSE WITH THE PROS MORE

Parking **P**
First Aid
Telephone **C**
Snack Bar
Restrooms
Chase ATM **$**
Restaurants
Lost and Found **L**
Parking Shuttle
Car Service Stand
Subway and Trains
Wheelchair Access
Arthur Ashe Endowment
American Express Radio *Live at the Open!*
Guest Information Hosted by American Express **?**

Click and drag the magnifying glass over the map to explore US Open activities and services.

DOWNLOAD MAP

TABLE OF CONTENTS

REWARDING LIVES : WELCOME

An exhibit of timeless photographs featuring more than 60 portraits by renowned photographer Annie Leibovitz

EXHIBITION

ACTIVATION

SUSTAINABILITY

PROCESS

Oct 15, 2004 – Jan 16, 2005
World Trade Center – Mezzanine
Mexico City

No Admission Fee

World Tour Comes to Mexico City

We are honored to have the opportunity to share REWARDING LIVES with Mexico City, a city known for its creative spirit. Originally designed to welcome employees back to American Express' New York headquarters after 9/11, the exhibition is currently on a 3-year international tour. REWARDING LIVES appeared in San Francisco in the fall of 2003 and the Pacific Design Center in West Hollywood during the spring of 2004. We hope that you will join us in celebrating REWARDING LIVES, an experience of light and hope designed to inspire the best in each of us.

REWARDING LIVES | EXHIBITION | ACTIVATION | SUSTAINABILITY | PROCESS

SAN FRANCISCO

GALLERY | INFORMATION | MEDIA

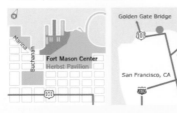

Open to the Public
September 8 - December 1, 2003
10am - 10pm
No admission fee

Herbst Pavilion at Fort Mason Center
Marina Boulevard and Buchanan Street
San Francisco, CA

REWARDING LIVES | EXHIBITION | **ACTIVATION** | SUSTAINABILITY | PROCESS

ACTIVATION

CUNNINGHAM DANCE COMPANY | TRIBECA FILM FESTIVAL | MACY'S PASSPORT

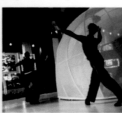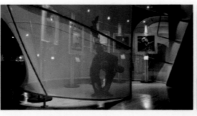

Merce Cunningham Dance Company
December 2002
American Express Tower
200 Vesey Street
New York, NY

PROCESS

THE VISIONARY
THE PIONEERING

7

EXHIBITION DESIGN | CURATION | ARCHITECTURE | FABRICATION AND INSTALLATION | THE EXHIBITION

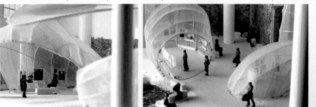

Left: Exhibition portraits are grouped by character and human potential.

Center and Right: Digital images of the scale model help to envision the final design.

CURATION

The exhibition portraits are grouped by character and human potential. Each pod presents one or two groups including VISIONARY, PIONEERING, NATURAL, PERFORMATIVE, LOVING AND CONNECTED, LEADING, VIBRANT, and INSPIRING AND CELEBRATED.

Each pod glows with a different hue selected to complement the character of the group as well as for its physiological and psychological effects.

NEW YORK

GALLERY | INFORMATION

← Back Next → 1 2 3 4 5 6 7 8 9 10 11

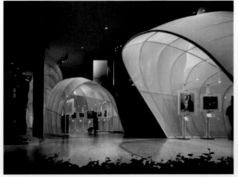

200 Vesey Street New York, New York
Photography © Paul Warchol

Visit our Los Angeles and San Francisco Exhibitions

JANINE JAMES

Founder and Creative Director The Moderns

Recognized within the business community and celebrated by clients, Janine James helps businesses and organizations marry commerce, art and community to build stronger brand cultures. Through her multidisciplinary firm, The Moderns, James offers her clients experience-enhancing solutions that are grounded in smart, effective business strategies and executed with stunning results across an array of mediums. Her work has helped businesses like Sundance Cinemas, Aveda, and American Express develop brand cultures that have spawned self-aggregating, self-sustaining communities.

Before founding The Moderns in 1992, James was Director of Design and Product Development for ICF. Prior to that, James worked in the innovative Design Lab in Herman Miller's London office.

Besides leading the success of The Moderns, James was recently a fellow at Harvard University where she taught with renowned psychiatrist and author Dr. Robert Coles. James has also taught at Oklahoma State University and the University of Oregon.

Janine James is founder and creative director of The Moderns

Photography:
© Maria Cox

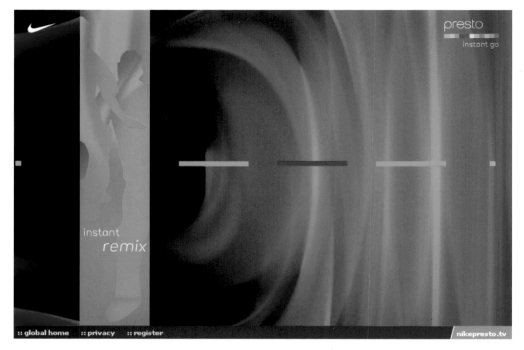

(this spread) Hello Design/Nike

 JegerStar

file:///Volumes/JES/jegerstar/glavni_content.html Q▾ Google

1

Wallpaperi

Screensaveri

TV spotovi

Je★s

© JegerStar

Zvuk

Boja

TOP 6 KANDIDATA ZA
OSVAJANJE NAGRADA

kresica	466
dovla	429
mislav	346
mislav	340
anita	310
keko	305

Prvi krug nagradne igre
traje od 06.09. do
01.10.2004.
Top 6 igrača koji će se na
ovoj list nalaziti
01.10.2004., osvajaju naše
nagrade.

 Igraj ponovo!

Cipele Accessories JegerStyle Info Press Dućani Kontakt

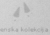

JegerStar

Je*s
© JegerStar

Zvuk
Boja

Ženska kolekcija

Muška kolekcija

Stranica 1 2 3 Odaberi brand

Cipele Accessories JegerStyle Info Press Dućani Kontakt

JegerStar

Wallpaperi

Wallpaperi
Screensaveri
TV spotovi

Je*s
© JegerStar

Zvuk
Boja

1024 × 768 px
800 × 600 px

1024 × 768 px
800 × 600 px

1024 × 768 px
800 × 600 px

1024 × 768 px
800 × 600 px

1024 × 768 px
800 × 600 px

1024 × 768 px
800 × 600 px

JESI ZA JEGERBALL?
Oprobaj se u našoj igri
spretnosti i uključi se u
veliki turnir! Najboljeg
igrača ovog mjeseca
očekuje par cipela
Acupuncture (Crocker), a tu
je i 5 Je*s majica za malo
manje uspješne igrače!

**Je*si siguran da si
najbolji?**
Odigraj partiju JegerBalla i
saznat ćeš...

Igraj!

**ili prije toga baci oko na
nagrade...**

Cipele Accessories JegerStyle Info Press Dućani Kontakt

JegerStar

Je*s
© JegerStar

Zvuk
Boja

SUPER BIKE

Boja: Brit Tan / Sand

Materijal: Koža

Cijena: 660 kn

Ženska kolekcija

Muška kolekcija

<< Prethodna Sljedeća >>

Cipele Accessories JegerStyle Info Press Dućani Kontakt

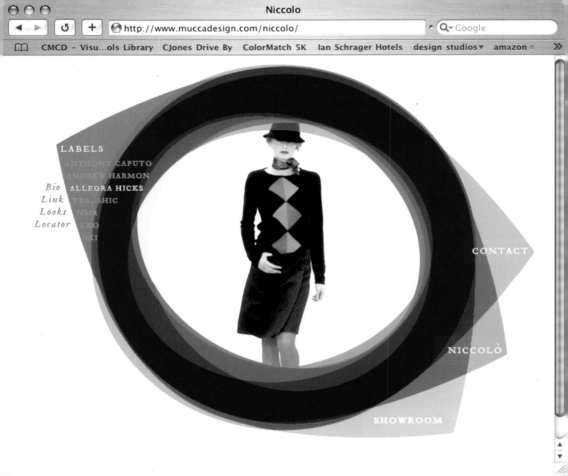

(this spread) Karen Skunta & Company/Details Salon

LOTIONS, POTIONS & PROMOTIONS 5

DETAILS
HAIR SALON

● PRODUCTS
● GIFT BASKETS

● GIFT CARDS

WE USE ONLY THE BEST PRODUCTS FOR OUR CLIENTS AND STAND BY OUR RECOMMENDATIONS
We are an AVEDA™ Concept Salon

SHARING DETAILS

1 2 3 4 5 6 7

©2004 details hair salon

Fiesta Creations feature over 80 patterns inspired by the use of our luxurious yarns and designed to feature our hand dyed colorways.

To create a special garment, gift or glorious home accessory, choose a Fiesta Collection or pattern category by style.

Culture
Collections
Creations
Outlet Store
Contact

Wholesale Info
Wholesale Log in
Find a retailer near you
ZIP Go

Featured Pattern
Lusso Poncho

Yarn: Lusso
Stitch: K2tog, yo
Needle: 13
Sizes: One Size

This pattern also works with Gelato and Rayon Boucle

FIESTA
Creations

Choose a line from our **Fiesta Collections**

Our patterns organized by style

©2004 Fiesta Yarns

Culture
Collections
Creations
Outlet Store
Contact

Wholesale Info
Wholesale Log in
Find a retailer near you
ZIP Go

Featured Yarn–Lusso
Moroccan

Fiesta Collections feature 13 spectacular yarn lines. Each line starts out as a premium fiber and is created completely by hand—from dyeing to packaging—in up to 38 glorious colorways.

Choose a favorite, let your imagination go, and knit or crochet your design into a lifetime of wearable art.

FIESTA
Collections

Try our yarn in your favorite pattern. Choose a fiber or needle size.

Fiber Type		Needle Size			Our recommended Fiesta yarn:
Cashmere	Rayon	6	8	9	
Cotton	Silk				
Mohair	Wool	10	10.5	11	

Due to the difference in how computer screens display colors, the color that you see may not match the actual color of the yarn.

©2004 Fiesta Yarns

Culture
Collections
Creations
Outlet Store
Contact

Wholesale Info
Wholesale Log in
Find a retailer near you
ZIP Go

Rain Forest

La Boheme

This original creation for Fiesta is our most popular yarn. La Boheme is two strands: rayon boucle and brushed kid mohair. Dyed together, they create a contrast of color, shine, and texture.

Fiber type: 64% Brushed Kid Mohair
28% Rayon and 8% Nylon
Gauge: 4.5 sts x 5.5 rows=1"
Needle size 9
Yardage: 165 yards/4 oz
Care: Felting may occur (A)

▶ ▶ **View Colorways** ● ● ● ●

FIESTA
Collections La Boheme

Chinchilla Flirt Gelato Heaven Kokopelli DK Kokopelli Le Luz Lusso Rayon Boucle WaterMark Zia Zuni

Try our yarn in your favorite pattern. Choose a fiber or needle size.

Fiber Type		Needle Size			Our recommended Fiesta yarn:	If you like working with **La Boheme**, try:
Cashmere	Rayon	6	7 8	9		· DK Kokopelli · La Luz
Cotton	Silk					· Gelato · WaterMark
Mohair	Wool	10	10.5	11		· Kokopelli

Due to the difference in how computer screens display colors, the color that you see may not match the actual color of the yarn.

©2004 Fiesta Yarns

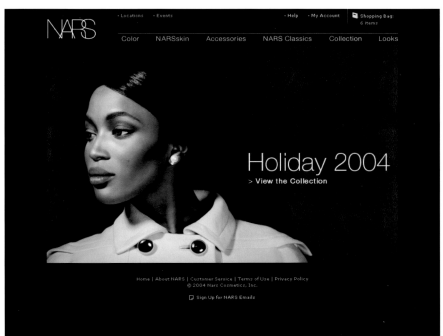

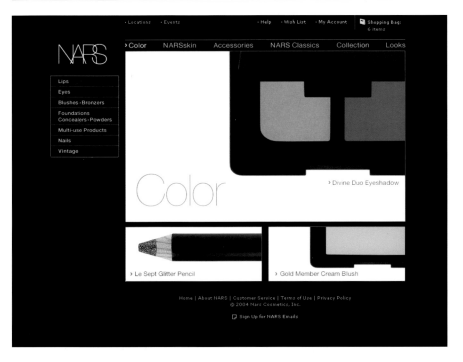

Sequel Studio/NARS Cosmetics

WORK
REEL 04 BROADCAST MUSIC VID CORPORATE PROJECTS
TROOPS
CONTACT

FUNCTION & FORM

WORK
REEL 04 BROADCAST MUSIC VID CORPORATE PROJECTS
OPERATIONS DARK TOWER
CONTACT OP SHOP
 CRUMB
 FUR PATROL
 BEN LOMUS

GLORIOUS COLLISION OF
MAN+
MACHINE

WORK
TROOPS THE GENERAL COMMANDERS SOLDIERS
CONTACT

K:H

 (K:H) SHOOT
TO
THRILL

K:H

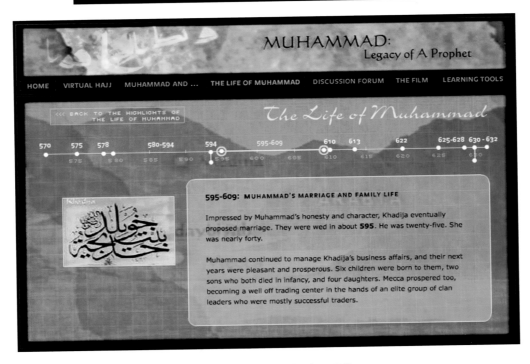

(this spread) Missing Pixel/Kikim Media

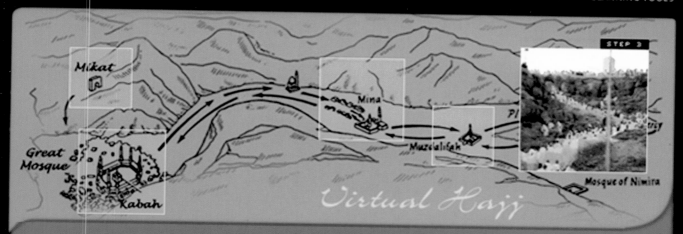

MUHAMMAD:
Legacy of A Prophet

Virtual Hajj

Step 3. Mina Valley, Plain of Arafat

STEP 1 STEP 2 STEP 3 STEP 4 STEP 5

THE HAJJ RITES IN THE DESERT: Mina Valley, Plain of Arafat

At this point, the Hajj becomes a moveable ritual, stopping four times along a circular fifteen-mile route through a desert landscape ringed with granite hills.

On the eighth day of the pilgrimage month, pilgrims all leave the city and troop five miles east, into **Mina Valley.** Here, a tent city of enormous proportions fills the valley for miles around. Pilgrims pass the night in Mina, leaving behind the comforts of civilization and further dissolving class and cultural distinctions, as everyone becomes a wayfarer.

On the morning of the ninth day, the exodus pushes another five miles east, to the **Plain of Arafat.** Here the high point of the Hajj takes place in the form of a group vigil, called the Day of Standing Together (Yawm al-Wakuf). At Arafat, pilgrims are transported into a timeless frame of mind: Arafat is the location where, Muslims believe, Adam and Eve were reunited after leaving Eden. This is a place set aside for spiritual reunion, where pilgrims come to seek pardon, reclaim their faith, and re-collect their spirit. Muslims often refer to this portion of the Hajj as a rehearsal for the Day of Judgment.

<< Previous Step Next Step >>

PLUG-IN HELP | SITE CREDIT | PBS PRIVACY POLICY | PRODUCED BY

PBS PROGRAM CLUB PICK

FUNDING FOR MUHAMMAD LEGACY OF A PROPHET HAS BEEN PROVIDED BY THE CORPORATION FOR PUBLIC BROADCASTING, THE DAVID AND LUCILE PACKARD FOUNDATION, ARABIAN BULK TRADE, SABADIA FAMILY FOUNDATION, IRFAN KATHWARI FOUNDATION, EL-HIBRI FOUNDATION, QURESHI FAMILY TRUST, AND MANY INDIVIDUAL CONTRIBUTORS.

HOME COMMUNITY NEWS FAN CLUB ON LOCATION

· FILMOGRAPHY

Film:

XXX: STATE OF THE UNION

A LIGHT KNIGHT'S ODYESSY

THE INCREDIBLES

GRAND THEFT AUTO: SAN ANDREAS

KILL BILL: VOL. 2

THE MAN

COACH CARTER

BIOGRAPHY FILMOGRAPHY GALLERY VIDEO CLIPS

SAMUEL L. JACKSON

Screen 1

GALLERY

the many faces *of* **Sam Jackson**

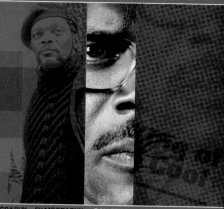

SAMUEL L. JACKSON

BIOGRAPHY FILMOGRAPHY GALLERY VIDEO CLIPS

Screen 2

BIOGRAPHY

Samuel Leroy Jackson

Samuel L. Jackson played bad guys and drug addicts before becoming an action hero, as the character Mitch Henessey, in The Long Kiss Goodnight, (1996) and in Die Hard: With a Vengeance (1995). His performance in Pulp Fiction (1994) gave him an Oscar nomination for his character Jules Winnfield.

In the seventies he joined the Negro Ensemble Company (together with Morgan Freeman). In the eighties he became well known by three movies made by Spike Lee - Do the Right Thing (1989), Mo' Better Blues (1990) and

▲
▼

SAMUEL L. JACKSON

BIOGRAPHY FILMOGRAPHY GALLERY VIDEO CLIPS

Screen 3

VIDEO CLIPS

COACH CARTER

S.W.A.T

BASIC

TWISTED

Choose the trailer you'd like to watch then select the resolution in which you'd like to view it.

We recommend low rez for modems up to 56K.

SAMUEL L. JACKSON

BIOGRAPHY FILMOGRAPHY GALLERY VIDEO CLIPS

History & Timeline

1925
The South Dakota American Legion creates a baseball league for teenage boys, complete with tournment structure, which quickly spreads to the rest of the country.

1938
In Williamsport Pennsylvania, oil company clerk Carl Stotz and friends organize a pre-teen baseball league using shortened baselines, and gain sponsorship from local companies for three teams. A year later, the first-ever Little League® game is played.

1947
First Little League World Series® (won by the Maynard Midgets of Maynard, PA)

1953
The Little League World Series is televised for the first time on CBS

1955
Little League's policy of racial integration is emphasized when it disqualifies 61 all-white leagues from South Carolina who had refused to play an African-American team.

1957
Monterrey, Mexico becomes the first non-US team to win the The Little League World Series.

1974
Bowing to lawsuits and bad publicity, Little League ends its prohibition against allowing girls to play. (However, it is believed that as early as 1950, several girls may have "passed" as boys and played anyway.)

2001
In the biggest controversy to hit Little League in years, a championship team from the Bronx, New York, is found to have had several overage players, including 14-year old pitcher Danny Almonte. The team is disqualified and its titles are revoked.

2004
Now in its 66th year of existence, the various divisions of Little League feature over two and a half million players comprising 7,000 leagues across 105 countries.

Source: Play Ball: The Story of Little League Baseball by Lance Van Auken and Robin Van Auken, Penn State University Press, 2001.

SMALL BALL
A Little League Story

Broadcast premiere, April 14, 2004 on PBS
Check local broadcast listings

About the Film
About Little League
The Dugout
Home Run Derby
Talk Back

12 gifted athletes.
24 nervous parents.
4 focused coaches.
1 great season.

**>> Check out the
Aptos Season
Calendar**

SMALL BALL
A Little League Story

Home Run Derby Game

Shank

HR	H	POINTS
0	0	0

GET READY...

200FT

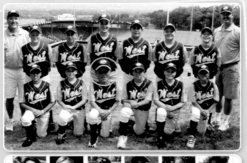

SMALL BALL
A Little League Story

Home **About the Film** About Little League The Dugout Home Run Derby Talk Back

SYNOPSIS | **CAST OF CHARACTERS** | APTOS SEASON CALENDAR | FILMMAKERS | CREDITS | EXTRAS

Cast of Characters

Kevin Eichhorn #8
POSITION: Pitcher,
2nd Base
FAVORITE PLAYER:
Chipper Jones

PARENTS:
Maryann & Mark Eichhorn

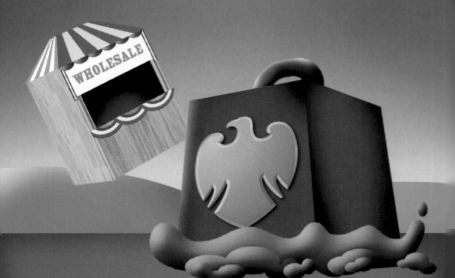

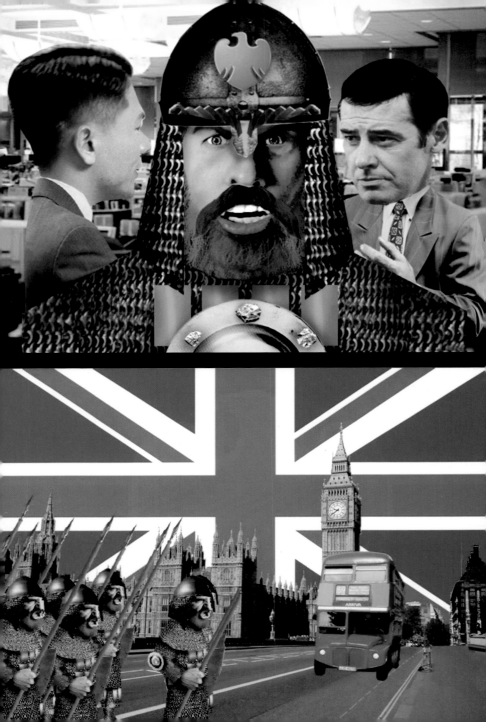

COLLECTIONS

WELCOME TO THE ARTstor COLLECTIONS

ARTstor is a digital resource — an organized and regulated space on the Internet — devoted to scholarship, teaching and learning in the arts, humanities and related social sciences.

The Image Gallery
A deep and broad collection of 225,000 images of world visual art and culture.

The Carnegie Arts of the United States Collection
A widely used collection of images documenting the history of American art, architecture, visual and material culture.

The Huntington Archive of Asian Art
A broad photographic overview of the art of Asia from 3000 B.C. through the present.

The Illustrated Bartsch
A collection derived from the standard art reference publication, The Illustrated Bartsch, which contains Old Master European prints from the 15th to 19th Centuries.

The Mellon International Dunhuang Archive
High resolution images, produced digitally, of wall paintings and sculpture from the Buddhist cave shrines in Dunhuang, China, a key site on the ancient Silk Route.

The MoMA Architecture and Design Collection
A comprehensive collection of digital images representing the collections of the Department of Architecture and Design of The Museum of Modern Art (MoMA) in New York.

ARTSTOR

About Us Collections Using ARTstor News & Notes Resources

NEWS & NOTES

:: Welcome to ARTstor!

:: Michele Tolela Myers and Kwame Anthony Appiah join ARTstor Board

:: ARTstor Adds Hartill Art Associates Collection

:: ARTstor Develops K-12 Plan

ITALIANO | FRANÇAIS | DEUTSCH | ESPAÑOL | 中文 | РУССКИЙ | PORTUGUÊS | عربي | 日本語

閉じる

ARTstor へようこそ

この度は、ARTstor（アートストア）のサイトをご覧いただき有難うございます。また、本プロジェクトへ関心をよせていただきましたことに感謝申し上げます。今後、さらに日本語によりアクセスできるサイトの内容を増加する意向でおります。まだ初期段階ではありますが、私ども ARTstorでは、本プロジェクトに関する基本的な情

肖願っております。本ページには、以下の内容が含まれています。

» 会長ならびに常任理事からのメッセージ
» 使命と目標
» ARTstor とそのなりたち

会長ならびに常任理事からのメッセージ

アンドリュー・W.メロン財団が設立いたしました ARTstor へようこそ。

ARTstor の目的は、美術史、人文学分野（関連する社会科
「含む）の学問において利用される、大規模な—そして、無

A R T S

News & Notes Resources

ys & NOTES

me to ARTstor!

le Tolela Myers and Kwame
ny Appiah join ARTstor Board

or Adds Hartill Art Associates
tion

ARTstor Develops K-12 Plan

ITALIANO | FRANÇAIS | DEUTSCH | ESPAÑOL | 中文 | РУССКИЙ | PORTUGUÊS | عربي | 日本語

ARTSTOR

About Us Collections Using ARTstor News & Notes Resources

NEWS & NOTES

:: Welcome to ARTstor!

:: Michele Tolela Myers and Kwame Anthony Appiah join ARTstor Board

:: ARTstor Adds Hartill Art Associates Collection

:: ARTstor Develops K-12 Plan

ITALIANO | FRANÇAIS | DEUTSCH | ESPAÑOL | 中文 | РУССКИЙ | PORTUGUÊS | عربي | 日本語

LEN LYE WAS A UNIQUE CREATIVE FORCE IN
20TH CENTURY ART - MAX GIMBLETT CALLED HIM
THE ARTIST FOR THE 21ST CENTURY
AS WE OPEN THE DOOR TO THAT CENTURY, WE
UNDERSTAND THE TRUTH OF THIS PROPHECY

BARBARA ROSE AMERICAN ART HISTORIAN

(this spread) DNA DESIGN//The LEN LYE Foundation

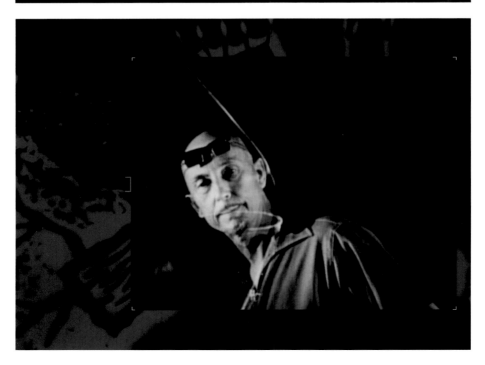

Leopold Ketel & Partners/Kettle Chips

Knoll

KnollStudio®
Wassily Chair

Breuer Collection Wassily chair

Marcel Breuer was an apprentice at the Bauhaus in 1925 when he conceived the first tubular steel chair, the Wassily chair, based on the tubed frame of a bicycle.

Back to Lounge Seating

Photos

View more images
Download brochure
Price list
Printer-friendly

Quick Links:

Office Systems
Seating
Wood Casegoods
Files and Storage
Tables and Desks
KnollExtra
KnollStudio
KnollTextiles
Environment
Knoll Essentials
Knoll Space
Government/GSA
Find a Knoll Location

Features

Marcel Breuer's signature is stamped into the base of each chair

Every piece has an individual number of identification and authenticity

Awards
The Museum of Modern Art Award, 1968

Dimensions
31" W x 27 ½" D x 29" H, with a seat height of 16 ½"

Construction
Frame is seamless tubular steel with a polished chrome finish

Upholstery
Thick cowhide leather upholstery option is available in black, light brown or white beige

Highly durable Cordura nylon strap option is available in black, brown, blue or red

Leather version complies with the California Technical Bulletin 133

Links

Designer Bio

Awards

Find a KnollStudio Location

Related Products

MR Lounge Collection

Platner Lounge Collection

Laccio Tables

KnollStudio
Ageless.
Exquisite.
Sublime.

Propeller Training and Conference Tables

Meeting Tables and Executive Office

Barstools

Lounge Seating

Dining and Occasional Tables

Conference Chairs

Side, Dining and Café Chairs

KnollStudio

Knoll

Quick Links:

Office Systems
Seating
Wood Casegoods
Files and Storage
Tables and Desks
KnollExtra
KnollStudio
KnollTextiles
Environment
Knoll Essentials
Knoll Space
Government/GSA
Find a Knoll Location

Spotlight: *Krefeld*

The Krefeld™ Collection, developed in collaboration with The Museum of Modern Art, is a "furniture suite" based on the master's 1927 drawings from the Museum's Ludwig Mies van der Rohe Archive. More

Propeller
Drum Base

The Propeller Drum Base table, by Emanuela Frattini, responds to the call for a conference table with advanced wiring that is easily accessible, discreet, and flexible. More

Links

Designers

Knoll Museum

Awards

Download KnollStudio Brochure

Price List

Find a KnollStudio Location

Florence Knoll Bassett at Philadelphia Museum of Art

Lecture by Carl Magnusson in conjunction with Florence Knoll Bassett Exhibition at the Philadelphia Museum of Art More

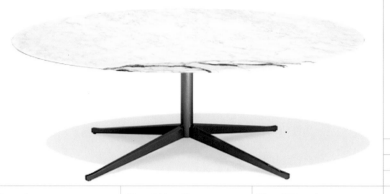

Knoll

Quick Links:

Office Systems ▸
Seating ▸
Wood Casegoods ▸
Files and Storage ▸
Tables and Desks ▸
KnollExtra ▸
KnollStudio ▸
KnollTextiles ▸
Environment ▸
Knoll Essentials ▸
Knoll Space ▸
Government/GSA ▸
Find a Knoll Location ▸

Office Systems

From open plan to private offices, Knoll addresses your current and future office needs. More

Seating

Knoll has the right chair for your style and ergonomic needs. More

KnollStudio

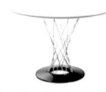

KnollStudio affirms our unwavering belief in the power and utility of modern design. More

KnollTextiles

KnollTextiles harmonizes color, pattern and texture. More

News

Knoll to Expand Distribution to U.S. and Canadian Retailers More

Christine Barber, Knoll Director Workplace Research, to Address International Facility Management Association New York Chapter More

More News >>

Define Your Home

With **Knoll Space**, Knoll has assembled the best of its past and present for the home and home office. More

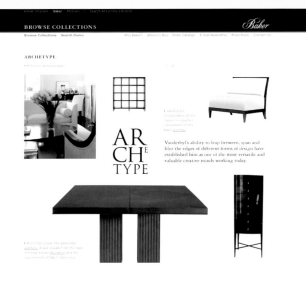

WHY BAKER?

Baker

Browse Collections Search Items Why Baker? Where to Buy Order Catalogs E-mail Newsletter Press Room Contact Us

DESIGN LEGACY

The 1950's

A time for prosperity and fine things coincides with the most fertile time
of a great connoisseur—and the people handpicked to continue his vision.

BROWSE COLLECTIONS

Baker

Browse Collections Search Items Why Baker? Where to Buy Order Catalogs E-mail Newsletter Press Room Contact Us

ARCHETYPE

MICHAEL VANDERBYL

"I am one of those designers who works as comfortably in
two dimensions as in three, and for whom design has neither
discrete disciplines nor barriers. My work in different
mediums is distinctive and eclectic, successful because it is
driven more by project requirements than an ego."

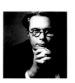

Vanderbyl develops his furniture designs from sketches,
looking for a spirit which can be made finite. The sketches are
xeroxed up to size, then refined until they become functional.

BROWSE COLLECTIONS

Baker

Browse Collections Search Items Why Baker? Where to Buy Order Catalogs E-mail Newsletter Press Room Contact Us

ARCHETYPE

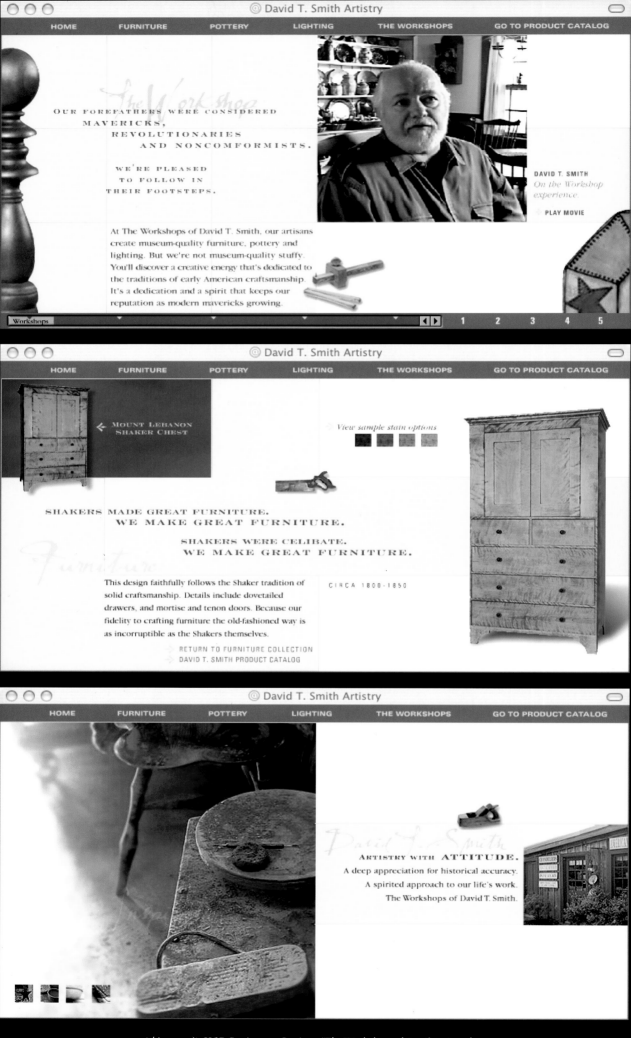

OUR FOREFATHERS WERE CONSIDERED MAVERICKS, REVOLUTIONARIES AND NONCOMFORMISTS. WE'RE PLEASED TO FOLLOW IN THEIR FOOTSTEPS.

DAVID T. SMITH
On the Workshop experience.
▸ PLAY MOVIE

At The Workshops of David T. Smith, our artisans create museum-quality furniture, pottery and lighting. But we're not museum-quality stuffy. You'll discover a creative energy that's dedicated to the traditions of early American craftsmanship. It's a dedication and a spirit that keeps our reputation as modern mavericks growing.

MOUNT LEBANON SHAKER CHEST

View sample stain options

SHAKERS MADE GREAT FURNITURE.
WE MAKE GREAT FURNITURE.
SHAKERS WERE CELIBATE.
WE MAKE GREAT FURNITURE.

This design faithfully follows the Shaker tradition of solid craftsmanship. Details include dovetailed drawers, and mortise and tenon doors. Because our fidelity to crafting furniture the old-fashioned way is as incorruptible as the Shakers themselves.

CIRCA 1800-1850

▸ RETURN TO FURNITURE COLLECTION
▸ DAVID T. SMITH PRODUCT CATALOG

ARTISTRY WITH ATTITUDE.
A deep appreciation for historical accuracy.
A spirited approach to our life's work.
The Workshops of David T. Smith.

(this spread) HSR Business to Business/The Workshops of David T. Smith

Pottery

WHISKEY NOT INCLUDED.

(Hiccup.)

REDWARE
EAGLE FLASK

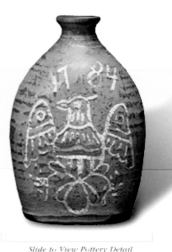

Thrown and flattened redware with an inlayed yellow slip, this piece is modeled after an original whiskey travel flask. You might choose a use other than the storing of spirits, but we tend to recommend faithfulness to all things historical.

→ RETURN TO POTTERY COLLECTION
→ DAVID T. SMITH PRODUCT CATALOG

Slide to View Pottery Detail

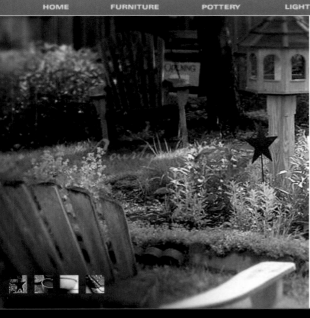

David T. Smith

ARTISTRY WITH **ATTITUDE.**
A deep appreciation for historical accuracy.
A spirited approach to our life's work.
The Workshops of David T. Smith.

← BEARS AND PEARS
LAMP

THERE WAS A TIME
WHEN THE OLD HOMESTEAD INSPIRED ART,
OF COURSE, THAT WAS BEFORE
THE DUPLEX AND THE DOUBLEWIDE.

Lighting

This whimsical table lamp's folk art design was inspired by a fireboard in the New York Metropolitan Art Museum. The lamp is thrown clay, slip-trailed with brush decoration. Add it to your decor and your house will feel more like home.

→ RETURN TO LIGHTING COLLECTION
→ DAVID T. SMITH PRODUCT CATALOG

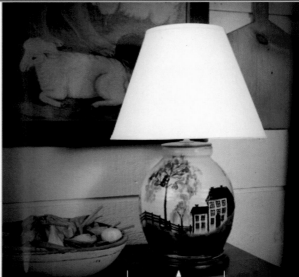

Dimmer Switch

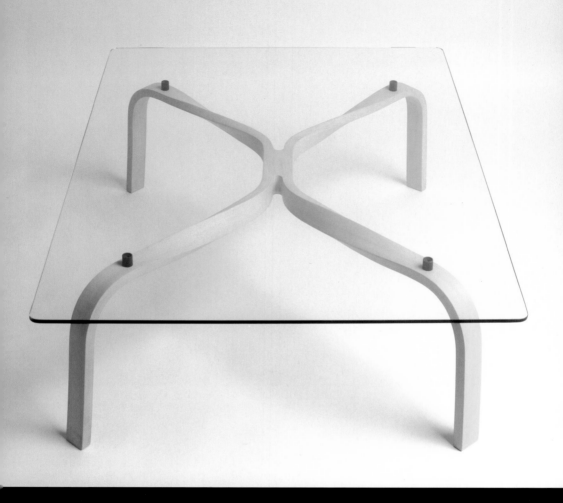

(this spread) Faculty of Design, Swinburne University of Technology/CRC Wood Innovations

BRETFORD PRODUCTS LIQUID WORKSPACE INSTALLATIONS RESOURCES ABOUT US

INSTALLATIONS

INSTALLATIONS ▼

LYNCH2
SAP NEW YORK
CHURCH WORLD
ELMWOOD PARK
LONGFELLOW
OAK BROOK
NEW TRIER WEST
GLENBARD WEST

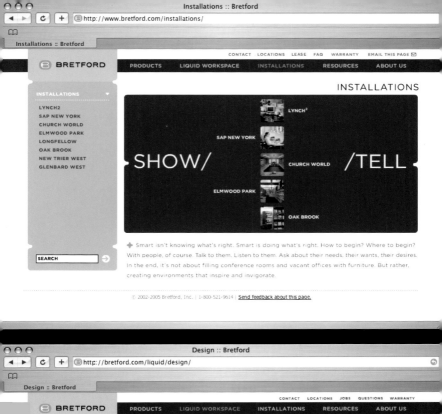

SHOW/ /TELL

SEARCH ➔

✦ Smart isn't knowing what's right. Smart is doing what's right. How to begin? Where to begin? With people, of course. Talk to them. Listen to them. Ask about their needs, their wants, their desires. In the end, it's not about filling conference rooms and vacant offices with furniture. But rather, creating environments that inspire and invigorate.

BRETFORD PRODUCTS LIQUID WORKSPACE INSTALLATIONS RESOURCES ABOUT US
WHY LIQUID LIQUID DESIGN ADAPT TO PEOPLE ADAPT TO SPACE ADAPT TO BUSINESS

LIQUID DESIGN

CREATE ▶
COMPONENTS ▶
CONFIGURATIONS ▶

✦ **ASPIRE. INSPIRE. BOTH.** I want to be more than a cubicle farm lit by flickering fluorescent lights. I want to be more than the smell of stale office coffee and that guy who wears too much cologne. I want to be more than Casual Fridays, water-cooler gossip, forbidden office romance, and a gallery of Successories® posters. I want to be more.

BRETFORD PRODUCTS LIQUID WORKSPACE INSTALLATIONS RESOURCES ABOUT US
WHY LIQUID LIQUID DESIGN ADAPT TO PEOPLE ADAPT TO SPACE ADAPT TO BUSINESS

LIQUID WORKSPACE

WHY LIQUID ▶
LIQUID DESIGN ▶
ADAPT TO PEOPLE ▶
ADAPT TO SPACE ▶
ADAPT TO BUSINESS ▶

INTRODUCING THE **LIQUID WORKSPACE.**
The effortless integration of power, data, performance, and privacy.
For today's agile company. "Best of NeoCon" 2003 Gold Award Winner.

Click on an image to discover more...

Close ✳

Indoor Outdoor Group

◀ 9 of 15 ▶

Ads 1950s

❮ Close Slide Show

As suburbs bloomed across the United States and the single-family house became part of the American dream, Herman Miller's residential furniture, much of it designed by Charles Eames and George Nelson, sold well. Herman Miller's advertisements during the 1950s show furniture in context, artfully displayed. The ads were often designed by Nelson and Eames themselves.

EUROPEAN LIVING

LIVING ROOM　　DESIGNERS
DINING ROOM　　MANUFACTURERS
KITCHEN + BATH　CATEGORIES
BEDROOM
WORKSPACE
OUTSIDE

CATALOG
COMPANY
CONTACT

info@europeanliving.com　+ 1 616 451 3376

Site by BBK Studio

Click on an image to discover more...

Close ✳

◀ 12 of 21 ▶

Eames Lounge Chair and Ottoman

❮ Close Slide Show

Some things make a mark and never fade. That's the case with the Eames lounge chair and ottoman. Perhaps this is because every chair made since 1956 carries on the spirit of the first one -- a present from Charles and Ray Eames to their friend Billy Wilder, the Academy Award-winning film director. Perhaps it's because they gave the chair the welcoming, "warm, receptive look of a well-used first baseman's mitt." Or maybe it's because they used production techniques that join technology and hand craftsmanship. Whatever the reasons, in homes

(this spread) BBK Studio/European Living

LIVING ROOM DESIGNERS
DINING ROOM MANUFACTURERS
KITCHEN+BATH CATEGORIES
BEDROOM
WORKSPACE
OUTSIDE

EUROPEAN LIVING

ACCESSORIES
DESKS
LIGHTING
SEATING
STORAGE
TABLES

KITCHEN + BATH

LIVING ROOM DESIGNERS
DINING ROOM MANUFACTURERS
KITCHEN+BATH CATEGORIES
BEDROOM
WORKSPACE
OUTSIDE

EUROPEAN LIVING

LIVING ROOM DESIGNERS
DINING ROOM MANUFACTURERS
KITCHEN+BATH CATEGORIES
BEDROOM
WORKSPACE
OUTSIDE

EUROPEAN LIVING

(this spread) Engine Interactive/Nintendo

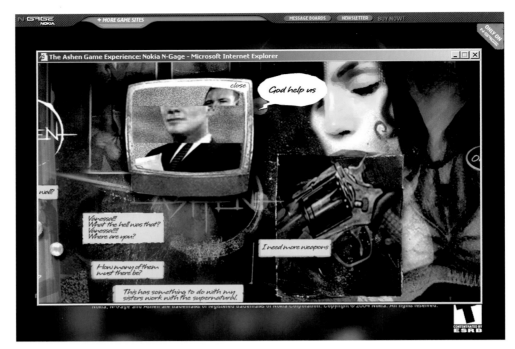

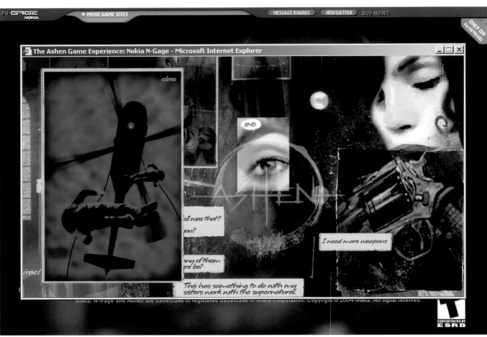

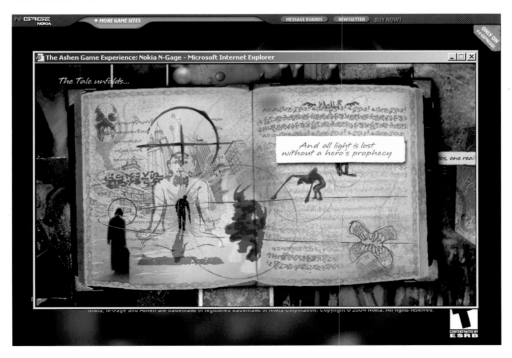

(this spread) Click Here/Nokia

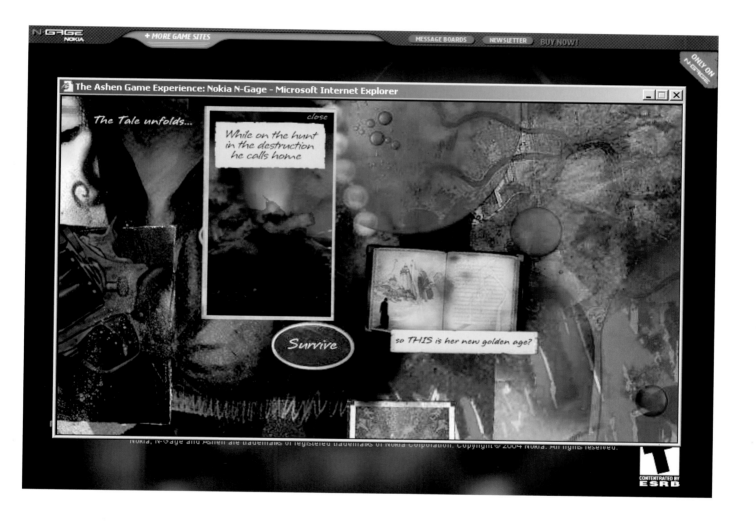

ePostcard from your friend, graphis

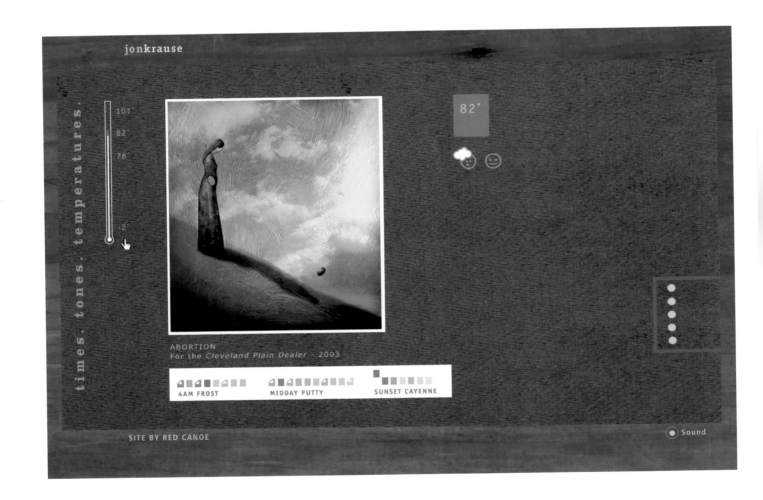

(this spread) Red Canoe/Jon Krause

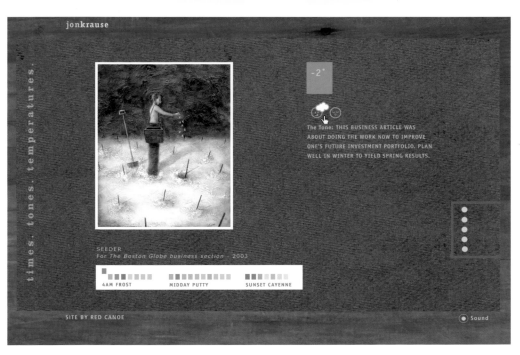

jonkrause

The Tone: THIS BUSINESS ARTICLE WAS ABOUT DOING THE WORK NOW TO IMPROVE ONE'S FUTURE INVESTMENT PORTFOLIO. PLAN WELL IN WINTER TO YIELD SPRING RESULTS.

-2°

SEEDER
For *The Boston Globe business section* – 2003

4AM FROST MIDDAY PUTTY SUNSET CAYENNE

SITE BY RED CANOE Sound

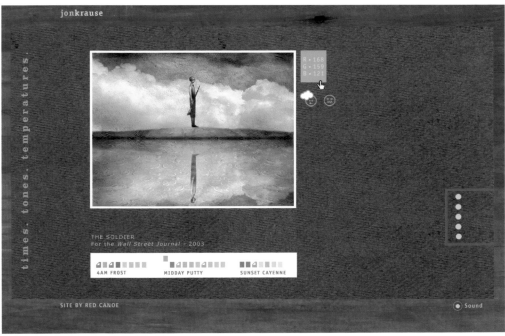

jonkrause

times. tones. temperatures.

R • 168
G • 159
B • 121

THE SOLDIER
For the *Wall Street Journal* – 2003

4AM FROST MIDDAY PUTTY SUNSET CAYENNE

SITE BY RED CANOE Sound

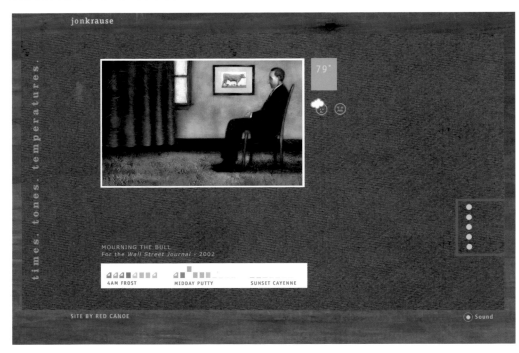

jonkrause

times. tones. temperatures.

79°

MOURNING THE BULL
For the *Wall Street Journal* – 2002

4AM FROST MIDDAY PUTTY SUNSET CAYENNE

SITE BY RED CANOE Sound

SEE
PLAN A VISIT
DO
DINE
SHOP
GROUPS
CALENDAR
EDUCATE
JOIN
JOBS
INSIDE VIEW
GAMES
CONTACT
HOME

EXAMINE HOURS, TICKETS, MAPS AND VISITOR SERVICES

PLAN A VISIT

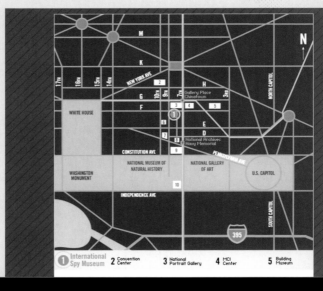

M

K

NEW YORK AVE

17th | 16th | 15th | 14th | 2

Gallery Place
Chinatown

G | 10th | 9th | 7th | H

WHITE HOUSE

F | 1 | 3 | 4 | 5

E

6

7 | 8 | National Archives
Navy Memorial

9

PENNSYLVANIA AVE

CONSTITUTION AVE

NATIONAL MUSEUM OF
NATURAL HISTORY

NATIONAL GALLERY
OF ART

U.S. CAPITOL

WASHINGTON
MONUMENT

10

INDEPENDENCE AVE

3rd | NORTH CAPITOL

N

395

SOUTH CAPITOL

1 International Spy Museum 2 Convention Center 3 National Portrait Gallery 4 MCI Center 5 Building Museum

LOOK CLOSER

800 F STREET TRANSFORMED
MORE

MISSION ACCOMPLISHED
MORE

WASHINGTON: SPY CITY
MORE

now! | exhibits | location | tickets | hours | shop | FAQ | Media 07·19·2002

SEE
PLAN A VISIT
DO
DINE
SHOP
GROUPS
CALENDAR
EDUCATE
JOIN
JOBS
INSIDE VIEW
GAMES
CONTACT
HOME

SPY MUSEUM NEWS July 19, 2002

Register now for the Museum's Programs! The Museum's October/November programs focus on: The Cuban Missile Crisis, Robert Hanssen, Intelligence Issues in the Post-9/11 World, Tools of the Trade, and John le Carré's *Tinker, Tailor, Soldier, Spy* [more]

Now Open! Take a look inside the new International Spy Museum, courtesy of Washingtonpost.com [more]

Spies in D.C. Washington, D.C. is the spy capital of the world. It has always been a hotbed of espionage activity. Presidents from George Washington on have excelled at or ignored the need to gather intelligence--with expected results. [more]

INTERNATIONAL
SPY
MUSEUM

need to know?
Enter your email address for future museum information

SUBMIT / POLICY

our mission:

The mission of the International Spy Museum is to educate the public about espionage in an engaging manner and to provide a dynamic context that fosters understanding of its important role in and impact on current and historic events. The Museum focuses on human intelligence and reveals the role spies have played in world events throughout history.

This site designed by: Nesnadny + Schwartz, Cleveland + New York + Toronto

(this spread) Nesnadny + Schwartz/International Spy Museum

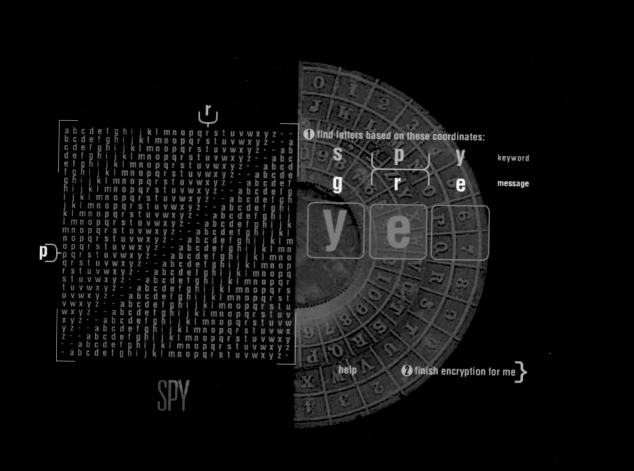

MODIGLIANI
EXHIBITION

HIGHLIGHTS: SCULPTURE

Only 27 sculptures by Modigliani are known to exist. In his sculpture, Modigliani tried to capture the raw, primitive and mysterious power of African masks, as well as the beatific smiles of Cambodian or Khmer heads. In their hardness, Modigliani's sculptures represent a conscious attempt to get away from the soft, modelled surfaces of Rodin's sculpture. They are also part of a modernist trend toward "direct carving," i.e. works that are simple and directly carved by the sculptor, instead of being part of an elaborate process involving many assistants and a foundry.

OTHER HIGHLIGHTS
► Portraits ► Children ► Nudes ► Caryatids

Head, 1911-13
Collection Solomon R. Guggenheim Museum, New York

HIS LIFE ► | MONTPARNASSE ►

ALBRIGHT-KNOX ART GALLERY **MODIGLIANI & THE ARTISTS OF MONTPARNASSE** OCTOBER 22, 2002 - JANUARY 12, 2003 SPONSORED BY M&T BANK TICKETS

MODIGLIANI
MONTPARNASSE

At the start of the twentieth century, the square mile of Paris known as Montparnasse was home to what some have called the first truly international group of artists. Move your mouse over the people below to identify them and click them for more information.

HIS LIFE ► | EXHIBITION ►

ALBRIGHT-KNOX ART GALLERY **MODIGLIANI & THE ARTISTS OF MONTPARNASSE** OCTOBER 22, 2002 - JANUARY 12, 2003 SPONSORED BY M&T BANK TICKETS

MODIGLIANI
EXHIBITION

HIGHLIGHTS: PORTRAITS

Modigliani is best known as a portraitist. He took this traditional medium and modernized it. Photography had freed artists of the need to be realistic or naturalistic, thereby allowing them to take artistic liberties. In Modigliani's case, he often elongated the neck of his sitters, creating an elegant and surrealistic image. His portraits are very soulful. As Jean Cocteau once wrote, Modigliani turned his sitters into Modiglianis.

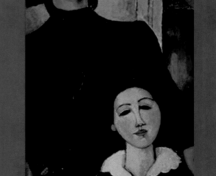

OTHER HIGHLIGHTS
► Nudes ► Children ► Sculpture ► Caryatids

Jacques and Berthe Lipchitz, 1916
Collection Art Institute of Chicago

HIS LIFE ► | MONTPARNASSE ►

ALBRIGHT-KNOX ART GALLERY **MODIGLIANI & THE ARTISTS OF MONTPARNASSE** OCTOBER 22, 2002 - JANUARY 12, 2003 SPONSORED BY M&T BANK TICKETS

Crowley Webb and Associates/Albright Knox Art Gallery

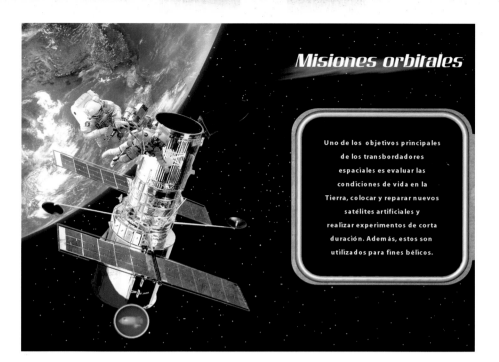

Margen Rojo S.C. Comunicación Visual/Museo de Historia Natural de Tamaulipas "TAMUX"

(this spread) Danne Woo/Danne Woo

Hello Design, Oceanmonsters, The_Groop, Wieden + Kennedy/Aiwa

INFORMATION 01

MUZAK AUDIO IMAGING
AUDIO ARCHITECTURE PORTFOLIO
AUDIO BRANDING OUR CLIENTS
NETWORK
CONTACT
WHAT'S HOT

AUDIO IMAGING

Audio Imaging is the approach we use to create an image with sound. It is our interpretation of a personality. Everything has one. Everything. A martini, an umbrella, a rose, even an eight ball possesses something that evokes a story. Choose an object and listen to how we bring those stories to life.

PRETTY COOL, HUH? TO AUDIO IMAGE YOUR BUSINESS, CLICK HERE.

© 2004 MUZAK CORPORATION

INSPIRATION

AUDIO IMAGING

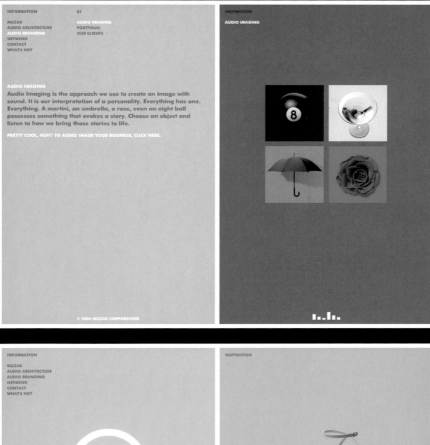

INFORMATION

MUZAK
AUDIO ARCHITECTURE
AUDIO BRANDING
NETWORK
CONTACT
WHAT'S HOT

© 2004 MUZAK CORPORATION

INSPIRATION

INFORMATION 01 02

MUZAK PROFILE BIG IDEAS
AUDIO ARCHITECTURE HISTORY MILESTONES
AUDIO BRANDING HEART&SOUL SOUND BITES
NETWORK PRESS
CONTACT
WHAT'S HOT

HISTORY

In the beginning there was the elevator. No wait. That came later. First came the man who had an idea that changed the world. Follow the evolution of Muzak from how it all began to where it is today.

© 2004 MUZAK CORPORATION

INSPIRATION

Pentagram Design/SF/Muzak, LLC

i ⏏ O Cantalopps
i ⏏ O From Town to Town
i ⏏ O Cold Cold Heart
i ⏏ O JazzMaze
i ⏏ O The Difference is You
i ⏏ O Zooloo Nation
i ⏏ O What's the Difference

◄▌ ⏐ I◄ II ►I ⏐ i ⏏ O ⏐ : Embrace . O • mixed tape

i ⏏ O Die neue CLS-Klasse
i ⏏ O Mandolay
i ⏏ O Autostrada
i ⏏ O Ronin
i ⏏ O Tell Me How
i ⏏ O Transform
i ⏏ O Spinning On A Chair Inside A Room

↳ DOWNLOAD EINER AUSWAHL → DOWNLOAD ALLER TITEL

Mercedes-Benz

i ⏏ O What A Day
i ⏏ O Star of the Stoy
i ⏏ O The True Form
i ⏏ O Blue
i ⏏ O The Session
i ⏏ O Friday I'll Be There
i ⏏ O KonTakt
i ⏏ O Extraordinary People

◄▌ ⏐ I◄ II ►I ⏐ i ⏏ O ⏐ : Titel: Too Much . O • mixed tape

i ⏏ O Who You Are
i ⏏ O Get Closer
i ⏏ O Classic
i ⏏ O Metro
i ⏏ O Warming
i ⏏ O Singalong Tammy

↳ DOWNLOAD EINER AUSWAHL → DOWNLOAD ALLER TITEL

Mercedes-Benz

◄▌ ⏐ I◄ II ►I ⏐ i ⏏ O ⏐ : Embrace . O • mixed tape

DETAILINFORMATIONEN ← VORHERIGER NÄCHSTER →

Titel Tell Me How
Künstler Camp
Genre Elektro-Rock
Label Alpinechic.ch

Die Mitglieder der Züricher Band Camp
(campground.ch) sammelten jeder für sich
musikalische Erfahrungen, ehe sie sich im Jahre
2003 als Band zusammenfanden. Beeinflusst von der
Synthi-Pop-Ära der 80er, Indie-Rock-Bands und der
Camp Intensität aktueller Clubmusik schaffen Dominic Suter
 (Gesang, Gitarre, Keyboard), Raphael Rogenmoser

→ ZURÜCK → PDF DOWNLOAD

(this spread) Scholz & Volkmer GmbH/Mercedes-Benz

i ✉ ○ La Ritournelle

i ✉ ○ Se Fue

i ✉ ○ Spiderboy

i ✉ ○ Feel So Weak

i ✉ ○ Silence

Künstler: DJane EmBee feat. Aleksz ○ ● mixed tape

i ✉ ○ House Eins

i ✉ ○ Perception

i ✉ ○ All Goes Down

i ✉ ○ Nights Between

i ✉ ○ Tres Amigos

i ✉ ○ Holiday

i ✉ ○ Everybody Knows

i ✉ ○ The Lowered Mood

i ✉ ○ Cross The Flow

↳ DOWNLOAD IHRER AUSWAHL → DOWNLOAD ALLER TITEL

LNM LUNA NEGRA MUSIC

touring schedule | the band | the press | merchandise | endorsements

touring schedule

LNM **reviews**

Reviews + Interviews

Where does the word 'criticism' come from?

The term criticism includes three overlapping fields of inquiry-- history, theory, and evaluative criticism. In history, the work is viewed as part of a historical process. In theory an attempt is made to describe the principles of the art form, its genres, techniques and functions. Criticism in the narrow sense of evaluative criticism concerns the study and analysis of specific works and their authors. This judgmental role is often singled out as the particular task of criticism and is a view sanctioned by the etymology of the term, which is derived from the Greek krinein, "to judge." The term kritikos as "a judge of literature" originated as early as the end of the 4th century BC.

Today the role of critic has expanded. Thousands of new works are being released daily and in this flood of output we often trust the critic to suggest to us which works are worthwhile. He has in fact become critic and curator.

"A 'critic' is a man (or woman) who creates nothing and thereby feels qualified to judge the work of creative men (and women). There is logic in this; he is unbiased - he hates all creative people equally." - Robert A. Heinlein, The Notebooks of Lazarus Long

This rather harsh quote of Robert A. Heinlein rings true sometimes, but today we need the critic more than ever, to help us cut through endless new works and releases.

-Ottmar

Reviews/Interviews:

press

contacts

connections

links

LNM

endorsements

(this spread) EPOS, Inc./Ottmar Liebert/Spiral Subwave Records/Luna Negra

SPIRAL SUBWAVE RECORDS INTERNATIONAL

music downloads | current release | catalog | artists | studio

NEW: Printable postcards from SSRI.

lnm

PICTURES

HOME

19 **95** OPIUM REC.

19 **96** OPIUM TOUR

19 **95** STUDIO

OTTMAR PICS

20 **01** TOUR

CHINA POSTCARDS

SANTA FE

Inducted 1987 | BMI Writer EARLY AMERICAN SONG: 1600–1879 TIN PAN ALLEY: 1880–1953 ROCK N' ROLL: 1953–PRESENT

CAROLE KING

▸ HOME
▸ BIOGRAPHY
▸ DISCOGRAPHY
▸ AUDIO CLIPS
▸ RECOMMENDED MATERIALS
▸ ACKNOWLEDGEMENTS

Carole King was born Carole Klein to Jewish parents in Brooklyn, New York on February 9, 1942. She was a proficient pianist by the age of four, and a prolific songwriter by her early teens. As a teenager, she recorded demos, sang backup, helped arrange recording sessions, and wrote and recorded a few singles that went nowhere.

While a student at Queens College, she met her future writing partner and husband, Gerry Goffin. King's 1960 single "Oh! Neil," which she recorded, was a riposte to her friend Neil Sedaka's song "Oh! Carol." It was not a hit, but it impressed Don Kirshner, who signed the King/Goffin team to his Aldon Music Empire.

Their first success arrived in 1960, when the Shirelles recorded "Will You Love Me Tomorrow?" This began a seven-year string of chart-toppers, including "Take Good Care Of My Baby" (Bobby Vee), "Up On the Roof" (The Drifters), "The Loco-Motion" (Little Eva), "One Fine Day" (The Chiffons), "Go Away Little Girl" (Steve Lawrence), "Don't Bring Me Down" (The Animals), "I'm Into Something Good" (Herman's Hermits), "Pleasant Valley
... MORE ≫

GREATEST HITS MORE CLIPS≫

"I Feel the Earth Move" PLAY ◀))

Discography Highlights

NATURAL WOMAN
Gerald Wexler, Gerry Goffin, Carole King,
Screen Gems EMI Music, Inc.

YOU'VE GOT A FRIEND
Carole King,
Colgems EMI Music, Inc.

▸▸ View Full Discography

Recommended Materials

MORE≫

INDUCTEE EXHIBITS

▸ LIST BY ERA
▸ LIST ALPHABETICALLY
▸ LIST BY YEAR OF INDUCTION

SEARCH FOR AN INDUCTEE
[Search for:]
Go≫

Through 2002, 312 individuals have been inducted into the Songwriter's Hall of Fame.

CLICK ON AN UNDERLINED NAME TO VIEW INDUCTEE EXHIBIT

NEW NEWLY OPENED INDUCTEE EXHIBITS

1600–1879	1880–1953	1953–PRESENT
EARLY AMERICAN SONG	**TIN PAN ALLEY**	**ROCK N' ROLL**
Early American song began with the fist settlers and continued through the Age of Reconstruction. Songs written during these years... MORE≫	"Tin Pan Alley" was the nickname given to the street where many music publishers worked during the period of 1880 to 1953. In the late 19th century... MORE≫	In 1955, Bill Haley and the Comets made a No. 1 hit with "Rock Around the Clock." By this time there was no doubt in the music business... MORE≫
Bates, Katherine Lee	Adamson, Harold	Adams, Lee
Becket, William	Adler, Richard	Anka, Paul
Billings, William	Ager, Milton	Ashford, Nickolas
Bland, James	Ahlert, Fred	Bacharach, Burt
Emmet, Daniel Decatur	Akst, Harry	Barry, Jeff
NEW Foster, Stephen	Alter, Louis	Barry, John
Gilmore, Patrick S.	Anderson, Leroy	Bartholomew, Dave
Howe, Julia Ward	Arlen, Harold	NEW Bergman, Alan
Key, Francis Scott	Aznavour, Charles	NEW Bergman, Marilyn
Payne, John Howard	Ball, Ernest	Berry, Chuck
Pierpont, J.S.	Benjamin, Bennie	Blackwell, Otis
Rexford, Eben E.	NEW Berlin, Irving	Brown, James
Root, George F.	NEW Bernstein, Leonard	Bryant, Boudleaux
Smith, Samuel Francis	Blane, Ralph	Bryant, Felice
Ward, Samuel A.	Bloom, Rube	Clapton, Eric
Winner, Septimus	Bock, Jerry	Cooke, Sam
Work, Henry C.	Bricusse, Leslie	Creed, Linda
	Brockman, James	Crewe, Bob
	Brown, Lew	Croce, Jim
	Brown, Nacio Herb	Darin, Bobby
	Bryan, Alfred	NEW David, Hal
	Burke, Joe	Denver, John
	Burke, Johnny	Diamond, Neil
	Caesar, Irving	Domino Jr., Antoine ("Fats")
	NEW Cahn, Sammy	Dozier, Lamont
	Caldwell, Anne	Dylan, Bob

STEPHEN

▸ HOME
▸ PHOTO GALLERY
▸ BIOGRAPHY
▸ DISCOGRAPHY
▸ TIME LINE
▸ RECOMMENDED MATERIALS
▸ ACKNOWLEDGEMENTS

PAUL S

▸ HOME
▸ BIOGRAPHY
▸ DISCOGRAPHY
▸ RECOMMENDED MATERIALS
▸ ACKNOWLEDGEMENTS

JOHNNY MERCER

© GEORGIA STATE UNIVERSITY

When people write about Johnny Mercer, they usually talk about his fabulous career, the sheer quantity of his output, the speed and ease with which he wrote, his southern charm, the hip sophistication of his lyrics. But all this misses the real point. Ask anyone who writes lyrics. Johnny Mercer was a genius.

He was born John Herndon Mercer on November 18, 1909 into an old Southern family in Savannah, Georgia. His father was a wealthy attorney with a flourishing real estate business, and young John was sent to a
... MORE»

Recommended Materials

MORE»

▸ HOME
▸ PHOTO GALLERY
▸ BIOGRAPHY
▸ DISCOGRAPHY
▸ AUDIO CLIPS
▸ RECOMMENDED MATERIALS
▸ ACKNOWLEDGEMENTS

GREATEST HITS MORE CLIPS»

"Moon River" PLAY 🔊

▶ ▶ ▶ ▶ ▶ SHoF FOUNDERS
PRESIDENT
1969-1973

Johnny Mercer
PHOTO GALLERY GO ▶▶

Discography Highlights

MOON RIVER
Johnny Mercer, Henry Mancini
Famous Music Corp.

COLUMBIA RIVER

IN ASSOCIATION WITH
Ford Motor Company

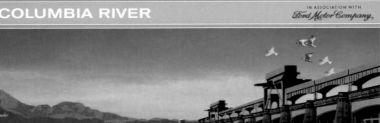

◄ DOWNSTREAM UPSTREAM ►

Salmon After several years at sea, Pacific salmon are seized by a biological imperative to. …
FULL STORY AND PHOTO ▸▸

Are making the world a better place.

RAIN FOREST AT NIGHT

IN ASSOCIATION WITH
Ford Motor Company

Mouse over and click for facts and photos.

▼ TO FOREST FLOOR

Ford Motor Company

EARTHPULSE
NATIONAL GEOGRAPHIC'S HOME FOR CONSERVATION

IN ASSOCIATION WITH
Ford Motor Company

Sunday, Jan 7, 8 p.m. ET
Heroes for the Planet
A Tribute to National Geographic

Hosted by
PIERCE BROSNAN

Live on the
National Geographic
Channel
and CNBC.

THIS MONTH: OCEANS NEXT MONTH: CLIMATE

Virtual World ▸▸
Interactive Kelp Forest Dive
Pilot a pocket-sized sub deep into Monterey Bay.

Expeditions Online ▸▸
Blue Frontier
Dive with explorer Sylvia Earle and her Sustainable Seas team
as they explore the U.S. marine sanctuaries.

Webcast ▸▸
Clinton Designates "Yellowstone of the Sea"

NEWS

• Ecotourists tickled pink
by flamingos...

**INTERACTIVE
MAPS**

• Wild World Ecoregions
Map

**VIRTUAL
WORLDS**

• Monterey Bay Kelp
Forest
• Great Barrier Reef

**MONTHLY
THEMES**

• Full List
• Global Warming

Hello Design/National Geographic Society

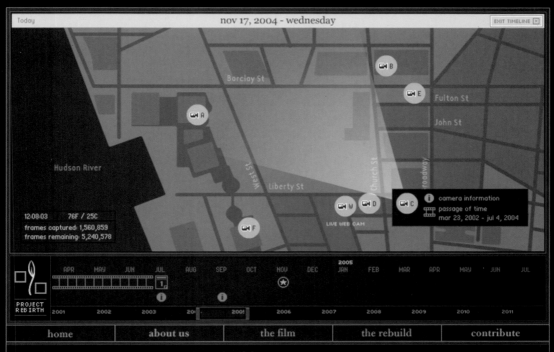

Today | nov 17, 2004 - wednesday | EXIT TIMELINE ☒

Barclay St

Fulton St

John St

Hudson River

Liberty St

West St

Church St

Broadway

12:08:03 76F / 25C
frames captured: 1,560,859
frames remaining: 5,240,578

LIVE WEB CAM

ⓘ camera information
passage of time
mar 23, 2002 - jul 4, 2004

PROJECT REBIRTH

APR MAY JUN JUL AUG SEP OCT NOV DEC **2005** JAN FEB MAR APR MAY JUN JUL

2001 2002 2003 20 2005 2006 2007 2008 2009 2010 2011

| home | about us | the film | the rebuild | contribute |

the film

View the Latest Film Trailer

A Rebuild in Time-lapse
Project Rebirth's completed film will show the full WTC site rebuild in just 60 minutes.

view the cameras »
more about time-lapse »

A Room of One's Own
Each camera is housed in a specially designed box to protect it from the elements and allow for temperature control.

learn more »

What do you think?
Send us your comments on the film-in-progress, the rebuild, and read what others are saying.

learn more »

Vote
How can we make this Web site more meaningful to you?
Your opinion matters
- More camera angles
- Construction crew interviews
- Photo galleries
- More technical information
- Other (tell us your idea below)

Tell us your idea

VOTE

Powered by Kettera

Web design partner: IconNicholson

the rebuild

About the WTC Site
Orient yourself to the physical site and its nearby surroundings.
go now »

What's involved?
In a project of this size and scope, planning is everything.
learn more »

Nearing a milestone
As construction of 7 World Trade moves nearer to completion, it will be the first to include many new technologies planned for the rebuild.
find out more »

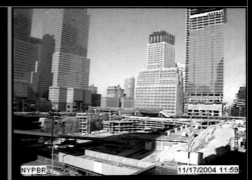

NYPBR 11/17/2004 11:59
Live Web cam New frame every minute.

Watch the WTC site in real-time from our live cam, situated atop NYFD Engine 10/Ladder 10 headquarters at 124 Liberty Street.

Web cam courtesy of WeatherBug

Discover the complexities inherent in a massive undertaking like this one – from building a skyscraper to planning electrical systems for the twenty-first century to understanding the needs of local businesses and victims' families.

- architecture
- engineering
- urban planning
- key organizations

Rebuilding from Ground Zero and up.

contribute
» Sign up for Email Updates
Don't miss out! Stay informed about site updates and news from Project Rebirth.

» Tell Your Friends About us

» Interested in Helping us?
Whether you're an individual or a corporation, your donations help us to sustain this important project.

» Visit our Guestbook
Share your thoughts about 9/11 and the rebuild, or read what others are saying.

© 2004 Project Rebirth Tell a Friend | Sign Up for Email | Contact Us | Site Map | Privacy Notice

THE MISSING PEACE

The Dalai Lama Portrait Project

PROJECT
SPONSORS
ARTISTS
VENUES
ART & PEACE
CONTACT US
TAKE PART

FOR PARTNERS

Funding
Venues
Press

The Missing Peace: The Dalai Lama Portrait Project is a multi-media art exhibition that will bring together over fifty well-respected artists, representing more than 21 countries. With the full life of the Dalai Lama as inspiration, the intention for this project is to shift the world's attention towards peace.

"Peace starts within each one of us. When we have inner peace, we can be at peace with those around us. When our community is in a state of peace, it can share that peace with neighboring communities." His Holiness the XIV Dalai Lama, 1989 Nobel Laureate for Peace.

The exhibition will be seen in cities around the world starting in the spring of 2006. Participating artists include: Richard Avedon, Ken Aptekar, Laurie Anderson, Guy Buffet, Michael Rovner, Adam Fuss, Jenny Holzer, Katarina Wong and Bill Viola.

The responsibility is ours to become the creators of a better world.

Sponsored by: THE COMMITTEE OF 100 FOR TIBET www.c100tibet.org and THE DALAI LAMA FOUNDATION (DLF) www.dalailamafoundation.org

Photo: Phil Borges , Site Design: Tank, Contact our Webmaster

(this spread) Tank Design/The Dalai Lama Foundation and the Committee of 100 for Tibet

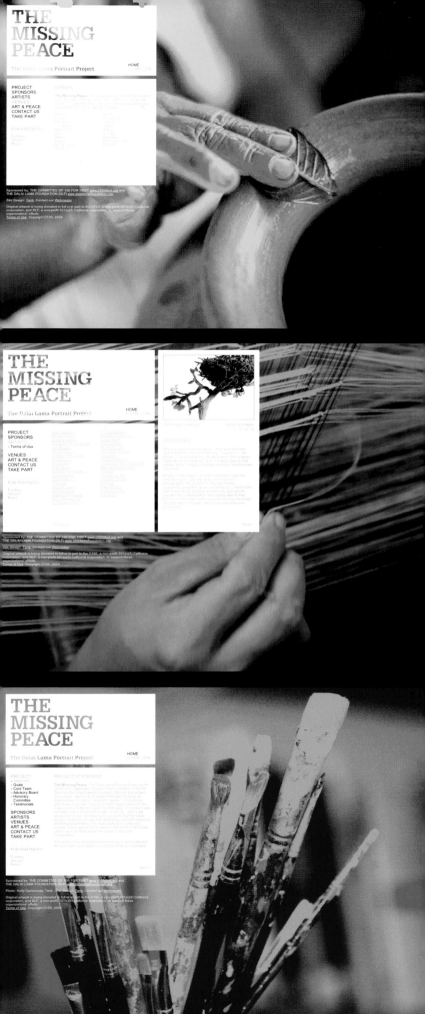

AD CLUB OF CENTRAL PA

2002 - JAN
2001 - DEC
2001 - NOV
Resources

Modern Dog - April 18, 2002

Modern Dog's principals, Robynne Raye and Mike Strassburger, will be the Ad Club of Central PA's featured guest speakers in April, 2002.

Date:
Thursday, April 18, 2002

Time:
Reception, 6:30
Presentation, 8:00

Place:
Whitaker Center for Science & Arts
222 Market Street
Harrisburg, PA 17101

Members: FREE
Non-members: $20
Students: $10

RSVP: 717-569-4040

Modern Dog's work has been accepted into the permanent archives of the Smithsonian Institute's Cooper-Hewitt National Design Museum, The Library of Congress, and The Experience Music Project Museum. Modern Dog has been featured in Communication Arts, Graphis, How, and Print magazines and has won more than 500 national and international awards for creative excellence! Their client list includes: K2 Snowboards, Nike, Converse, Nordstrom, and Warner Bros., among many others.

The evening is sure to be an event unlike any other the Ad Club has hosted! Mark your calendar now - you won't want to miss this one!

Click here to find out more about Modern Dog.

Sign Up for Ad Club Mailings: info@adclubpa.com.

Hosting and technical support provided by Visual Impact.

AFRICANS IN THE AMERICAS:
Celebrating the Ancestral Heritage

This commemorative site is presented by the Schomburg Center for Research in Black Culture in conjunction with the General Services Administration.

map of historic sites | schedule 2004

HOME | RITES OF ANCESTRAL RETURN | EXPLORE THE AFRICAN BURIAL GROUND

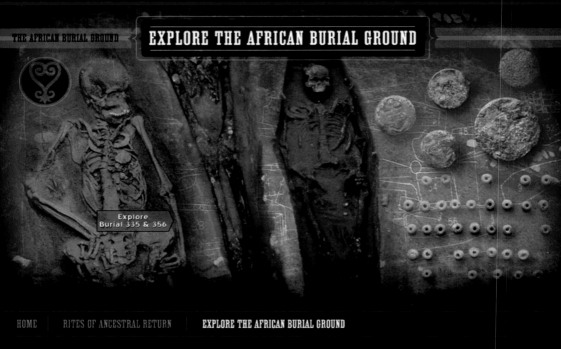

THE AFRICAN BURIAL GROUND

EXPLORE THE AFRICAN BURIAL GROUND

Explore
Burial 335 & 356

HOME | RITES OF ANCESTRAL RETURN | EXPLORE THE AFRICAN BURIAL GROUND

(this spread) Missing Pixel/The Schomburg Center for Research in Black Culture & The U.S. General Services Administration

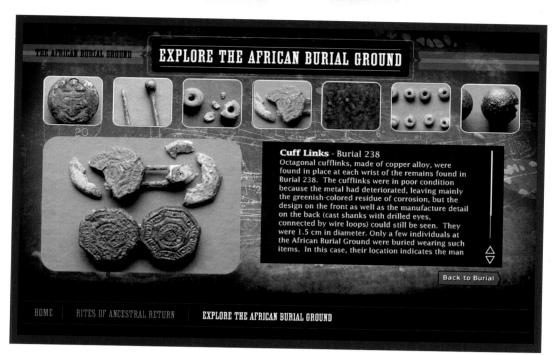

EXPLORE THE AFRICAN BURIAL GROUND

Cuff Links - Burial 238

Octagonal cufflinks, made of copper alloy, were found in place at each wrist of the remains found in Burial 238. The cufflinks were in poor condition because the metal had deteriorated, leaving mainly the greenish-colored residue of corrosion, but the design on the front as well as the manufacture detail on the back (cast shanks with drilled eyes, connected by wire loops) could still be seen. They were 1.5 cm in diameter. Only a few individuals at the African Burial Ground were buried wearing such items. In this case, their location indicates the man

Back to Burial

HOME | RITES OF ANCESTRAL RETURN | EXPLORE THE AFRICAN BURIAL GROUND

THE AFRICAN BURIAL GROUND

RITES OF ANCESTRAL RETURN CHRONICLES
COMMEMORATING THE COLONIAL AFRICAN HERITAGE

TRIBUTE ROUTE MAP

Watch Slide Show →
Tribute Program 2
D.C, Maryland, Delaware,
Philadelphia, and Newark

Watch Slide Show →
Tribute Program 1
New York City

view the route

2003 SCHEDULE AND LOCATIONS
TRIBUTE HIGHLIGHTS
MAP / SLIDESHOWS

HOME | RITES OF ANCESTRAL RETURN | EXPLORE THE AFRICAN BURIAL GROUND

THE AFRICAN BURIAL GROUND

RITES OF ANCESTRAL RETURN CHRONICLES
COMMEMORATING THE COLONIAL AFRICAN HERITAGE

The African Burial Ground represents the important role and major contribution that enslaved African men, women, and children made to the economy, development and culture of America, both in the South and the North. View here elements of the celebration commemorating the colonial African heritage in different cities in 2003.

2003 SCHEDULE AND LOCATIONS
TRIBUTE HIGHLIGHTS
MAP / SLIDESHOWS

HOME | RITES OF ANCESTRAL RETURN | EXPLORE THE AFRICAN BURIAL GROUND

MEADWESTVACOPAPERS LOGIN
PRODUCTS SUPPORT KNOWLEDGE ORDER CENTER ABOUT US NEWS AND EVENTS CONTACT US LINKS

ORDER CENTER

Bookmark the Order Center, come back when you need to, and get in and out quickly. Move less paper across your desk and more out your door.

» Our detailed order status lets you see where your order is and when you'll get it.

» Order paper by material number, saved lists, or product search, and
check on its availability.

» Login to Order Center

LEGAL/PRIVACY POLICIES | COPYRIGHT 2002 | MEADWESTVACO CORPORATION MeadWestvaco

MEADWESTVACOPAPERS LOGIN
PRODUCTS SUPPORT KNOWLEDGE ORDER CENTER ABOUT US NEWS AND EVENTS CONTACT US LINKS

PAPER CATALOG: Coated Family

COATED CARBONLESS DIGITAL

GRADE	NAME	FINISH	SHEET/WEB	COVER WEIGHTS	TEXT WEIGHTS	DIGITAL ALT?
CC	Sterling Ultra Cast Coated	Cast Coated	S	8pt, 10pt, 12pt	N/A	✓
	Signature True	Gloss, Dull	S / W	80, 100, 120	70, 80, 100	N/A
02	Sterling Ultra	Gloss, Dull, Matte	S / W	65, 80, 100, 120 6pt, 7pt, 7pt HY, 8pt, 9pt, 80/7pt, 80/9pt, 100/9pt	60, 70, 80, 100 110/7pt BRC: 100/7pt	✓
	Focus Plus	Gloss, Matte	W	80	45, 50, 60, 70, 80, 100	N/A
	Vision Plus	Gloss, Velvet	W	N/A	45, 50, 60, 70, 80, 100	N/A
04	Escanaba Plus	Gloss, Matte	W	N/A	45, 50, 60, 70, 80	N/A
	Dependoweb Plus	Gloss	W	N/A	40, 45, 50, 60, 70, 80	N/A
	Anthem	Gloss, Matte	S	80, 100	60, 70, 80, 100	N/A
C1S	Sterling Ultra C1S	Gloss	S / R	N/A	60, 70, 80, 100	N/A
	Sterling Litho C1S	Gloss	S / R	N/A	60, 70, 80, 100	N/A
	Oxford C1S	Gloss	S / R	N/A	55, 60, 70	N/A

LEGAL/PRIVACY POLICIES | COPYRIGHT 2002 | MEADWESTVACO CORPORATION MeadWestvaco

MEADWESTVACOPAPERS LOGIN
PRODUCTS SUPPORT KNOWLEDGE ORDER CENTER ABOUT US NEWS AND EVENTS CONTACT US LINKS

PAPER

See what makes us great. All our paper samples and programs are right here.

» See our paper in action. Order our samples and promotional pieces.

» Find the paper you're looking for in our catalog.

LEGAL/PRIVACY POLICIES | COPYRIGHT 2002 | MEADWESTVACO CORPORATION MeadWestvaco

Pulp, Paper & Packaging
Containerboard

CONTAINERBOARD
- ▸ **About Containerboard**
- ▸ **Products and Services**
- ▸ **Education**
- **Resources**

If you've carried a box or picked up a package recently, chances are you held containerboard in your hands. Containerboard is the building block of corrugated packaging, its properties giving corrugated products their strength and versatility.

Weyerhaeuser Company is one of the world's largest manufacturers of containerboard (linerboard and medium), producing approximately four million tons per year from 14 paper machines in the United States and Canada. That's enough to circle the earth 222 times or reach the moon and back 11 times.

Our customers are in North America, Central and South

In the packaging industry,

About Us | **Our Products** | Media Gateway | Citizenship | Investor Information | Careers
BUILDING PRODUCTS | PULP, PAPER, AND PACKAGING | TIMBERLANDS | REAL ESTATE DEVELOPMENT | TRANSPORTATION

Our Products

|when| Weyerhaeuser was founded more than 100 years ago, the company had a singular focus: timberlands. Today, Weyerhaeuser is an innovator—both in the management of our forestry holdings and in the development of new ways to utilize this renewable resource.

From the seedlings and forests of our timberlands section to the production of building products and pulp, paper and packaging, these sections provide information about our wide selection of forest products. You can also learn how

Our products are connected by a commitment to continued product enhancement, unparalleled quality and responsible resource management

About Us | Our Products | Media Gateway | Citizenship | Investor Information | Careers
WHAT WE DO | WHERE WE OPERATE | OUR HISTORY | LEADERSHIP | OUR VISION | OUR VALUES | CONTACT US

What We Do
Managed Forests

Weyerhaeuser's way of managing the forest is based on our knowledge of the natural forest and its cycles. We are continuously learning about and improving our understanding of trees, soil, water and life within the forest. Applying the principles of science, we protect natural resources, improve the productivity of the forest, and provide an indispensable, renewable resource from which we all benefit.

Balancing the needs of nature and the needs of people is our challenge, one that is important to all of us.

Our timberlands business sustainably manages 5.7 million acres (2.3 million hectares) of private working forests in the United States. In Canada, Weyerhaeuser holds long-term licensing rights on 31.6 million acres (12.8 million hectares) of

There is an excellent chance that Weyerhaeuser has touched your life in one way or another in recent days—from the newspaper you read, to the house you live in, to the package you receive in the mail. We are involved in nearly every

(this spread) Hornall Anderson Design Works LLC/Weyerhaeuser Corporation

Finish
○ Color ×
Grade Category
Weight/Caliper
Paper Size ×
Project ×
Printer/Copier Compatibility
Offline Technique

Color | **Hue**

Specify Your All Colors

Your Selections

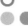

Your Search Results

VIEW SEARCH RESULTS There are 6 brands and 34 products available for you.

ACCENT OPAQUE	HAMMERMILL
BECKETT	SPRINGHILL
BRITE-HUE	STRATHMORE
CAROLINA	VIA
GREAT WHITE	WILLIAMSBURG

INTERNATIONAL PAPER

CLOSE HELP ANIMATION

ACCENT OPAQUE	HAMMERMILL
BECKETT	SPRINGHILL
BRITE-HUE	STRATHMORE
CAROLINA	VIA
GREAT WHITE	WILLIAMSBURG

INTERNATIONAL PAPER

BACK TO YOUR SPECS.

Strathmore

Choose from these available sheets

Strathmore provides most complete and versatile premium correspondence paper system. Strathmore is ideal for corporate identity programs.

○ More Product Details
○ Order Swatch Book

Your Selections

Strathmore Elements Cover Dots
Strathmore Elements Cover Grain
Strathmore Elements Cover Grid
Strathmore Elements Cover Lines
Strathmore Elements Cover Squares
Strathmore Elements Cover Zig Zag
Strathmore Elements Writing Dots
Strathmore Elements Writing Grain
Strathmore Elements Writing Grid
Strathmore Elements Writing Lines
Strathmore Elements Writing Squares
Strathmore Elements Writing Zig Zag
Strathmore Script Cover Pinstripe
Strathmore Script Cover Smooth

ACCENT OPAQUE	HAMMERMILL
BECKETT	SPRINGHILL
BRITE-HUE	STRATHMORE
CAROLINA	VIA
GREAT WHITE	WILLIAMSBURG

INTERNATIONAL PAPER

BACK TO YOUR SPECS.

Accent Opaque

Accent Opaque **Cover Super Smooth**
Accent Opaque **Cover Vellum**
Accent Opaque **Digital Cover Smooth**
Accent Opaque **Digital Smooth**
Accent Opaque **Vellum**

Beckett

Beckett Cambric **Cover Linen**
Beckett Cambric **Text Linen**
Beckett Cambric **Writing Linen**
Beckett Concept **Cover Vellum**
Beckett Concept **Text Vellum**
Beckett Concept **Writing Vellum**
Beckett Enhance **Cover Silk**
Beckett Enhance **Text Silk**
Beckett Enhance **Writing Silk**
Beckett Expression **Cover Super Smooth**
Beckett Expression **Text Super Smooth**

BriteHue

BriteHue **Cover Semi-Vellum**
BriteHue **Laser/Copy Smooth**
BriteHue **Text Semi-Vellum**

Your Selections

Show All Results

Click the color blocks to scroll through
search results by brand.

ACCENT OPAQUE	HAMMERMILL
BECKETT	SPRINGHILL
BRITE-HUE	STRATHMORE
CAROLINA	VIA
GREAT WHITE	WILLIAMSBURG

INTERNATIONAL PAPER

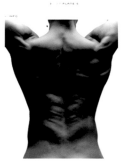

CLICK TO VIEW SERIES / ▶ ▶ ▶ // PERSONAL EXHIBITION

▶ // PLATE 3

← WORK

∨ INFO

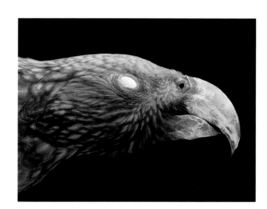

CLICK TO VIEW SERIES / ▶ ▶ ▶ // PERSONAL EXHIBITION

▶ // PLATE 4

← WORK

∨ INFO

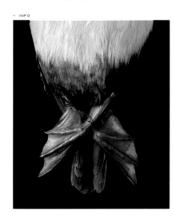

HEFFERNANICONS STOCK PRINT FILM STOCK CONTACT

PEOPLE
SPORTS/GAMES ARTS & CRAFTS
TECHNOLOGY FILM
ARTS MASKS
BUSINESS MUSIC
CULTURE

⊙ View Lightbox ⊕ Enlarge Photo ⊕ Add to Lightbox

Internet zone

○ ○ ○ ⊙ Heffernan Icons : Photography Film Images

Back Forward Stop Refresh Home AutoFill Print Mail

Address: http://heffernanicons.com/ go

Live Home Page Apple Apple Support Apple Store .Mac Mac OS X Microsoft MacTopia Office for Macintosh MSN

HEFFERNANICONS
PRINT FILM STOCK

Internet zone

○ ○ ○ ⊙ Heffernan Icons : Photography Film Images

Back Forward Stop Refresh Home AutoFill Print Mail

Address: http://heffernanicons.com/ go

Live Home Page Apple Apple Support Apple Store .Mac Mac OS X Microsoft MacTopia Office for Macintosh MSN

FILM

HEFFERNANICONS PRINT FILM STOCK CONTACT

Papa Murphy's
:30
160x120 / 796 K
358x253 / 1.8 MB

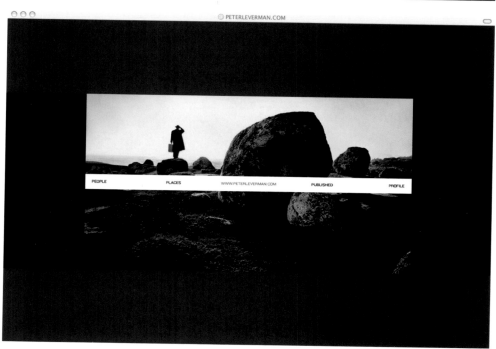

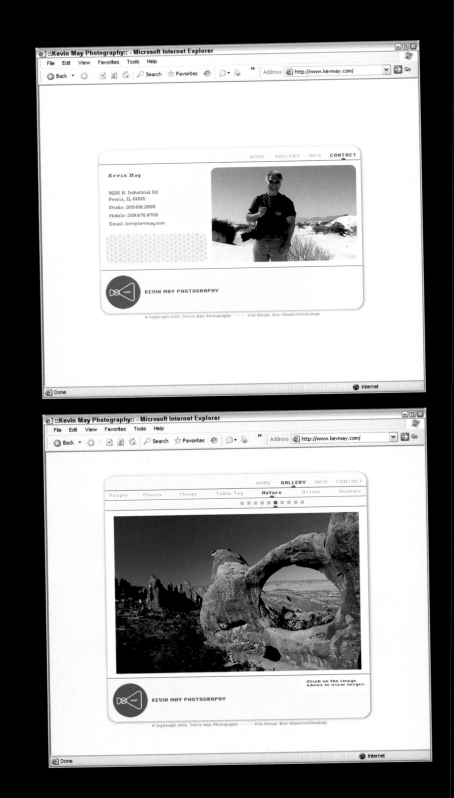

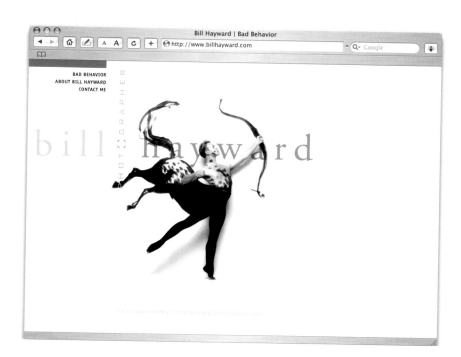

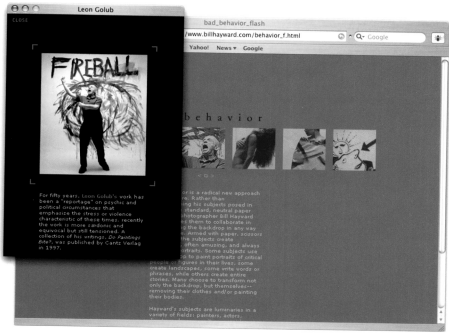

Bernhardt Fudyma Design Group/Bill Hayward

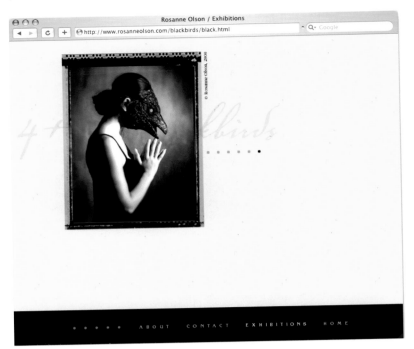

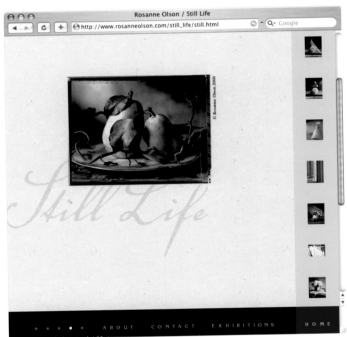

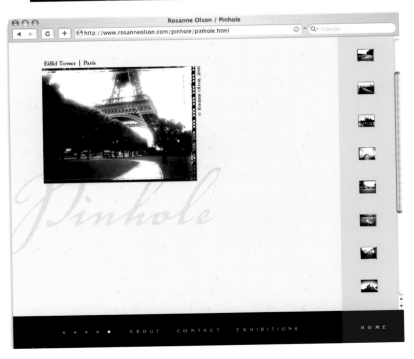

(this spread) Belyea/Rosanne Olson

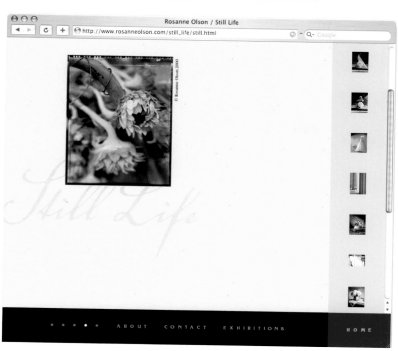

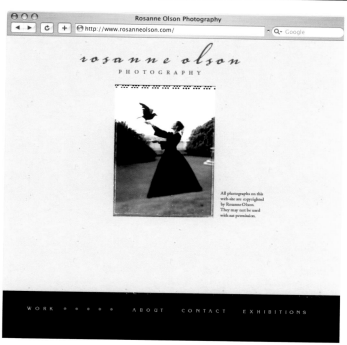

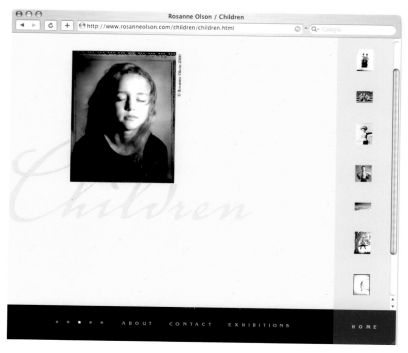

http://jameystillings.com/

Google Apple .Mac Amazon eBay News ▾ Yahoo!

Jamey Stillings Photography

.01 PORTFOLIO .02 ARCHIVE .03 ABOUT THE STUDIO

JAMEY STILLINGS PHOTOGRAPHY

http://jameystillings.com/view.asp?OP=CONCEPTS

Google Apple .Mac Amazon eBay News ▾ Yahoo!

Jamey Stillings Photograph...

.02 .03 .01 PORTFOLIO

JAMEY STILLINGS PHOTOGRAPHY

concepts

Client - Millennium Project

VIEW FLIPBOOK

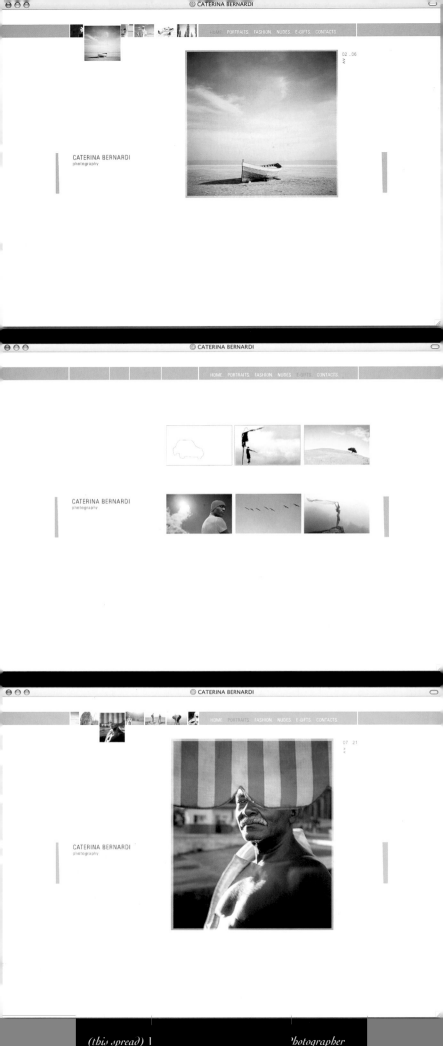

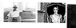 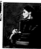

HOME. PORTRAITS. FASHION. NUDES. E-GIFTS. CONTACTS.

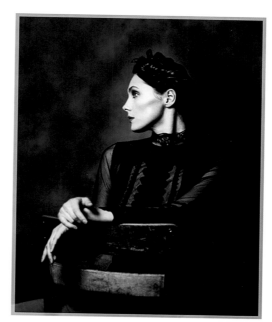

05 25

CATERINA BERNARDI
photography

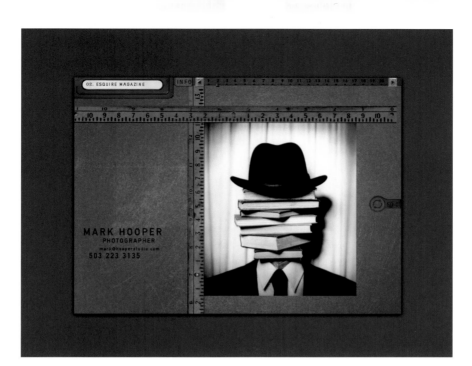

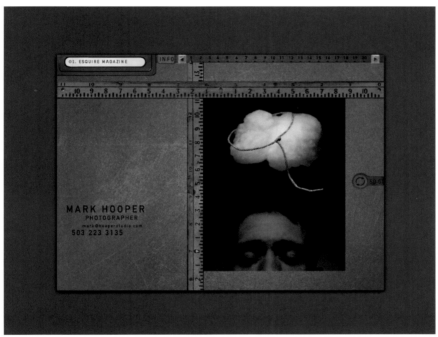

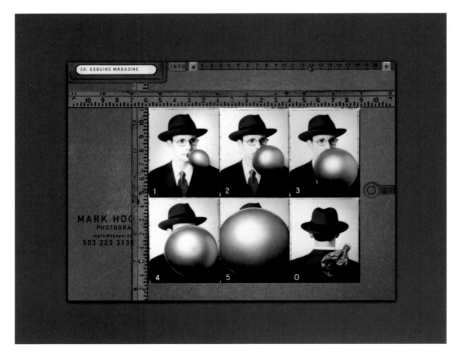

fine art

HOME ⟋ CLICK ON DUCK TO CONTINUE

HOME

FOR INFORMATION ON OUR STOCK IMAGE COLLECTION, PLEASE CONTACT MARJI@WEIDMANPHOTO.COM 610.388.9818

Stock

HOME

PORTFOLIO CONTACT CLIENTS FINE ART CAPABILITIES

HOME

yellow

yellow is her
she goes her way
lives her life
yellow is her identity

about ■
news ■
clients list ■
links ■
contract ■

claudiagoetzelmann

©

please select a project

about ■
news ■
clients list ■
links ■
contract ■

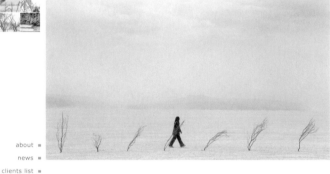

claudiagoetzelmann

returning home

tree man

tree man
nevada desert 2002

about ■
news ■
clients list ■
links ■
contract ■

claudiagoetzelmann

please select a project

about ■
news ■
clients list ■
links ■
contract ■

claudiagoetzelmann

returning home

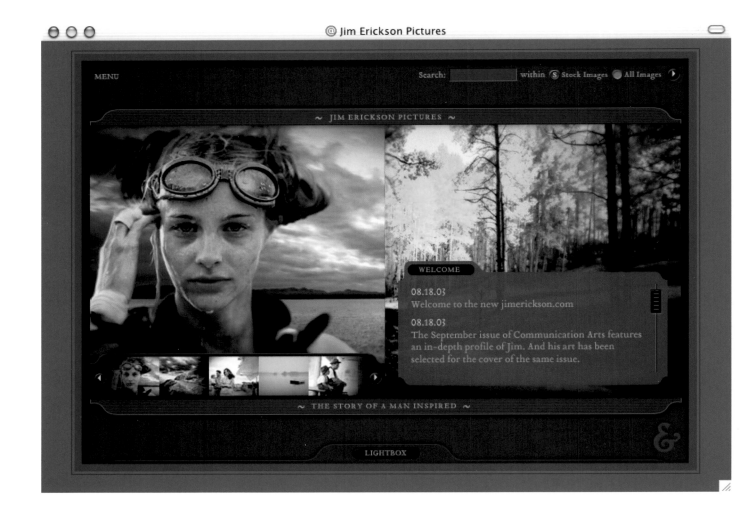

(this spread) Eleven Inc./Jim Erickson

JIM BRANDENBURG

GALLERY

← **TO MAIN MENU**

 COVERS

BAMBOO

CANADIAN ROCKIES

CHINA

ELLESMERE

NAMIBIA

NORTH POLE

OTHER | MISC.

RUSSIA | VIKINGS

SCOTLAND

WHITE WOLF

HOME / GALLERY / PRODUCTS / EVENTS / FEATURES / ABOUT / CONTACT

JIM BRANDENBURG

POSTERS

ARCTIC FOX

ARCTIC WOLF

AURORA BOREALIS

AUTUMN PASSING

AUTUMN WOLF

BROTHER WOLF

CHASED BY THE LIGHT

DREAM BACK THE BISON

FAMILY PORTRAIT

FIRST SNOW

FIRST SONG

GRAY WOLF

NORTH WOLF

PEACE IN THE FOREST

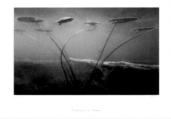

SECRET BAY

SPIRIT OF THE FOREST

TIMBER WOLF

TOP OF THE WORLD

TURTLE AND LILY PADS

WATCHERS OF THE WOODS

WHITE WOLF

WINTER WOLF

WOLF ENCOUNTER

WOLF FRONTIER

WOLF HARMONY

WOLF PUPS

WOLF RIDGE

HOME / GALLERY / PRODUCTS / EVENTS / FEATURES / ABOUT / CONTACT

CONTACT + STOCK +

PHOTOGRAPHER
ZACHARY SCOTT

+

SHARPE +
ASSOCIATES

SITE WIDE SEARCH

STOCK ONLY

+ FIND

NEAL +
BROWN

ROBERT +
KENT

HUGH +
KRETSCHMER

ZACHARY + PORTFOLIO
SCOTT ARCHIVE

JAMEY + STOCK
STILLINGS CLIENTS
 BIO
ERIC + CONTACT
TUCKER

REIMERS AND +
HOLLAR

COMRADE +

CONTACT + STOCK +

SHARPE +
ASSOCIATES

PHOTOGRAPHER
SEARCH RESULTS

girl FIND +

NEAL +
BROWN

ROBERT +
KENT

HUGH +
KRETSCHMER

ZACHARY +
SCOTT

JAMEY +
STILLINGS

ERIC +
TUCKER

REIMERS AND +
HOLLAR

COMRADE +

+ IMAGE INFO < PREVIOUS NEXT > MORE +

CONTACT + STOCK +

PORTFOLIO
ARCHIVE
STOCK
CLIENTS

SHARPE +
ASSOCIATES

PHOTOGRAPHER
HUGH KRETSCHMER

BIO FIND +
CONTACT

NEAL +
BROWN

ROBERT +
KENT

HUGH +
KRETSCHMER

ZACHARY +
SCOTT

JAMEY +
STILLINGS

ERIC +
TUCKER

REIMERS AND +
HOLLAR

COMRADE +

+ IMAGE INFO < PREVIOUS NEXT > MORE +

thomas arledge photography

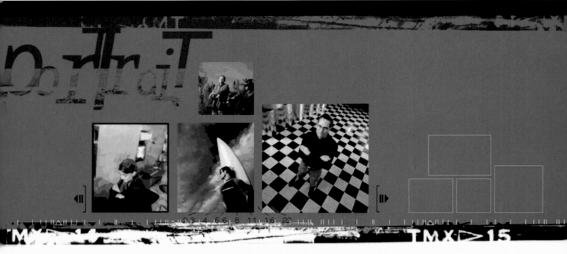

thomas arledge photography

thomas@thomasarledge.com
phone 301.320.0330
fax 301.320.0331

[LOCATION • PORTRAIT • LANDSCAPE • PROFILE]

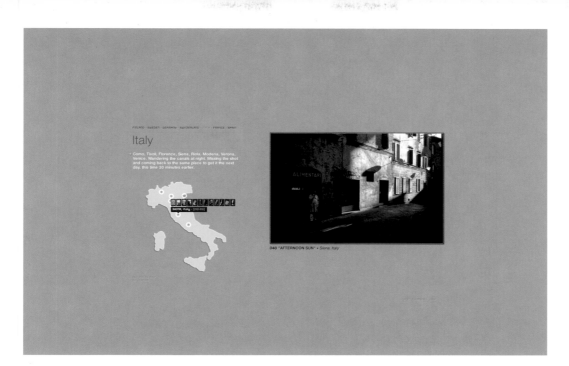

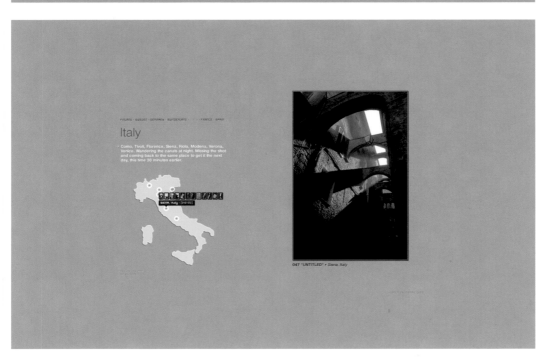

Nikolai Cornell/Nikolai Cornell

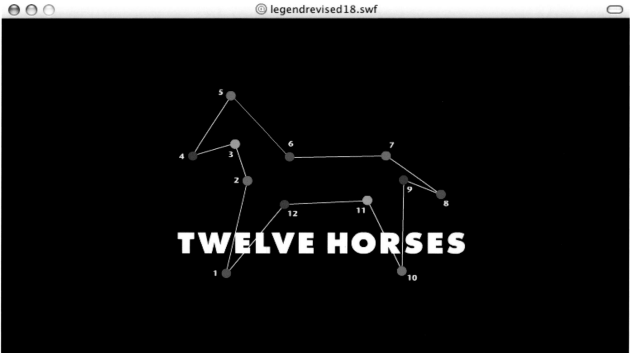

Screenshot 1:

TwelveHorses

Back | Forward | Stop | Refresh | Home | AutoFill | Print | Mail

Address: http://www.hadw.com/sites/twelvehorses/

Live Home Page | Apple | Apple Support | Apple Store | .Mac | Mac OS X | Microsoft MacTopia | Office for Macintosh | MSN

site map • contact

TWELVE HORSES

in action

{power} company

partners

services

Welcome to Twelve Horses, the first business-to-business service company to combine the speed of electronic messaging with the power of traditional

Control Your Message

print services and literature management. We help organizations communicate efficiently, increase revenues and reduce costs-quickly and easily.

Featured Areas
How our service works.

The story behind our name.

Twelve Horses seeks partnerships with strategic print and digital service companies.

Exciting career opportunities at Twelve Horses.

login: [] password: [] GO | login help

copyright © 2001 Twelve Horses Inc. worldwide patent pending • terms & conditions • privacy & security

Internet zone

Screenshot 2:

TwelveHorses

Back | Forward | Stop | Refresh | Home | AutoFill | Print | Mail

Address: http://www.hadw.com/sites/twelvehorses/company/company.html

Live Home Page | Apple | Apple Support | Apple Store | .Mac | Mac OS X | Microsoft MacTopia | Office for Macintosh | MSN

site map • contact • home

TWELVE HORSES

in action

{company}

partners

services

legendrevised18.swf

imagination

power

courage

speed

copyright © 2001 Twelve Horses Inc. worldwide pa

Internet zone

Screenshot 3:

TwelveHorses

Back | Forward | Stop | Refresh | Home | AutoFill | Print | Mail

Address: http://www.hadw.com/sites/twelvehorses/services/services.html

Live Home Page | Apple | Apple Support | Apple Store | .Mac | Mac OS X | Microsoft MacTopia | Office for Macintosh | MSN

site map • contact • home

TWELVE HORSES

company

in action

{services}

partners

who benefits
about
FAQs
ROI calculator
pricing
contact sales

MessageMaker is a literature management and deployment tool. In its simplest terms, Messagemaker enables users to identify essential literature, create an electronic "Virtual Literature Rack®" to house this content in digital format, and then access these digital files to communicate with key audiences either electronically or via traditional

how it works { description process difference

login: [] password: [] GO | login help

copyright © 2001 Twelve Horses Inc. worldwide patent pending • terms & conditions • privacy & security

Internet zone

Waters International

Press Room The Workwell Reading Room Careers Contact

WHAT WE DO WHO WE ARE PORTFOLIO CLIENTS TECHNOLOGY

Beyond Ideas

The ergonomics of business communications

The BEST SEAT in the HOUSE

INTERACTIVE PORTFOLIO
highlights strategy and skills >>

NEW BRAND
moniker for GretagMacbeth >>

COLORFUL EXHIBIT
by Waters International >>

PARTICIPATE
and stay informed >>

Privacy Statement | ©2004 Waters International, Inc.

Waters International

Press Room The Workwell Reading Room Careers Contact

WHAT WE DO WHO WE ARE PORTFOLIO CLIENTS TECHNOLOGY

BACK

CLIENT'S NAME: Columbia University ○ Description ○ Website ○ Case Study

● ○ ○ ○ ○ ○ SOUND MUTE – |||||||||| + PAUSE ❚❚ SKIP ▶▶

This page requires the free FLASH Player plug-in to view this portfolio. Please click **here** to download it.

Send This Page

Privacy Statement | ©2004 Waters International, Inc.

Waters International

Press Room The Workwell Reading Room Careers Contact

WHAT WE DO WHO WE ARE PORTFOLIO CLIENTS TECHNOLOGY

THE INFORMATION AGE IS HISTORY
book excerpt >>

TELL US WHAT YOU READ
>>

Books

Whet Papers

Click on any cover to purchase directly from Amazon.com.

Recommended Books

The real business of web design

The Real Business of Web Design
John Waters

"This book reads like a gestalt view of Web design," is how Karl Speak, Principle of Beyond Marketing Thought, summed-up The Real Business of Web Design. "This is not only a book about Web design; it's a book about the evolution of the culture of design management." It is a must read for any business wanting to take full advantage of the Web.

The Substance of Style
Virginia Postrel

An economics writer for The New York Times presents a thorough and provocative case for the value of aesthetics. Drawing from diverse fields she chronicles America's current affair with "look and feel" and argues for its importance in a balanced and stable society. This is an easy read and offers much to think about.

Brand Gap
Marty Neumeier

Welcome to SV Floral Consulting

Enter Here

Requirements:
800 x 600 Screen Resolution

Flash Plugin

SV Floral Consulting

Offering You

a sure-fire

investment in

your future

and your

business.

Biography Client Worksheet Clients Consulting Products Warranty Contact

Biography Client Worksheet Clients Consulting Products Warranty

Zembla "IS UNLIKE ANY C

HTML+

OR

FLASH

1024 X 576 SCREEN SIZE
FLASH 7+ PLUG-IN REQUIRED

DOWNLOAD FLASH

Zembla Magazine 2004
SITE IN EMERGENCY

B

b u g s

A close-up stand-off

until the age of the electron microscope.
This discovery of a new world-within-a-
world had a profound influence on
contemporary perceptions of the everyday
world. The disorientating effect of the
new perspective is memorably captured
in Swift's descriptions of Lilliput and
Brobdingnag in Gulliver's Travels.
Text: S.F.R.B.

A

ABCDEF
GHIJKL
MNOPQR
STUVWX
YZ

CONTACT
SUBSCRIPTIONS
STOCKISTS
SUBMISSIONS

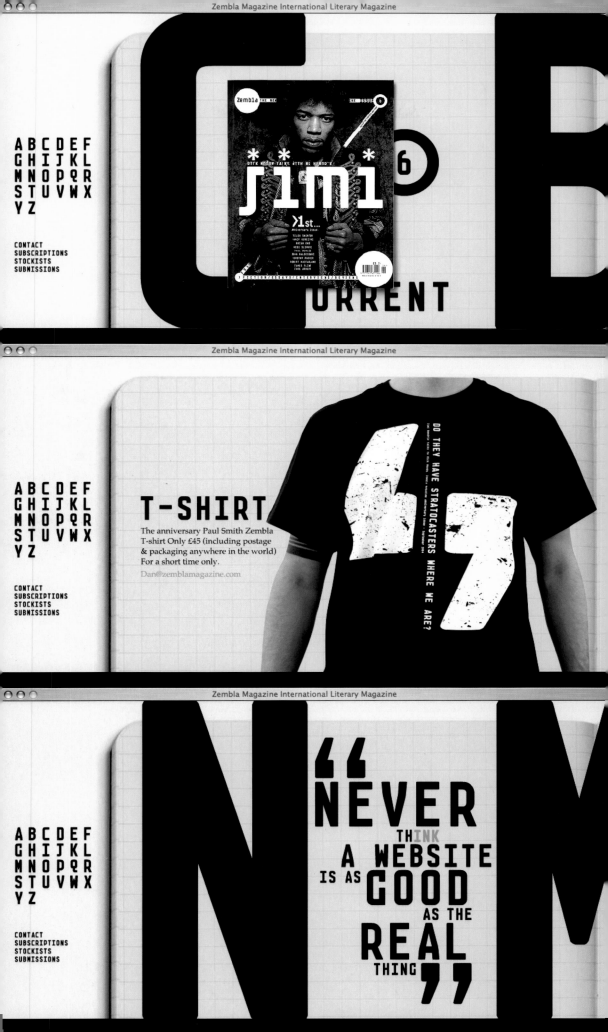

SAINT JOSEPH'S ABBEY

Horarium *Morning* *Midday* *Evening*

ORIGINS

OUR DAY

BECOMING A MONK

RETREATS

SCRIPTORIUM

WORK OF OUR HANDS

DIRECTIONS

From the rising of the sun
to its setting, the name of the Lord
is to be praised.

Psalm 113

167 North Spencer Rd. | Spencer, MA 01562-1233 | Tel. 508.885.8700 | Contact Us | Links

SAINT JOSEPH'S ABBEY

ORIGINS

OUR DAY

BECOMING A MONK

RETREATS

SCRIPTORIUM

WORK OF OUR HANDS

DIRECTIONS

167 North Spencer Rd. | Spencer, MA 01562-1233 | Tel. 508.885.8700 | Contact Us

SAINT JOSEPH'S ABBEY

Planning your visit

ORIGINS

OUR DAY

BECOMING A MONK

RETREATS

SCRIPTORIUM

WORK OF OUR HANDS

DIRECTIONS

Come away to a lonely place
all by yourselves and rest awhile..

Mark 6.1

167 North Spencer Rd. | Spencer, MA 01562-1233 | Tel. 508.885.8700 | Contact Us | Links

(this spread) kor group/Saint Joseph's Abbey

Horarium Morning Midday Evening

Morning

BLESSED ARE YOUR EYES, FOR THEY SEE GOD'S WORKS. AND YOUR EARS, FOR THEY HEAR HIS WORD.

RESPONSARY AT VIGILS

SINCE PRAYER IS the monk's most important work he begins well before dawn. Rising in the quiet of the night he offers penance, praise and adoration, thanksgiving and intercession. He remains watching in silent vigil, deeply attuned to the love which God places before him and pondering how to respond. He pours over the Scriptures, struggling with its message and savoring its sweetness. At dawn, his watch ended, he offers praise at the coming of the light which announces the True Light illumining all creation.

EUCHARIST FOLLOWS. It is the focal point of his day, when the Body of Christ is his daily bread and the Cup his saving help. Made whole by these sacred mysteries, the monk tends to physical needs. He may take some bread and hot liquid as nourishment for the morning work ahead.

IN THE MORNING LET ME KNOW YOUR LOVE, FOR I PUT MY TRUST IN YOU.

ORIGINS

OUR DAY

BECOMING A MONK

RETREATS

SCRIPTORIUM

WORK OF OUR HANDS

DIRECTIONS

E-CARDS

Send an animated personalized e-card to friends, family... whoever!

More e-cards coming soon.

SELECT • PERSONALIZE • SEND

valentine's day e-card

everyday e-cards

Anniversary
Thank You
Good Luck
Graduation
Thinking of you
Birthday
Bad News
Congrats
Get Well

Love
Crush

seasonal e-cards

Valentine's Day
St. Patrick's Day
Mother's Day
Father's Day
Halloween
Thanksgiving
Holiday

▲ tell a friend

◉ BULLSEYE · E-CARDS · GUYS · GIRLS · SOUNDS GOOD · GAMES · SWEEPS · ›TARGET.COM · › GET INTO THE GAME

CHOOSE A DIFFERENT CARD >>>>>>>>>>>>>>>>

TO :::::::::::::::
Name:
E-mail:

FROM :::::::::::::::
Your Name:
Your E-mail:

YOUR PERSONAL MESSAGE :::::::::::::::::::::::::::::

The e-mail addresses you provide on this page will only be used to send and confirm the e-card.

PREVIEW CARD >>>>>>>>> SEND CARD >>>>>>>>>>>

Even I wouldn't eat **fruitcake!**

◉ BULLSEYE · E-CARDS · GUYS · GIRLS · SOUNDS GOOD · GAMES · SWEEPS · ›TARGET.COM · › GET INTO THE GAME

CHOOSE A DIFFERENT CARD >>>>>>>>>>>>>>>>

TO :::::::::::::::
Name:
E-mail:

FROM :::::::::::::::
Your Name:
Your E-mail:

YOUR PERSONAL MESSAGE :::::::::::::::::::::::::::::

The e-mail addresses you provide on this page will only be used to send and confirm the e-card.

PREVIEW CARD >>>>>>>>>> SEND CARD >>>>>>>>>>>>

Noses are wet, canines are true, there's a big red heart I'm fetching for you.

REPLAY >

◉ BULLSEYE · E-CARDS · GUYS · GIRLS · SOUNDS GOOD · GAMES · SWEEPS · ›TARGET.COM · › GET INTO THE GAME

CHOOSE A DIFFERENT CARD >>>>>>>>>>>>>>>>

TO :::::::::::::::::::::
Name:
E-mail:

FROM :::::::::::::::::::
Your Name:
Your E-mail:

YOUR PERSONAL MESSAGE :::::::::::::::::::::::::::

The e-mail addresses you provide on this page will only be used to send and confirm the e-card.

PREVIEW CARD >>>>>>>>>> SEND CARD >>>>>>>>>>>>

THAT'S NOTHING, I once had a wicked crush **on a garden gnome** for months.

WILLIAMS-SONOMA, INC. | COMPANY OVERVIEW | INVESTOR INFORMATION | NEWS | CAREERS | SEARCH

WELCOME
to our home.

—

COMPANY OVERVIEW
INVESTOR INFORMATION
NEWS
CAREERS
SEARCH

WILLIAMS SONOMA POTTERY BARN POTTERY BARN KIDS HOLD EVERYTHING CHAMBERS

Contact Us | Request a Catalog | Find a Store | Corporate Timeline | ©2001 Williams-Sonoma, Inc. All Rights Reserved.

WILLIAMS-SONOMA, INC. | COMPANY OVERVIEW | INVESTOR INFORMATION | NEWS | CAREERS | SEARCH

WILLIAMS-SONOMA POTTERY BARN POTTERY BARN KIDS HOLD EVERYTHING CHAMBERS

WILLIAMS-SONOMA

The first Williams-Sonoma store opened in 1956, selling a small array of cookware imported from France. Since then, the brand has expanded to hundreds of products from around the world, more than 200 stores nationwide, a direct-mail business that distributes millions of catalogs a year, and a highly successful e-commerce site. What has never changed is Williams-Sonoma's dedication to customer service and strong commitment to quality.

RETAIL CATALOG ONLINE PUBLISHING PRODUCTS

Contact Us | Request a Catalog | Find a Store | Corporate Timeline | ©2001 Williams-Sonoma, Inc. All Rights Reserved.

WILLIAMS-SONOMA, INC. | COMPANY OVERVIEW | INVESTOR INFORMATION | NEWS | CAREERS | SEARCH

CORPORATE TIMELINE EXECUTIVE BIOGRAPHIES

THE HOME WE'VE BUILT
✳ ✳ ✳

Founded in 1956, Williams-Sonoma, Inc. is the premier specialty retailer of home furnishings in the United States. Our brands are among the best known and most respected in the industry. We successfully market them through all three major channels—retail stores, catalogs, and the Internet.

Between all five of our business concepts, we cover every room in the house: from the kitchen to the living room, bedroom, home office, and even the hall closet. To learn more about who we are, where we came from and what we've accomplished, visit our corporate timeline.

WILLIAMS-SONOMA POTTERYBARN pottery barn kids holdeverything Chambers

Contact Us | Request a Catalog | Find a Store | Corporate Timeline | ©2001 Williams-Sonoma, Inc. All Rights Reserved.

WILLIAMS-SONOMA, INC. | COMPANY OVERVIEW | INVESTOR INFORMATION | NEWS | **CAREERS** | SEARCH

EMPLOYMENT OPPORTUNITIES CORPORATE VALUES HIRING PRACTICES BENEFITS

CAREERS

Williams-Sonoma, Inc. is always looking for intelligent, imaginative and self-motivated people for all levels of our company. We provide an exciting and creative work environment, and a variety of opportunities for professional as well as personal growth.

EMPLOYMENT OPPORTUNITIES
SELECT AREA OF INTEREST ▼

Contact Us | Request a Catalog | Find a Store | Corporate Timeline | ©2001 Williams-Sonoma, Inc. All Rights Reserved.

WILLIAMS-SONOMA, INC. | **COMPANY OVERVIEW** | INVESTOR INFORMATION | NEWS | CAREERS | SEARCH

WILLIAMS-SONOMA POTTERY BARN **POTTERY BARN KIDS** HOLD EVERYTHING CHAMBERS

pottery barn kids

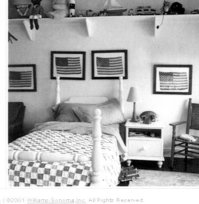

Since its launch in 1999, Pottery Barn Kids' rapidly growing catalog business and expanding retail presence have filled the void for whimsical, stylish and well-made furnishings for children. To date, the brand's unprecedented growth has more than exceeded our company's expectations.

RETAIL

CATALOG

ONLINE

PRODUCTS

Contact Us | Request a Catalog | Find a Store | Corporate Timeline | ©2001 Williams-Sonoma, Inc. All Rights Reserved.

WILLIAMS-SONOMA, INC. | COMPANY OVERVIEW | INVESTOR INFORMATION | **NEWS** | CAREERS | SEARCH

PRESS RELEASES

NEWS
—

Read the most recent Williams-Sonoma, Inc. press release, or search the press release archive.

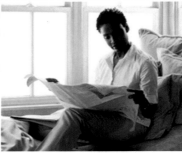

MOST RECENT PRESS RELEASES

- 10/19/01 | Williams-Sonoma, Pottery Barn and Pott...
- 06/20/01 | Pottery Barn Kids Welcomes Its New Arr...
- 05/15/01 | Williams-Sonoma, Inc. Announces the Pr...
- See all press releases

Contact Us | Request a Catalog | Find a Store | Corporate Timeline | ©2001 Williams-Sonoma, Inc. All Rights Reserved.

(this spread) Fallon/Microsoft

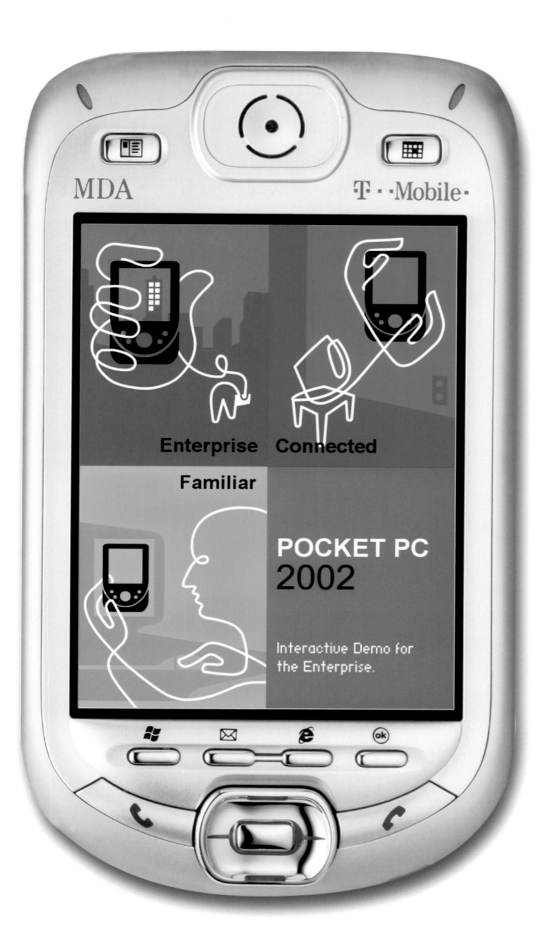

You golf because four generations before you have golfed and you don't want to break the streak.

TELL A FRIEND SHARE A LEGEND GET ALERTS EVENTS

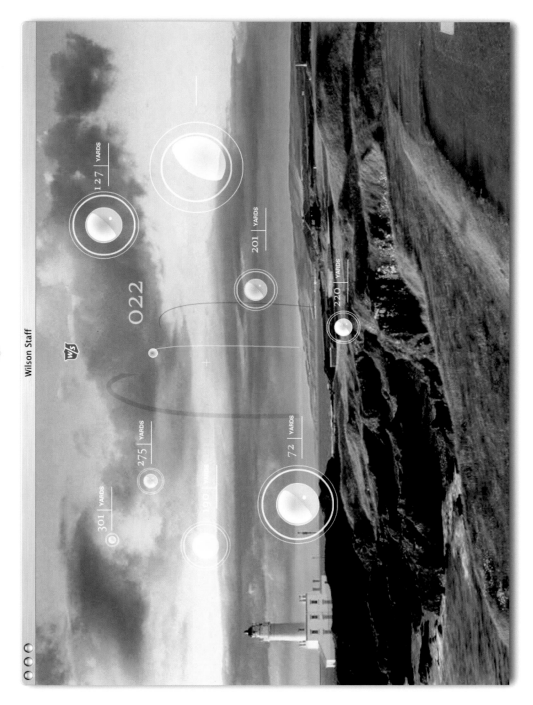

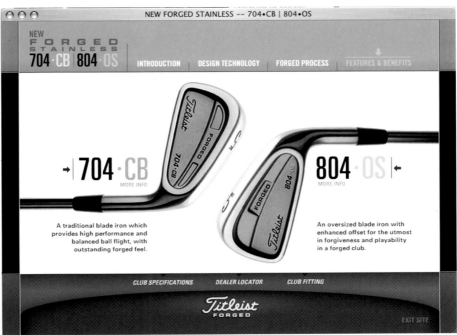

:Road Wheel Technology

○ CLOSE WINDOW

A. OFFSET SPOKE BED (OSB)

B. PAIRED SPOKE TECHNOLOGY

C. BLADED SPOKES

D. WELDED / MACHINED SIDEWALLS

E. TORQUE SHARING REAR HUBS

F. OCLV CARBON RIMS

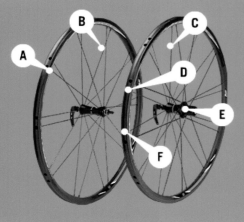

ROAD WHEEL TECHNOLOGY Our technology may be rooted in common sense, but it's anything but simple. You see, we don't build wheels. We build wheelsystems. Each individual feature is intended to optimize the performance of every other feature. For example, OSB rims reduce wheel dish more effectively when paired with torque sharing hubs. It may be a cliché, but the whole really is greater than the sum of its parts.

:Road Wheel Technology

○ CLOSE WINDOW

A. OFFSET SPOKE BED (OSB)

B. PAIRED SPOKE TECHNOLOGY

C. BLADED SPOKES

D. WELDED / MACHINED SIDEWALLS

E. TORQUE SHARING REAR HUBS

F. OCLV CARBON RIMS

DETAIL MAGNIFICATION 200%

D

WELDED / MACHINED SIDEWALLS All our aluminum rims have welded, not pinned, seams that are machined down to a beautiful and consistent braking surface. This makes a huge difference in wheel strength and braking performance — and it's a feature you'll find in precious few brands of wheels.

(this spread) Planet Propaganda/Trek Bicycle/Bontrager Wheelworks and Components

http://bontrager.com/

Bontrager • Home Page

WHEELWORKS COMPONENTS KEITH WORKSHOP NEWS

WE SET OUT TO MAKE THE BEST WHEELS ON THE PLANET.

JAAN KIRSIPUU | STAGE SIX 2001 TOUR DE FRANCE

SKIP

Since 1980, the name Bontrager has represented the highest level of mechanical refinement to the world of mountain biking. Not because of hype or gimmicks, but because of honest innovation. Considering all the knowledge about materials, design and manufacturing contained within the collective heads of Keith and everyone at Bontrager — our decision to build wheels and components for the road side was inevitable, if not a little overdue.

Race X Lite Wheelset

One of the wheelsets of choice of the US Postal Service Team, Race X Lites are now sleeker and lighter than ever before. >>

Discovery Team Revealed

Lance Armstrong unveiled his new Discovery Channel Pro Cycling Team this week, the evolution of the USPS team. Bontrager returns as a proud sponsor. This season Bontrager provides a much broader selection of components to support Lance. >>

Wheel Comparison Tool
Which wheel is for you? Check out three different models at a glance. >>

Race XXX Lite Seat Post

Whatever your angle, you'll find the new Race XXX Carbon Post lighter, stronger, and a whole lot easier to install. >>

FIND A DEALER DEMO CENTERS QUESTIONS TEAMS BONTRAGER

© 2003 Bontrager Wheelworks and Components | Problems with the site? Please let us know.

Bontrager • Saddles

http://bontrager.com/saddles/

Bontrager • Saddles

WHEELWORKS COMPONENTS KEITH WORKSHOP NEWS STORE >

SADDLES · POSTS · STEMS · BARS · CRANKS · FORKS

Saddles

Bontrager saddles offer more than just a comfortable place to park your rear. Keith intends them to help riders improve their technical skills by allowing easier center of gravity changes, whether sitting on the very tip of the nose or hanging way off the back. The Bontrager saddles on the right are available in a variety of colors and with options like gel inserts, Kevlar corners and titanium rails.

Race Lite
FS 2000
FS 2000 WSD

FIND A DEALER DEMO CENTERS QUESTIONS TEAMS BONTRAGER

© 2003 Bontrager Wheelworks and Components | Problems with the site? Please let us know.

Bontrager • Home Page

http://bontrager.com/

Bontrager • Home Page

WHEELWORKS COMPONENTS KEITH WORKSHOP NEWS

OUR RIDERS SET OUT TO MAKE THEM THE FASTEST.

ROLAND GREEN | UCI WORLD CUP OVERALL TITLE

SKIP

Since 1980, the name Bontrager has represented the highest level of mechanical refinement to the world of mountain biking. Not because of hype or gimmicks, but because of honest innovation. Considering all the knowledge about materials, design and manufacturing contained within the collective heads of Keith and everyone at Bontrager — our decision to build wheels and components for the road side was inevitable, if not a little overdue.

Race X Lite Wheelset

One of the wheelsets of choice of the US Postal Service Team, Race X Lites are now sleeker and lighter than ever before. >>

Discovery Team Revealed

Lance Armstrong unveiled his new Discovery Channel Pro Cycling Team this week, the evolution of the USPS team. Bontrager returns as a proud sponsor. This season Bontrager provides a much broader selection of components to support Lance. >>

Wheel Comparison Tool
Which wheel is for you? Check out three different models at a glance. >>

Race XXX Lite Seat Post

Whatever your angle, you'll find the new Race XXX Carbon Post lighter, stronger, and a whole lot easier to install. >>

FIND A DEALER DEMO CENTERS QUESTIONS TEAMS BONTRAGER

© 2003 Bontrager Wheelworks and Components | Problems with the site? Please let us know.

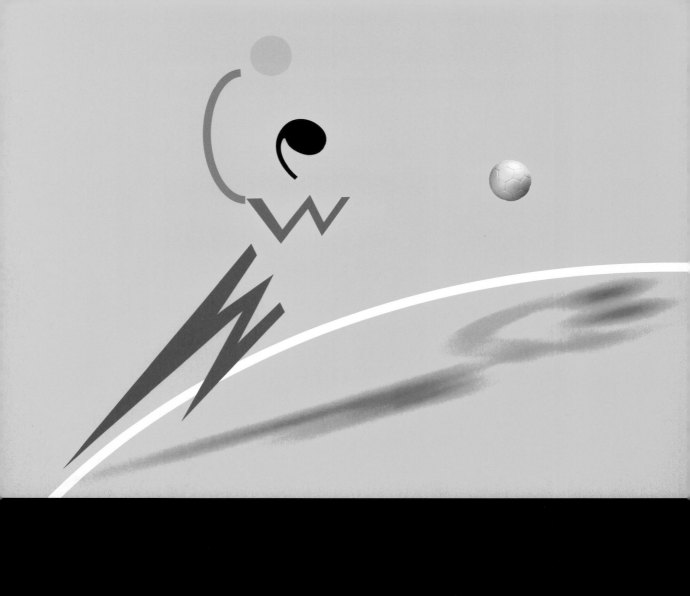

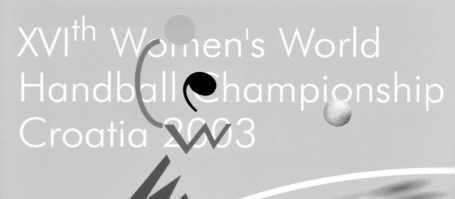

Bridgeline Software (formerly Lead Dog Digital)/Max Air Productions, Inc.

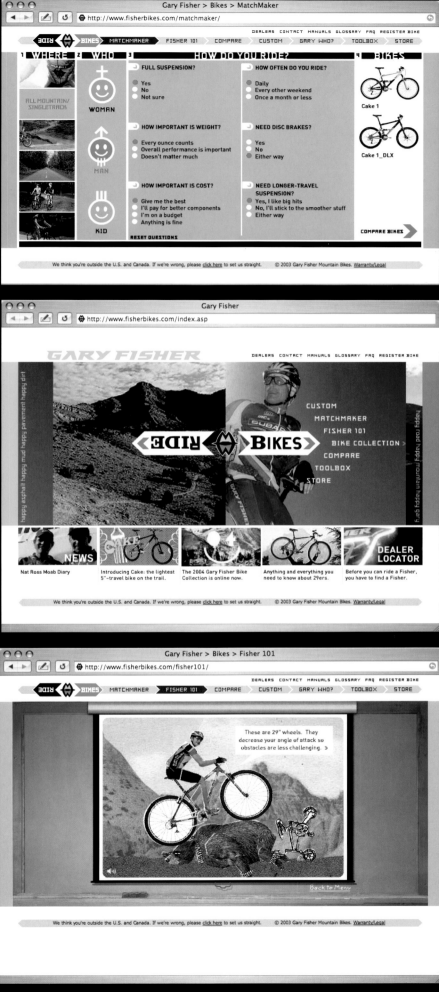

(this spread) DNA DESIGN/TELECOM

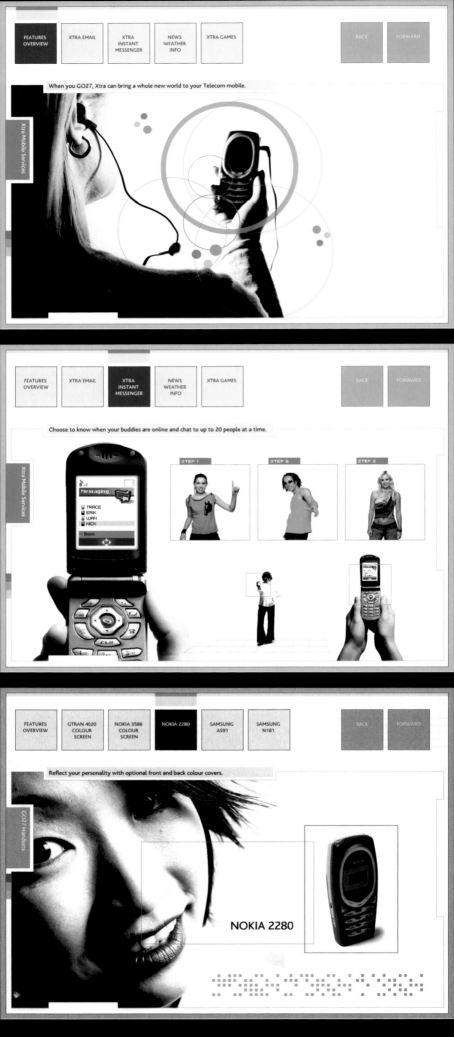

FEATURES OVERVIEW | XTRA EMAIL | XTRA INSTANT MESSENGER | NEWS WEATHER INFO | XTRA GAMES | BACK | FORWARD

Xtra Mobile Services

When you GO27, Xtra can bring a whole new world to your Telecom mobile.

FEATURES OVERVIEW | XTRA EMAIL | XTRA INSTANT MESSENGER | NEWS WEATHER INFO | XTRA GAMES | BACK | FORWARD

Xtra Mobile Services

Choose to know when your buddies are online and chat to up to 20 people at a time.

Messaging
TRACE
ERIK
LIAN
NICK
Back

STEP 1 | STEP 2 | STEP 3

FEATURES OVERVIEW | GTRAN 4020 COLOUR SCREEN | NOKIA 3586 COLOUR SCREEN | NOKIA 2280 | SAMSUNG A591 | SAMSUNG N181 | BACK | FORWARD

GO27 Handsets

Reflect your personality with optional front and back colour covers.

NOKIA 2280

(this spread) DNA DESIGN/TELECOMMUNICATIONS

FEATURES OVERVIEW | CHARLIE'S ANGELS | CLOCKS | LIKE A STONE | GIRLS ON FILM | BACK | FORWARD

Ringtones

Sample some cool sounding Polyphonic tunes.

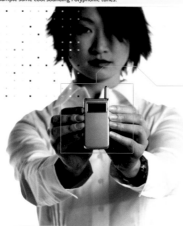

Want To Personalise Your Mobile? Try Jazzing It Up with a cool ringtone, or with the right handset download a richer sounding Polyphonic Ringtone!

With the range of ringtones available from Xtra, you have one more way to make your mobile sing out in a crowd.

FEATURES OVERVIEW | **XTRA EMAIL** | XTRA INSTANT MESSENGER | NEWS WEATHER INFO | XTRA GAMES | BACK | FORWARD

Xtra Mobile Services

Easy access to your Xtra email account and send messages from wherever you are.

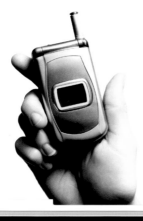

FEATURES OVERVIEW | GTRAN 4020 COLOUR SCREEN | NOKIA 3586 COLOUR SCREEN | NOKIA 2280 | SAMSUNG A591 | SAMSUNG N181 | BACK | FORWARD

GO27 Handsets

GO27 has a huge range of great phones to choose from.

We have some cool and funky mobiles available when you GO27, select an option above and find out more details about some of our more popular mobiles.

GO27

Netscape: nokia

connectingnokia.com

Netscape: nokia

Netscape: nokia

signage

marketing support materials

are just a click away

get connected.

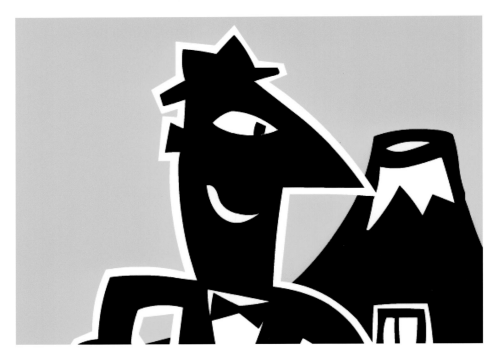

DNA Design/Telecom New Zeland

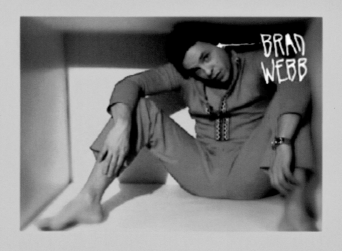

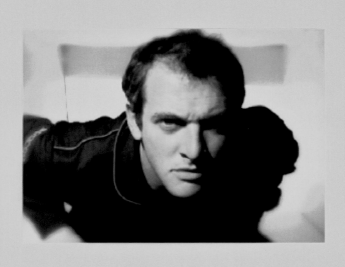

About Us
Fleet
Pilots
Pricing
Contact

Best Of The Best

It's easy to spot your pilots in the airport. They're wearing sharp navy suits and the distinctive yellow ties designed especially for CitationShares. You'll always fly with two pilots, each with pilot-in-command proficiency and each well schooled in both safety and service.

Since they are too modest to mention it, we'll let you know that our average pilot is 47 years old and has more than 7,000 flight hours. Out of 10,000 applicants for the position, your pair of pilots had the right credentials and the right personality ~ they had what it takes to wear the yellow tie.

Learn About Our Pilot Requirements ↗

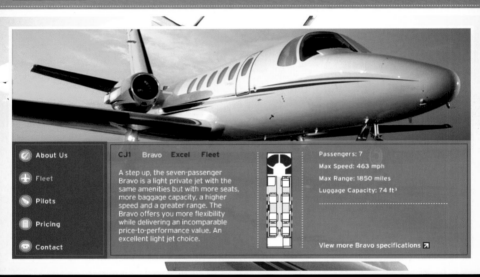

About Us
Fleet
Pilots
Pricing
Contact

CJ1 Bravo Excel Fleet

A step up, the seven-passenger Bravo is a light private jet with the same amenities but with more seats, more baggage capacity, a higher speed and a greater range. The Bravo offers you more flexibility while delivering an incomparable price-to-performance value. An excellent light jet choice.

Passengers: 7
Max Speed: 463 mph
Max Range: 1850 miles
Luggage Capacity: 74 ft³

View more Bravo specifications ↗

About Us
Fleet
Pilots
Pricing
Contact

We're ready to welcome you.

You can become a Vector JetCard member in no time. The contract is a simple two-page document. It's perfectly simple.

CITATIONSHARES

© CitationShares 2004

Or send us a note:

Vector JetCard by CitationShares
Five American Lane
Greenwich, CT 06831

P 877.832.8678
F 203.861.2792

Submit your email ↗

Official Tourism Website of
The Islands Of The Bahamas

My Bahamas / Sign up to save, share and print your vacation plans.

About The Bahamas Plan a Trip Book a Trip Events Weather

THE ISLANDS OF
THE bahamas

Island Hopping.
Day 2. Follow in no one's footsteps.

Vacation Planning Tools
◦ Start with our Vacation Guide
◦ Plan a trip with My Bahamas
◦ Book a trip online

The Bahamas Experience
◦ News
◦ World-class Sportfishing
◦ Diving in The Bahamas

Vacation Packages
◦ Atlantis- Paradise Island Beach Tower
◦ Sheraton at Our Lucaya Beach & Golf Resort
◦ Treasure Cay Hotel Resort & Marina
 See All Packages

Bahamas Island Hop Tour ℠
Download and explore panoramic views
and video interviews from 22 locations.

© 2004 The Islands Of The Bahamas // Contact Us // Privacy // Site Map

THE ISLANDS OF
THE bahamas

My Bahamas / Sign up to save, share and print your vacation plans.

About The Bahamas Plan a Trip Book a Trip Events Weather

The Abacos

Images
View Island

About the Island
History
What To Do
Where To Stay
Vacation Packages
Events
Map
Getting There
Getting Around
Travel Tips
Gallery

Download the Bahamas
Island Hop Tour ℠

© 2004 The Islands Of The Bahamas // Contact Us // Privacy // Site Map

THE ISLANDS OF
THE bahamas

My Bahamas / Sign up to save, share and print your vacation plans.

About The Bahamas Plan a Trip Book a Trip Events Weather

Diving
Types of Diving
View by Island
Dive Association
Travel Tips

Day 6.
Talk to a stranger.

Coral reefs. Blue holes. Walls. Caves. Shipwrecks. Sharks. Dolphins. Stingrays. The
variety of islands in The Bahamas present a variety of diving experiences. Beginners
and experts are welcome. Lessons and guides can be found throughout the islands.

Add to **My Bahamas**:
Diving
Sign up to save, share and
print your vacation plans.

The Bahamas Experience
◦ World-class Sportfishing
◦ Diving in The Bahamas
◦ Search for Treasure

© 2004 The Islands Of The Bahamas // Contact Us // Privacy // Site Map

Fallon/The Islands Of The Bahamas Ministry Of Tourism

Prepared by one of four acclaimed
ROSEWOOD CHEFS.

ROSEWOOD
HOTELS & RESORTS

The
ROSEWOOD EPICUREAN

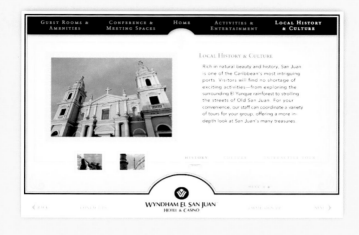

GUEST ROOMS &
AMENITIES

CONFERENCE &
MEETING SPACES

HOME

ACTIVITIES &
ENTERTAINMENT

LOCAL HISTORY
& CULTURE

LOCAL HISTORY & CULTURE

Rich in natural beauty and history, San Juan
is one of the Caribbean's most intriguing
ports. Visitors will find no shortage of
exciting activities—from exploring the
surrounding El Yunque rainforest to strolling
the streets of Old San Juan. For your
convenience, our staff can coordinate a variety
of tours for your group, offering a more in-
depth look at San Juan's many treasures.

WYNDHAM EL SAN JUAN
HOTEL & CASINO

WYNDHAM EL SAN JUAN
HOTEL & CASINO

GUEST ROOMS &
AMENITIES

CONFERENCE &
MEETING SPACES

HOME

ACTIVITIES &
ENTERTAINMENT

LOCAL HISTORY
& CULTURE

INTERNATIONAL
BALLROOM
Click for full specs

WYNDHAM EL SAN JUAN
HOTEL & CASINO

Ross Creative+Strategy/TRICON/Better Built

Index

ArtDirectorsDesigners

ArtDirectorsDesigners

DesignFirmsAdAgencies

DevelopersProgrammers

DevelopersProgrammers

AnimatorsIllustratorsPhotographersWriters

AnimatorsIllustratorsPhotographersWriters

Clients

Alterpop
1001 Mariposa Street #304
San Francisco, CA 94107
Tel 415 558 1515
Fax 415 558 8422
www.alterpop.com

Arnold Worldwide
701 Market, Suite 200
St. Louis, MO 63101
Tel 314 421 6610
Fax 314 421 5627
www.arnoldwldwide.com

Bamboo
119 North 4th Street, Suite 503
Minneapolis, MN 55401
Tel 612 332 7105
Fax 612 332 7101
www.bamboo-design.com

BBK Studio
648 Monroe Avenue, Suite 212
Grand Rapids, MI 49503
Tel 616 459 4444
Fax 616 459 4477
www.bbkstudio.com

Belyea
1809 7th Avenue, Suite 1250
Seattle, WA 98101
Tel 206 682 4895
Fax 206 623 8912
www.belyea.com

**Bernhardt Fudyma
Design Group**
133 East 36th Street
New York, NY 10016
Tel 212 889 9337
Fax 212 889 8007
www.bfdg.com

BombasticPlastic
71 Broadway, Apt 19G
New York, NY 10006
Tel 917 825 2108
www.bombasticplastic.com

**Brandenburg/Nishigaki
Design House**
433 Thomas Avenue South
Minneapolis, MN 55405
Tel 612 377 4422
Fax 612 374 5648
www.brandenburg-nishigaki.com

Bridgeline Software
(formerly Lead Dog Digital)
104 West 40th Street, 10th Floor
New York, NY
Tel 212 201 5635
Fax 212 564 6886
www.bridge-line.com

Bruketa & Zinic
Zavrtnica 17
Zagreb, Croatia 10 000
Tel +385 1 6064 017
Fax +385 1 6064 001

Business Architects Inc.
Gobancyo YS Building,12-3,
Gobancho, Chiyoda-ku
Tokyo, Japan 102-0076
Tel +81 3 3512 2541
Fax +81 3 3512 2540
www.b-architects.com

Candide Media Works
350 7th Avenue Suite 701
New York, NY 10001
Tel 212 647 0400
Fax 212 647 8255
www.candidemedia.com

Catalyst Studios
126 N 3rd Street, Suite 200
Minneapolis, MN 55401
Tel 612 339 0735
Fax 612 339 0739
www.catalyststudios.com

Claudia Goetzelmann
2443 Fillmore Street
San Francisco, CA 94115
Tel 415 305 7425
www.claudiagoetzelmann.com

Click Here
8750 N. Central Expressway,
Suite 1200, Dallas, TX 75231
Tel 214 891 5334
Fax 214 891 5333
www.clickhere.com

**Concrete Design
Communications, Inc.**
2 Silver Avenue
Toronto, ON Canada
Tel 416 534 9960
Fax 416 534 2184
www.concrete.ca

Crowley Webb and Associates
268 Main Street
Buffalo, NY 14202
Tel 716 856 2932 x 209
www.crowleywebb.com

**Deanne Delbridge Creative Focus
H. Mark Weidman Photography**
28 Hanover Drive
West Chester, PA 9382
Tel 610 388 9818
Fax 610 388 9820
www.weidmanphoto.com

Design Guys
119 N 4th Street, Suite 400
Minneapolis, MN 55401
Tel 612 338 4462
Fax 612 338 1875
www.designguys.com

DHI Visual Communication
520 W Erie Street, Suite 230
Chicago, IL 60610
Tel 312 664 0006
Fax 312 664 7194
www.thinkDHI.com

Digitas
355 Park Avenue S
New York, NY 10010
Tel 212 610 5121
www.digitas.com

DNA Design
PO Box 3056, 262-264
Thorndon Quay, Thordon
Wellington, New Zealand
Tel +64 4 499 0828
Fax +64 4 499 0888
www.dna.co.nz

Duffy & Partners
710 Second Street S, Suite 602
Minneapolis, MN 55401
Tel 612 548 2314
Fax 612 548 2334
www.duffy.com

Duplexlab
170 Mercer Street, #4E
New York, NY
Tel 212 529 2300
Fax 212 529 2323
www.duplexlab.com

Eleven Inc.
445 Bush Street
San Francisco, CA 94108
Tel 415 707 1111
Fax 415 707 1100
www.eleveninc.com

Emeryfrost
Sydney Studio, Level 1
15 Foster Street, Surry Hills,
NSW Australia 2010
Tel +61 2 9280 4233
Fax +61 2 9280 4266
www.emeryfrost.com

Engine Interactive
1415 10th Avenue, Studio #4
Seattle, WA 98122
Tel 206 709 1955
Fax 206 709 1958
www.enginei.com

EPOS, Inc.
1639 16th Street
Santa Monica, CA 90404
Tel 310 581 2418
Fax 310 581 2422
www.eposinc.tv

**Faculty of Design, Swinburne
University of Technology**
144 High Street
Melbourne,Victoria Australia 3181
Tel +61 3 9214 6885
Fax +61 3 9521 2665
www.swin.edu.au

Fahrenheit Studio
10303 Mississippi Avenue
Los Angeles, CA 90025
Tel 310 282 8422
Fax 310 282 8522
www.fahrenheit.com

Fallon
50 S 6th Street
Minneapolis, MN 55402
Tel 612 758 2459
Fax 612 758 2346

Firstborn
630 9th Avenue, Suite 605
New York, NY 10036
Tel 212 581 1100
Fax 212 765 7605
www.firstbornmultimedia.com

**FOTOJ: Photography &
Images of Jim Krantz**
14 N Peoria Street
Chicago, IL 60607
Tel 312 733 9958
Fax 312 733 9968
www.fotoj.com

Go Welsh!
987 Mill Mar Road
Lancaster, PA 17601
Tel 717 569 4040
Fax 717 569 3707
www.gowelsh.com

Goodby, Silverstein & Partners
720 California Street
San Francisco, CA 94108
Tel 415 955 6049
Fax 415 788 4303
www.goodbysilverstein.com

Grafik
1199 N Fairfax Street
Suite 700 Alexandria, VA 22314
Tel 703 299 5996
Fax 703 299 5999
www.grafik.com

Hello Design
8684 Washington Boulevard
Culver City, CA 90232
Tel 310 839 4885
Fax 310 839 4886
www.hellodesign.com

**Hornall Anderson Design
Works LLC**
1008 Western Avenue, Suite 600
Seattle, WA 98104
Tel 206 826 2329
Fax 206 467 6411
www.hadw.com

HSR Business to Business
300 E-Business Way, Suite 500
Cincinnati, OH 45241
Tel 513 671 3811
Fax 513 671 8163
www.hsr.com

IconNicholson
295 Lafayette Street
New York, NY 10012
Tel 212 274 0470
Fax 212 274 0380
www.iconnicholson.com

iDivaDesign
11930 Dorothy Street Suite 1
Los Angeles, CA 90049
Tel 310 980 2397
Fax 310 826 4491
www.idivadesign.com

Inergy Group
15 Old Danbury Road
Wilton, CT 06897
Tel 203 563 9977
Fax 203 563 9984
www.inergygroup.com

Juicy Temples
2424 E Robinson Street
Orlando, FL 32803
Tel 407 895 5015
Fax 407 895 1883
www.juicytemples.com

Karen Skunta & Company
1382 West 9th Street Suite 201
Cleveland, OH 44113
Tel 216 687 0200
Fax 216 687 0214
www.skunta.com

DesignFirmDirectory

kor group
1 Design Center Place, Suite 733
Boston, MA 02210
Tel 617 330 1007
Fax 617 330 1004
www.kor.com

Leopold Ketel & Partners
112 SW 1st Avenue
Portland, OR 97204
Tel 503 295 1918
Fax 503 295 3601
www.leoketel.com

Lesniewicz Associates
222 N Erie Street
Toledo, OH 43624
Tel 419 243 7131
Fax 419 243 3200
www.designtoinfluence.com

Liska + Associates
515 North State Street, 23rd Floor
Chicago, IL 60610
Tel 312 644 4400
Fax 312 644 9650
www.liska.com

**Margen Rojo
Comunicación Visual**
Marcos Carrillo 270
Mexico City, Mexico 08200
Tel 55 519 47 94
Fax 55 519 74 22
www.margenrojo.com

Mirko Ilic Corp
207 E 32nd Street
New York, NY 10016
Tel 212 481 9737
Fax 212 481 7088
www.mirkoilic.com

Missing Pixel
853 Broadway Suite 1116
New York, NY 10003
Tel 212 674 6454
Fax 212 674 9747
www.missingpixel.net

Mucca Design
568 Broadway Suite 604a
New York City, NY 11217
Tel 212 965 9821
Fax 212 625 9153
www.muccadesign.com

Nesnadny + Schwartz
10803 Magnolia Drive
Cleveland, OH 44106
Tel 216 791 7721
Fax 216 791 9560
www.NSideas.com

Pentagram Design
387 Tehama Street
San Francisco, CA
Tel 415 896 0499
Fax 415 541 9106
www.pentagram.com

Phoenix Design Works
325 W 38th Street, Suite 1110
New York, NY 10018
Tel 212 465 8585
Fax 212 465 0567
www.phoenixdesignworks.com

PIKABOO design
4301 New Brighton Drive
Apex, NC
Tel 919 749 4123
Fax 919 573 9591
www.pikaboodesign.com

Planet Propaganda
605 Williamson Street
Madison, WI 53703
Tel 608 256 0000
Fax 608 256 1975

Planning Group
12931 SW 89th Court, #202
Miami, FL USA 33133
Tel 305 506 1130
Fax 305 253 0100
www.planninggroup.com

Play
800 Washington Avenue N #690
Minneapolis, MN 55401
Tel 612 339 1433
www.playdesignwork.com

Red Barn Creative
2024 Red Barn Road
Woodstock, IL 60098
Tel 815 206 5100
Fax 815 206 5111
www.redbarncreative.com

Red Canoe
347 Clear Creek Trail
Deer Lodge, TN 37726
Tel 423 965 2223
Fax 423 965 1005
www.redcanoe.com

Ross Creative + Strategy
305 SW Water Street, 4th Floor
Peoria, IL 61602
Tel 309 680 4140
Fax 309 637 3051
www.rosscps.com

SamataMason
101 South 1st Street
Dundee, IL 60118
Tel 847 428 8600
Fax 847 428 6564
www.samatamason.com

Sandstrom Design
808 SW 3rd Avenue, Suite 610
Portland, OR 97204
Tel 503 248 9466
Fax 503 227 5035
www.sandstromdesign.com

Scholz & Volkmer GmbH
Schwalbacher Straße 76
Wiesbaden, Germany 65183
Tel +49 0 611 180 990
Fax +49 0 611 180 9977
www.s-v.de

Sequel Studio
12 W 27th Street, 15th Floor
New York, NY 10001
Tel 212 994 4311
Fax 646 935 0582
www.sequelstudio.com

Sharpe + Associates, Inc.
7536 Ogelsby Avenue
Los Angeles, CA 90045
Tel 310 641 8556
Fax 310 641 8534
www.sharpeonline.com

Sibley Peteet Design
3232 McKinney Avenue
Suite 1200 Dallas, TX 75204
Tel 214 969 1050
Fax 214 969 7585
www.spddallas.com

Siegel & Gale
9441 W Olympic Boulevard
Beverly Hills, CA 90212
Tel 310 228 3313
Fax 310 228 3301
www.siegelgale.com

smashLAB
910-409 Granville Street
Vancouver, BC Canada V6C 1T2
Tel 604 683 2250
Fax 250 564 2237
www.smashlab.com

space150
212 3rd Ave N Suite 150
Minneapolis, MN 55401
Tel 612 460 2800
Fax 612 332 6469
www.space150.com

Studio International
Buconjiceva 43
Zagreb, Croatia HR-10 000
Tel +385 1 37 60 171
Fax +385 1 37 60 172
www.studio-international.com

Studio Blue
800 W Huron Street, Suite 3N
Chicago, IL 60622
Tel 312 243 2241
Fax 312 243 1173
www.studioblueinc.com

Tank Design
158 Sidney Street
Cambridge, MA 02139
Tel 617 995 4044
Fax 617 995 4001
www.tankdesign.com

Terhorstdesign
170 Broadway, 5B
Brooklyn, NY 11211
Tel 917 701 4837
www.terhorstdesign.com

The Art Department
222 Avenue B #2R
New York, NY 10009
Tel 212 228 5552
www.artdepartment-nyc.com

The Moderns
900 Broadway, Suite 903
New York, NY 10003
Tel 212 387 8852
Fax 212 387 8824
www.themoderns.com

Thirteen / WNET New York
450 W 33rd Street
New York, NY 10001
Tel 212 560 6956
Fax 212 560 2903

UP Design LLC
24-26 Church Street
Montclair, NJ
Tel 973 783 1155
Fax 973 783 3447
www.updesign.com

VSA Partners, Inc.
1347 S State Street
Chicago, IL 60605
Tel 312 895 5049
Fax 312 427 3246
www.vsapartners.com

Waters International, Inc.
15 Maiden Lane
New York, NY 10038
Tel 212 513 0711
Fax 212 513 0733
www.watersi.com

WC Social
Rua Batataes 166, Jardim Paulista
São Paulo, SP Brazil 01423-010
Tel +55 11 38898585
Fax +55 11 38898585
www.wcsocial.com.br

Weymouth Design
332 Congress Street
Boston, MA 02210
Tel 617 542 2647
Fax 617 451 6233
www.weymouthdesign.com

Wunderman
7535 Irvine Center Drive
Irvine, CA
Tel 949 754 2138
Fax 949 754 2001

Young & Laramore
310 E Vermont
Indianapolis, IN 46204
Tel 317 264 8000
Fax 317 264 8001
www.yandl.com

Graphis Magazine

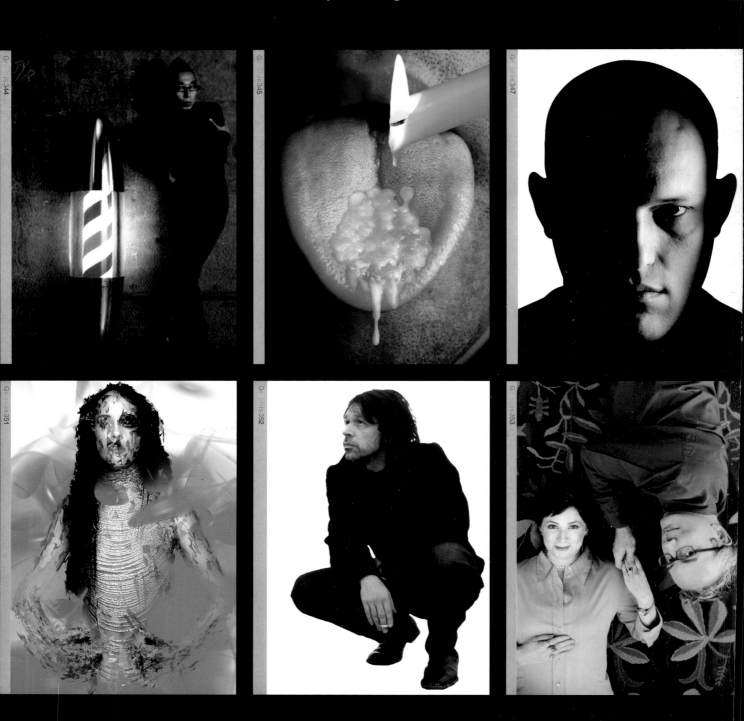

Graphis Call for Entries

Now register on-line at:

www.graphis.com